DESIGN FUNDAMENTALS

Packaging Prototypes

Published and distributed by RotoVision SA
Rue du Bugnon 7
CH-1299 Crans-Près-Céligny
Switzerland

RotoVision SA, Sales, Production & Editorial Office
Sheridan House, 112–116A Western Road
Hove, East Sussex, BN3 1DD, UK

Tel: +44 (0)1273 72 72 68
Fax: +44 (0)1273 72 72 69
Email: sales@rotovision.com

Distributed to the trade in the United States by:
Watson-Guptill Publications
1515 Broadway
New York, NY 10036
USA

ISBN 2-88046-389-0

10 9 8 7 6 5 4

Design by James Campus
Photography by Malcolm Robertson
Template designs by Three Monkeys Packaging Constructors

Production and separations by ProVision Pte. Ltd., Singapore
Tel: +65 334 7720
Fax: +65 334 7721

Packaging Prototypes

CONTENTS

PREFACE

Packaging imagery is vital; it enhances sales, it differentiates, it helps in the creation of a brand and in developing the personality of a pack. Consumers 'see' a shape, a combination of colours, or recognise a particular font style. Finding a familiar product in a familiar pack can be as similar and satisfying an experience as catching sight of an old friend.

Despite the general acceptance of the need for packaging, its fundamental role of protecting, preserving and containing products is not widely appreciated. The positive selling benefits generated by an excellent pack can rapidly dissolve once the pack is opened, the product is used or consumed and the pack itself becomes disposable rubbish. This negative image can unfortunately be as powerful as the positive selling image.

It is the positive selling image that excites the customer, inspires creativity in the designer, pleases the retailer and gives birth to such catch phrases as, "Packaging is good for you, try living without it!"

It is a fact that the huge conglomerate of manufacturers, converters, pack-fillers, the logistics chain and associated ancillary occupations, known collectively as the 'packaging industry', is little known to those not actually in it.

Packaging technology has been described as an occupation which embraces both art and science. The technological aspects of packaging are well catered for in many different texts – at all levels of interest – on the various packaging materials and processes; there are also reference books on boxes and cartons of all shapes and sizes. However, the concentration is largely on the management and application of the important and fundamental principles of packaging technology – to protect, to preserve, to contain and to inform (and where appropriate, to sell). The art of packaging has now been recognised and is beautifully presented in this exciting new reference work. Whilst it focuses primarily on carton design – which is superbly and graphically illustrated – notes on packaging history, the environmental concerns and a collection of classic packaging examples elevate *Packaging Prototypes* to an essential text for any designer, packaging technologist, student or packaging practitioner.

Packaging shapes and forms are presented in plan view and shown assembled with excellent photography highlighting the aesthetic qualities that designers seek to achieve within the constraints of machine running and predictable journey hazards. Each pack is also succinctly described with emphasis on the key design elements.

This is not, therefore, a book on packaging technology but rather a record of excellence in creative design; a collection of superb packaging imagery, but above all a source of inspiration for designers and would-be designers.

It will hopefully provide a new and positive view for those who consider packaging a necessary evil.

Jim McDermott MSc
Head of Education & Training
The Institute of Packaging

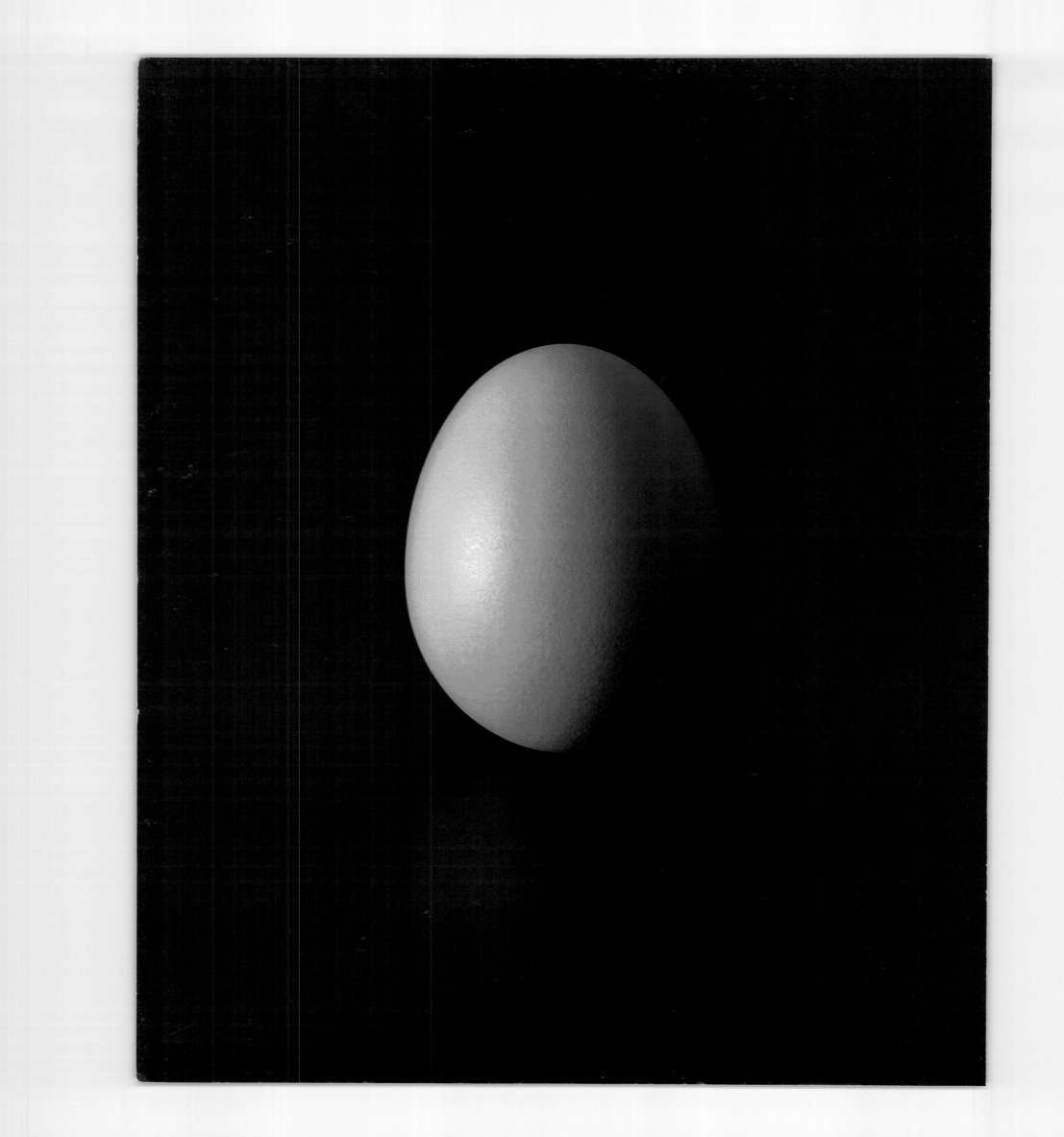

INTRODUCTION

A Short History of Packaging

Originally a phenomenon of nature, packaging has, in the past two centuries, grown in epic proportions in its man-made form in response to commercial demand. Though packaging of some description has always been used to contain or protect products, today it is infinitely more sophisticated and more developed than at any time throughout history. In today's world of advanced transportation and distribution networks, and with the sophistication of modern retailing, we have become completely dependent on packaging to bring goods safely and securely from their point of manufacture, via the retail outlet, to where they are required for use. It is often something we take for granted, yet it can function as a portable advertising placard, a protective skin, an information device and even part of the product itself.

Principally, the purpose of packaging is to contain and protect a product throughout its distribution and sale. Today, however, this has broadened greatly to encompass a wide range of functions and uses. This can be attributed, in part, to the pressures of the modern retailing system and the opportunities that have arisen as a result of the way we now choose to live.

The origins of packaging as we know it today can be traced back to the late eighteenth century when the Industrial Revolution brought massive change to the manufacturing industry. Whereas before, most processes relied heavily on manual labour and small batch production, the introduction of large-scale mechanisation allowed the production of far greater quantities of a single item from a production line. This not only applied to the commodity itself but also to the packaging. For the first time, food could be contained in sealed and hygienic metal containers – i.e. the tin can. Cardboard cartons were also extensively utilised, as they provided lightweight and easily printable packages whilst their construction as a pre-fabricated flat-pack also saved space. Metal boxes also developed extensively during this period and were a useful alternative to cardboard, especially in the sale of perishables, such as biscuits and confectionery, where a greater level of protection was required. By the turn of the twentieth century, manufacturing techniques had advanced far enough to allow these metal containers to come in almost any shape or form. This gave rise to the first examples of novelty packaging which, with computer-aided manufacturing techniques and the development of plastics, we take for granted today.

Printing techniques, which had already flourished in the early-nineteenth century, needed to diversify in order to keep apace with advances in packaging technology. The brand image had to be displayed on the container regardless of the material used. Glass bottles, earthenware pots, metal boxes or cans, cardboard cartons or simply paper wrappers – all required a label or identity of some form. This had far-reaching consequences in terms of giving added value or special interest to an otherwise bland commodity. The glaring graphics on a box of washing powder, for example, are more likely to catch the attention than the product itself. The

ability to use print on the package meant it could have a flexible identity and display a far greater degree of information about the product contained within. This in turn allowed a higher level of self-service, reducing the need for informed and specialised shop staff. With the benefit of hindsight, we can appreciate the enormity of this phenomenon when we compare today's retail superstores with the localised high-street shops of the past.

The development of coloured printing allowed artists to provide an image for a product which often became its identity. Today brand identity can be as important as the product itself and is likely to play a vital role in the consumer's purchasing decision. Many of the successful images forged in those early days are still just as strong and, in many cases, formed the foundation of the established corporate identities that we see today. This whole new area of art and design in retail formed the basis of what we now recognise as the vast and complex industry of advertising. Competition for space and attention at the point of sale has never been more aggressive and it is packaging that plays the vital role of communicating the right message to the consumer.

The Principles of Packaging

Depending on the requirements laid out in any packaging brief, the emphasis on the purpose of the packaging will vary considerably. This can be recognised most effectively when comparing and contrasting an elaborate gift-wrapped box of chocolates with a budget-box of breakfast cereal, for example. Both packages perform the primary purpose of containment and protection, but vary enormously in appearance, texture, graphics, shape, cost and structure. This principle must be remembered when designing a package – no single package is necessarily right or wrong but one might be considerably more appropriate than another.

The variations and options available to the packaging designer are wide-ranging. One product might be its own greatest asset and therefore need to be displayed on the packaging, or visible though it, whereas another product might be best concealed. It is often just as important for the packaging to enhance and identify the product as it is to protect it.

Not all packaging is designed to be seen at the point of sale. There is often an additional need to provide protection for the product and package when in transit and distribution, making it necessary to provide varying layers of packaging depending on the different stages of the distribution process, but still fulfilling the principal purpose of protection.

Essentially there are two key types of packaging: either 'primary' or 'secondary'. The primary packaging is that which immediately covers a product; the secondary package contains the many individual primary units, usually for transportation purposes. Depending on the product and the specific distribution requirements, there may also be a need for extra levels of packaging beyond this – requiring tertiary or quaternary layers. However, one can usually assume that the primary packaging is that which is seen on the shop shelf, and the secondary is that which is used in the transportation and distribution of the product units.

The primary package has the most important task in the area of product or brand identity. It will contain all relevant or necessary information regarding the product. It will be of a standardised size and dimension, so that it fits standardised shelf layouts and transportation containers. It will bear a strong graphic identity and product imagery. In some cases, the packaging is designed to aid the consumer in using the product, for example, a drinks' carton might allow the user to consume the contents effectively. It can, in some cases, be the single most important device in the identity of the product, therefore carrying considerable importance in terms of commercial success in the market place. This is not necessarily the graphic designer's work – the form or structure of the packaging often creates strong product imagery and becomes widely recognised as 'being' that product. Good examples of this are the Toblerone chocolate bar, with its instantly recognisable long triangular tube, and the classically curved Coca-Cola bottle.

The secondary packaging serves to contain and protect primary units in their transportation and distribution from the point of manufacture through to the point of sale. Although it is as important as primary packaging in terms of providing protection, it seldom plays a role in brand imagery. In this respect, secondary packaging is not required to fulfil the many other functions and requirements of the primary package.

Packaging and the Environment

Modern transportation and distribution networks, together with advances in technologies related to food processing and storing, have allowed goods to be imported from around the world safely and reliably. With trade increasingly taking place on a global scale, packaging becomes even more important – its role is essential in ensuring that this trade is carried out efficiently and with minimum waste. However, there is only a fine line between the balance of waste created by damaged goods – resulting from poor or insufficient packaging – and waste created by over-packaging. Despite assertions from the packaging industry that all packaging is necessary in reducing product waste, Sheila Clarke, Managing Director of the design agency, Packaging Innovations (U.K.), comments interestingly:

'The rigours of the distribution system, and the lack of control over it, lead to packaging specifications which cost money and use up resources. They are geared to ensuring a very high percentage of products arrive in safe and pristine condition at their destination, despite the rigours of the journey. By definition, therefore, any product which has not been subjected to being stacked under two other pallets, has not been dropped one metre from the truck's tailboard, and has not been stored in a warehouse for the maximum period of its shelf life, is over-packaged.'

Packaging and the environment are often seen as two incompatible elements with conflicting interests and aims. A vast quantity of material is used by the packaging industry just to bring products safely to our homes. It would be misleading, however, to suggest that this is entirely wasted. Without this material, much of what we purchase would be broken or have perished before we got the chance to use or even see it. What needs to be questioned is the level of material we use in packaging our products, and how we can continue to decrease that amount and recycle what we do use. All this must be achieved without compromising the protective efficiency of the packaging, as well as taking into account the problems Sheila Clarke refers to, necessitating a reappraisal of the systems we use to distribute our products.

The manufacturing techniques of packaging materials and packaging itself are in a constant state of evolution. Better manufacturing techniques to produce entirely new packaging; development of lighter-weight materials to produce stronger yet lighter cartons; and achieving increased strength from less material through quality design; these are all ways in which the packaging industry has helped to reduce the burden on resources.

The importance of the designer should not be understated when deciding on packaging for a new product, and it is important to consider the full life-cycle of the packaging when it is still at the design stage. Primarily, the emphasis of any packaging must be on using the least amount of material, without jeopardising the effectiveness of that package in its task of protecting the product. Each unit must be transported to the product, and then along with the product from the point of manufacture, through the retail outlet, and on to disposal. The cost in terms of energy and pollution can be greatly reduced if the designer is able to use lighter or fewer materials. Less weight in each unit will make a considerable difference over the number of products packaged and the number of miles transported. The size of the package, in terms of efficient use of space, is equally important. If the designer can make an equally effective yet smaller package, then a greater number can be transported each time. There is no economic sense in packaging large volumes of 'air' unnecessarily.

The designer must consider whether the packaging will be recycled, reused or, at worst, disposed of. Such considerations need to take into account the materials used, the environment in which the package is likely to appear or the use that is likely to be gained from the package. Re-using a package is regarded as more efficient and less of a burden on resources than recycling. In the light of this, the designer needs to think about the potential of the package to be re-used. This usually requires a higher level of material but a considerably longer service life will result. The best example of this is in the dairy and beverage industry, where a very high proportion of bottles are returned for refilling after use.

The final consideration for the designer in terms of resource use is that of recycling. The recycling debate has been very popular amongst consumers over the past decade and is now well established. Recycling has become a popular and somewhat overstated characteristic which industry has used to its advantage, though there is little proof of any significant environmental benefit, despite popular

consumer perception to the contrary. Although recycling increases the life-cycle of a raw material, it still has a finite life span. As the fibre length decreases after each recycling, so too does the strength of the recyclate, therefore compromising its effectiveness as a packaging material. This perpetual demise does not even take into account the environmental cost of the transportation of recycled material and the recycling process.

In terms of design, there are important considerations to be made when addressing recycling. The types of material used can affect the ability of that package to be recycled. Some materials will contaminate others if recycled together, therefore degrading the recyclate. Plastics, in particular, are problematic to recycle and need to be identified so that they can be separated easily and recycled correctly. An increasingly popular solution to plastics recycling is to use the recycled material as a fuel in energy production through incineration, but despite modern filtering techniques in incineration plants, there are still concerns over the by-products created by such processes. Sometimes it is down to the designer to consider recycled materials for entirely different design solutions. A good example of this is the increased use of fibreboard pulp as a packaging material, which has good protective qualities, and can replace expanded polystyrene.

In a future where materials and resources become more scarce, and therefore more expensive, and the methods of disposal become more costly and accountable, designers and manufacturers constantly need to rethink and improve methods of packaging. It has become a fundamental part of our modern lifestyle, we rely on it absolutely and it is up to us to manage it efficiently and responsibly.

Classic Packages

Packaging has become such a recognised and fundamental part of our everyday lifestyle that wherever you live in the world, there will always be a need for packaging of some description. The following examples of packaging have been chosen as a broad range of 'classic' designs that have become successful either by introducing some technological or design innovation, or have simply succeeded in forging an instantly recognisable brand image through the brilliance of their graphic and structural design.

THE BEVERAGE CAN

The idea of storing consumable material in a metal can has been around for over two hundred years now, dating from 1795, when Napoleon offered a reward to anyone suggesting a successful method of preserving food for his armies. The development of metal packaging has continued at a regular and consistent rate ever since. Manufacturing and food preservation methods developed apace with each other throughout most of the nineteenth century.

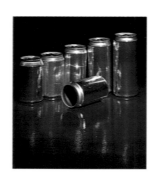

From around 1810 an individual craftsman was able to produce around 60 tin-plated steel cans a day, and in 1846 a man named Henry Evans invented a machine that could produce 600 cans a day. Today, modern processing plants produce over one million cans a day, with Europe alone producing over 32 billion cans per year.

By 1885, the Americans were producing the first liquids stored in cans in the form of 'condensed' milk. By 1940, beer was sold in the United States and parts of Europe in steel cans constructed in three separate parts. These cans had a cone-shaped lid sealed by a 'crown' cork.

Aluminium was the next great step in can technology. In 1963 The Dayton Reliable Tool Company, working with Alcoa, invented the aluminium easy-open end that was set to revolutionise the growth of can sales due to its increased level of convenience over previous designs. By the 1980s the two-piece can had come to dominate the market over the three-piece can, accounting for nearly 100% of the U.K. beverage market.

Perhaps the most significant developments in can technology of late are the environmental achievements. These include the development of the retained ring-pull which superseded the highly littering detachable ring-pull, as well as the light-weighting of cans through improved design and materials technology. The weight of the steel tinplate can has fallen by over 50% since 1960, from over 60g to under 30g. The weight of aluminium

cans has fallen from 21g to under 15g since 1970. Assuming these technological achievements continue and the recycling infrastructure continues to develop to cope with increasing production, there is every reason to believe that this form of drinks package remains a manufacturing and consumer phenomenon.

Can Makers' Information Service

HEINZ

Henry J. Heinz started out in food containment in 1860, at the age of 16, when he used to bottle horseradish from the family garden in Pennsylvania, USA. By 1886 Heinz Tomato Ketchup was being sold across the Atlantic in Fortnum & Mason's, London. By 1901 the first Baked Beans were being sold in the United Kingdom and by 1905 the first U.K. factory was built in Peckham, London. The strong and instantly recognisable graphics incorporated in the keystone-shaped emblem has remained as much a part of Heinz as the products themselves. Since first appearing on the labels in around 1880, the world-famous brand logo has appeared all over the world and is now a recognised image in most homes.

The product range, though never set at 57, would always carry the insignia, '57 Varieties', simply because Henry J. Heinz felt that number sounded about right. Although Heinz now has over 300 varieties, the one lasting and certainly enduring brand that sticks out amongst others in contemporary households today is Heinz Baked Beans. 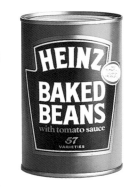 With the daily sales of Heinz Baked Beans at over a million and a half cans, it still proves to be a clear market leader.

H. J. Heinz Company Ltd

TOBLERONE

Theodor Tobler, son of the Swiss 'Specialist Confectioner', Jean Tobler, together with Emil Baumann, are the creators of Toblerone. On his travels Emil Baumann came across nougat, the confectionery made from honey, almonds and sugar. He and his cousin, Theodor Tobler, began working to produce this confectionery in their own unique way. When they had perfected their product they named it after their Tobler factory and the famous Italian nougat, Torrone – to make Toblerone.

The shape of this product is now world-famous and certainly one of the most successful chocolate products on the global market. It is believed to be the only chocolate mould ever patented, and the origin of this distinctive triangular shape is shrouded in controversy. It has been suggested that one influence might have been Parisian dancers dressed in beige dresses forming a pyramid during their finale, or even that it suggests links with certain emblems and symbols inside the Masonic Society. However, the most likely account is that this shape was derived from the mountain peaks that are such a famous and inspiring feature of Switzerland.

The packaging has changed little throughout the twentieth century. There have been six minor developments to the basic design throughout its long history. The first and smallest package, from 1908, showed an eagle clutching the Swiss flag between its talons. In 1920, the eagle had been replaced by a bear – the animal featured on the Berne flag. By 1930 the eagle had re-replaced the bear and was now holding a flag emblazoned with a 'T' for Tobler. In 1970 the name Toblerone filled the whole front space and the Matterhorn symbol appeared on the ends. In 1984 the JS (Jacobs Suchard) logo was added. The latest change appeared in 1987, when the Matterhorn was replaced with the blue and white triangle. With such a successful graphic and physical image it is no wonder that the shape or visual content has changed little over this century, though with the introduction of new flavours to the Toblerone range, other colour backgrounds (apart from the original beige) have been used to differentiate between them. The success of this design has had such a lasting impact on consumers that a survey conducted in the United Kingdom found that 94% of consumers could recognise Toblerone just by its shape.

Kraft Jacob Suchard

THE AEROSOL CAN

The idea of producing a spray from a pressurised liquid has been around for many centuries.

13

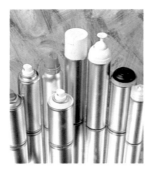

However, aerosol technology was first invented in Norway in 1929 and became a commercial success in the 1940s. The aerosol has now opened up a whole new dimension in packaging, making major gains in markets as diverse as asthma inhalers to tomato ketchup dispensers. Aerosols require a pressurising agent, usually a gas propellant, to dispense a product from the container when a valve is pressed. The key innovation in aerosols was to use a liquid that would be gas at room temperature. Under pressure or at low temperature it would remain a liquid. The product being dispensed could be anything from wet sprays – like hair-spray, or foam spray for shaving foam – through to dry powder for anti-perspirants.

The container itself could be manufactured in aluminium, tin-plate, stainless steel, glass and plastic. Tin-plate containers account for 75% of the U.K. market, while other European countries seem to prefer the aluminium container. Manufacturing techniques usually rely on two or three-piece construction of the cylinder, although aluminium, due to its malleability, can be impact-extruded from a single ingot. This can allow for a greater degree of design freedom in the shape of the container. The sheer size of production of aerosols is testament to their success as a container of the products we use. Over 1.5 billion aerosols are produced in the United Kingdom alone each year.

The British Aerosol Manufacturers' Association

THE COCA-COLA GLASS BOTTLE

The cool curvaceous Coca-Cola glass bottle has been enjoyed by Presidents, movie stars, and described by Andy Warhol as, the 'design icon of the decade'. It has been acclaimed as one of the most recognised containers on earth. The design was originally conceived in the early 1900s when bottlers of Coca-Cola faced constant threats of imitation of both product and packaging. And so in 1916 the brief was to find:

'A Coca-Cola bottle which a person will recognise as a Coca-Cola bottle even if he feels it in the dark.

The Coca-Cola bottle should be so shaped that, even if broken, one could tell at a glance what it was.'

This 192ml size bottle is still in use in many countries around the world, and larger sizes have appeared from time to time. In 1997 the Coca-Cola bottle was officially launched in a unique British 330ml glass bottle. The launch followed extensive research undertaken by The Coca-Cola Company, which confirmed that consumers still see drinking from the glass bottle as the 'ultimate' way of enjoying Coca-Cola.

Coca-Cola G.B

KIWI SHOE POLISH

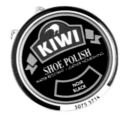

Kiwi's traditional tin of shoe polish is instantly recognisable across many different languages and cultures. Famous for its Kiwi bird symbol in red and white on the tin lid, Kiwi has become a packaging icon across the world. The company was established in Australia in 1906 by pioneering Scotsman William Ramsey who named the company after the birthplace of his New Zealand wife. It is now sold in 130 countries.

Shoe polishing became important in the nineteenth century, for the classes that could afford expensive leather footwear. By the twentieth century the methods of producing polish had expanded and developed to the point where it was commonly available. Kiwi successfully produced its original polish in Australia in 1906 before expanding to the U.K. in 1911. With the advent of the First World War, the need to protect and maintain large numbers of boots created a steady increase in demand for boot polish. This demand continued during the Second World War as a second generation of users relied on it to protect their valuable footwear. Soldiers returning to civilian life continued to use shoe polish to care for their boots and shoes; Kiwi soon became established as the number-one brand of polish and remains a world leader today.

H & BC U.K. Ltd

Dr. Ruben Rausing founded the company Tetra Pak in 1951 as a subsidiary of the parent company, Akerlund & Rausing. Following nearly ten years of development, he was able to introduce his packaging concept for containing liquid in a low-material, highly-sterilised carton. By September 1952, commercial production of the Tetra Classic tetrahedron-shaped 100ml carton for packaging cream was underway in Sweden. Developments in material lamination meant polyethylene-coated plastic could be used to provide a sterile and efficient seal for the cartons. By 1955 the larger 300ml cartons were being produced, followed by the one litre cartons in 1957.

In 1963 the first Tetra Brik cartons were launched in Sweden. This remarkable innovation contained sterile liquid in a carton, the dimensions of which complied with the international standards for loading pallets. As with the tetrahedron carton, this rectangular carton was produced from a flat sheet of laminated material, then filled and sealed below the surface of the liquid.

By 1967 the Tetra Rex was under production in Sweden. With its familiar gable top, this package was the company's first departure from the principle of sealing under the liquid level. The Tetra Pak product range has increased consistently throughout the last few decades. However, despite regional variations and special edition cartons, the products will remain the most revolutionary and recognisable carton designs for the storage of liquids this century. With a manufacturing and distribution network that spans the globe, the famous laminated carton, designed with minimum material usage in mind, has become a world-famous packaging design. It contains over 46,000 million litres of liquid in over 78,000 million cartons around the world each year.

Tetra Pak Ltd

BRASSO

Introduced into the U.K. in 1905, Brasso, with its striking sunburst pack design, is still the best-known metal polish brand in the marketplace. A director of Reckitt & Sons

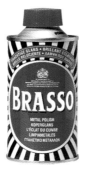

visited Australia at the turn of the century and found that a liquid product had superseded the paste-type of metal polish sold in the U.K. He brought the formulation back and the resulting Brasso liquid was very similar to today's tried and tested version: a siliceous polishing powder suspended in an ammonium soap gel and dispersed in white spirit.

Very few characteristics of Brasso have changed since its introduction into the U.K. nearly 100 years ago. The special 'recipe' has barely altered and the packaging has retained its authentic appearance. The packaging only changed once in Brasso's history when, in 1941, the can was replaced by a glass bottle because of a shortage of metal during the war.

Reckitt and Coleman Products

OXO

A brilliant German chemist named Baron Justus von Liebig discovered a way of producing beef extract from carcasses in the mid 1800s. His method proved very expensive and yielded only small amounts of the brown liquid, so he advertised for help in producing the extract on a larger scale. George Giebert, a Belgian engineer, successfully answered the advertisement and he and the Baron set about producing the extract in larger quantities.

By 1865 it was so popular that Liebig was able to establish Liebig's Extract of Meat Company.

In 1899 Liebig's Extract became known as 'Oxo' and it has been a familiar product in British kitchens ever since. It was not until the early 1900s that a technological breakthrough led to the product being sold in individually-wrapped cubes. Hand-wrapped and packed in small metal cartons printed with the familiar red and white colours, they cost just a penny each. During the First World War almost the entire production of cubes went out to the forces and over 100 million cubes were consumed from 1914-18.

Today more than two million Oxo cubes are sold daily and more than half of British households use them. The eye-catching graphics and simple package shape have barely changed in a hundred years, which is why Oxo has become such a strong packaging icon.

Van den Bergh Foods Ltd

Demand for the supermarket vest carrier bag has grown dramatically in the last twenty years and is worth many millions globally. The growth in supermarkets in the early-80s brought a change in shopping habits which meant that supermarkets had to provide bigger and stronger bags, to cope with increased demand from the consumer. In the U.K., the vest carrier was first produced at Moore and Co. in Nottingham, however, it was Alida Packaging in Heanor, Derbyshire, who saw its application within supermarkets and drove its success. The design of the vest carrier has been so successful that the only real changes in the last 15 years have been in the material used. More recently, legislative changes and environmental concerns have brought about the 'Bag for Life' (BFL). The idea of the BFL is that it is sold only once to the consumer who then reuses it until it breaks.

Alida Packaging Ltd

THE EGG BOX

The egg box is a world-famous symbol of pulp packaging and has remained almost unchanged in design, and unchallenged in the market, since its original conception around the 1930s. Despite massive pressure from the ever-increasing dominance of plastics in the mid 1900s, the pulp egg box has held out against all possible competitors.

It is an interesting tale that might live to symbolise the timeless appeal of paper pulp against the relatively temporary presence of plastics. The origins of pulp go back as far as paper itself, with fragments found in China dating back as far as 50–1000 BC. Unlike recycled paper, pulp does not require the high-quality surface and bleached appearance that paper so often needs. Instead, it proudly displays its textured surface finish, organic appearance and, as a result, succeeds in the market place. With chemical pollution at an all-time high and increasing fears over the production and disposal methods of plastics, pulp offers a chemical-free range of packaging ideas that the designer has yet to exploit fully.

The shell of an egg is one example of nature's own exceptional packaging. The long-standing success of the egg box lies in the material used and the simplicity of design. It is a classic example of synthetic packaging that compliments the fragile natural packaging within.

Cullen Packaging

The Carton

Carton design and development has evolved with increasing rapidity throughout this century. Although it initially started out as paper or board packaging, it now encompasses a vast field of laminates, different container designs and product requirements.

In spite of its ancient and varied history, paper is now predominantly manufactured from wood. Over 25 million tons are produced each year for world consumption, of which five million tons are used in packaging. The paper board used for corrugated and carton board is of a lesser quality than that used for printable or writing paper, and this is due to the way it is manufactured. Lower grade board is produced by grinding the wood against a submerged grindstone, thereby using all the wood in the process. The production of quality paper is more refined and uses a chemical reaction to extract the cellulose fibres from the wood. In both instances, the fibres are laid on a mesh and built up to the required grammage (weight in grams per unit area). Carton board differs from paper because of the grammage of the material. Paper becomes structurally suitable for carton board around 160 g/m^2, although carton board is usually multi-ply, whereas paper is single-ply. Depending on the specific requirements of the board, the pulp is treated to determine the visual and physical characteristics of the finished material. Bleaching produces a 'clean' white appearance, whilst most recycled and low-grade boards remain a distinct brown colour. Carton board is nearly always a multi-layer material, as this allows for printing,

price, appearance and performance to be taken into account. Consequently the surface layer will be of a higher quality to allow for printed graphics to be applied to the carton, whilst the bulk of the material in the inner layers will be lower grade pulp. The back often includes a barrier-layer. Of course, this varies enormously depending on the requirements of the carton. Modern liquid or freezer cartons will have additional barrier-layers of foil or plastic.

Once the board is produced it has to go through three processes before becoming a carton. There are approximately six key board qualities, ranging from low-quality waste paper board through to high-quality bleached chemical pulp.

The first of the three processes in carton production is printing, whereby various coloured inks are applied to the board, depending on the print process, to provide the necessary graphics and imagery specified by the client. Printing is not the only way to apply graphics to a carton – labels and embossing also provide a visual medium. Labels may be considered where the board quality is not of a printable standard; embossing is achieved by pressing the board between a die and a mould to create an imprinted image of the mould in the board, often used to convey a sense of style or class.

The second process is die-cutting, where the board is stamped by a die-cutter to the required shape of the carton layout – this is the basic shape of the carton laid out in flat card. The necessary folding lines are stamped and the excess material is recycled as waste.

The layout then passes to the third and final stage of finishing, where the last touches are applied to the carton before construction. This might include die-cutting of window panels, application of adhesives, and lamination or coating, to provide the carton board with a protective layer against the environment in which it is required to perform. This could vary from being damp, hot, freezing, humid, dry or subject to chemical contamination by gas, UV light or liquid, amongst many other possible conditions.

The carton designer must carefully consider the requirements of the package laid out in the design brief, because they will affect the nature, style and material of the design. Unlike packaging in general, carton design is not necessarily required to protect its contents, which may allow for greater freedoms of design and flamboyancy of shape. However, in transit all carton designs need to be flat-packed or

protected. If the carton functions as the protective packaging, then the designer needs to consider the requirements of the product. Is it fragile, liquid, solid or gas? Will it be stacked or not? Is it heavy or light? Will the package form a part of the point of sale display? Will it require a strong reliance on graphics or will its material, colour and texture form the basis of its visual appeal?

The nature of the product is also likely to determine the way in which the carton is filled and this in turn, will certainly affect the design. If the carton is to be hand-filled (as in most fast food cartons) it needs to be simple and easy to erect. If it is machine-filled then the designer needs to know the nature and limitations of the machine process. Is it likely to require adhesive or is it self-locking? At what speed are the cartons to be produced and filled? And are they filled at different premises?

An experienced designer is likely to know the feasibility and limitations of one design from another and will therefore quickly arrive at a working solution. It is true to say that for a vast majority of products a simple and similar carton design style might be suitable. Such solutions are tried and tested and listed by formalised code in manuals, such as the FEFCO Code for Corrugated Designs and the ECMA (European Carton Manufacturers' Association) Booklet for Carton Designers. Despite the almost standard range of carton design styles, there are numerous alterations to the carton that can be applied to make it more appropriate to a particular packaging requirement. Very often these may be minor alterations to the closure, the base, or the way the box is constructed, using adhesives or tucks. These variations are highlighted in the following section of the book, however, they are only an indication of possible variations open to the designer.

Corrugated cases must not be left out from the list of packaging designs available in fibre board. The corrugated 'box' is often used as a secondary package as its protective qualities are superior to carton board. Corrugated board is comprised of a layer of liner paper fixed to a corrugated layer to provide protection and rigidity. The number of corrugated layers depends on the protective requirements necessary to protect the product sufficiently within the package. Such is the strength of corrugated board that in some cases multi-layered corrugated board is now being used to transport products on instead of wooden pallets.

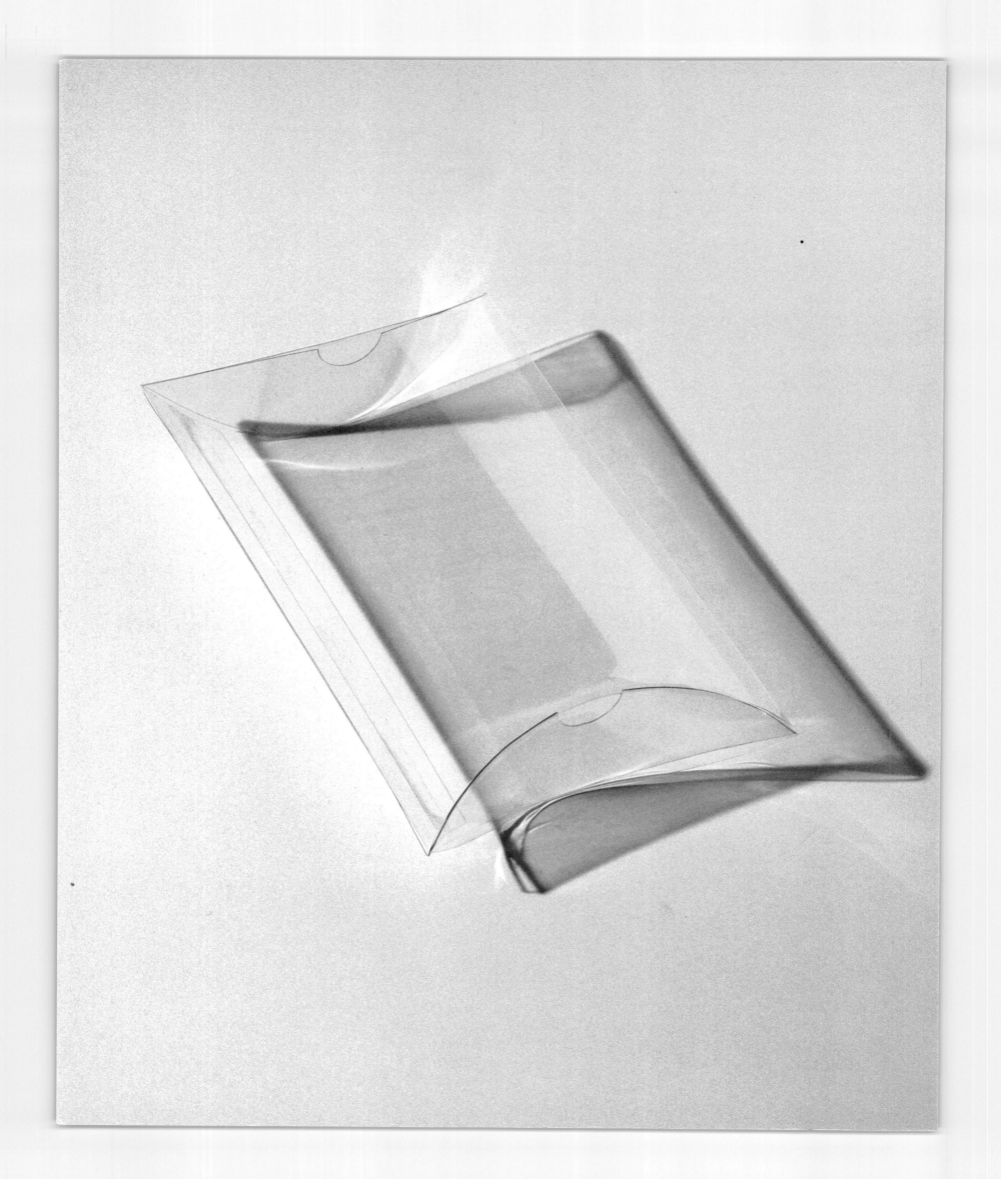

Different Types of Closures

There are five common styles for carton closures. The following all can be further adapted to fulfil a specific requirement; for example, tamper evidence, suitability for filling or assembly lines. The closure is an important part of the carton as it often provides or completes the carton's rigidity, whilst also providing a temporary barrier between the product and the outside environment.

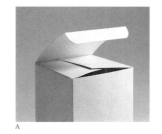

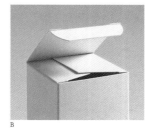

TUCK-END CARTON

These closures all tuck into place and require no gluing, they can either be opened and closed many times or used once depending on different types of fixtures such as dagger/spade, slit, and tab locks.

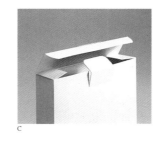

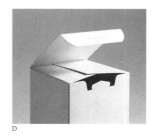

A] *Standard Tuck-Flap Carton.*

B] *Slit-Lock Tuck Carton. Provides a more secure seal.*

C] *Tab-Lock. Provides additional protection against the lid being forced open from the inside. With slits in the tab, this design provides a level of tamper-proofing.*

D] *Postal Lock. This provides a level of security as the tab-ends crease on opening providing proof of entry. Since the tabs do not tear immediately the closure has limited re-use. A dagger lock is a variation of this design and has an arrowhead tab which tears on opening; this is not re-usable but completely tamper-proof.*

A

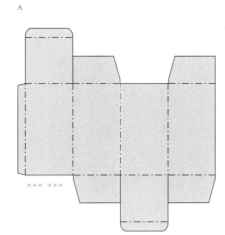

B

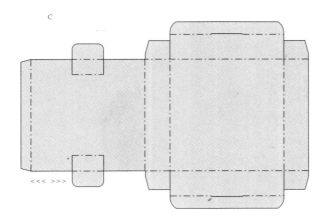

19

C

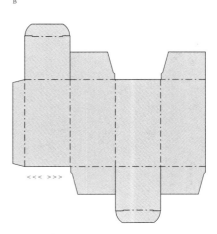

D

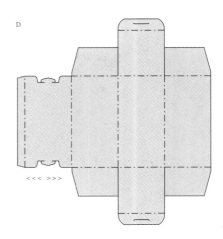

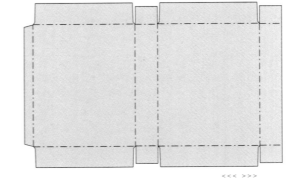

<<< >>>

SKILLET OR SEALED ENDS

Most of the transit cartons use this type of closure as it provides the most economical use of carton board in a competitive market. It also provides little scrap removal which is a labour intensive and costly process.

Flaps are sealed using glue or tape, normally on a production line, using an automatic sealer.

A, B] *Skillet (with butting tape-sealed ends).*

C] *Skillet with a Partial Overlap Seal. This provides a decorative tab and lock slot.*

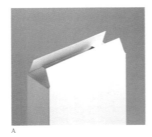

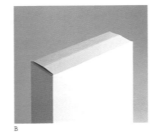

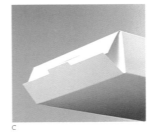

A

B

C

TUCK-TOP CRASH BASE CARTON

These are used increasingly when fast assembly of the carton is required. They are pre-glued and folded flat. For assembly the carton needs to be opened and the base slides into position and locks when all sides meet.

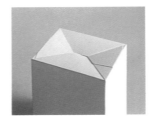

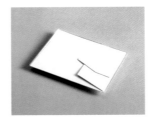

20

The above and below views of this closure show it to be glued lengthways along the external sides of the carton with the flaps from the widthways sides glued down. The base has slid into place when the carton was pushed together and it then snapped closed as the friction between the faces pushed the paperboard together. (See also template below).

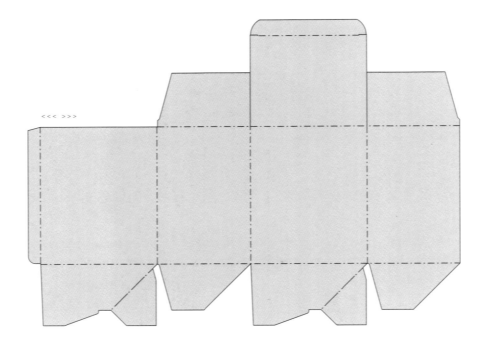

<<< >>>

This is used for easy-erect trays without the use of glue. Because the design does not need glue, time and resources are saved during production. There is a diagonal fold across each corner that creates a web when erected, the web corners are held in place by flaps that fold down over them. The corners can be glued to give further strength if required.

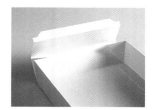

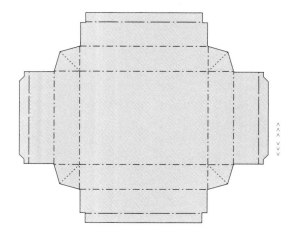

This type requires gluing which provides extra strength and ease of assembly. The corners are pre-glued and the structure is erected by pulling out the sides of the tray.

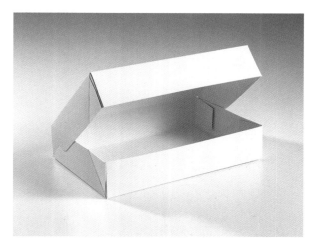

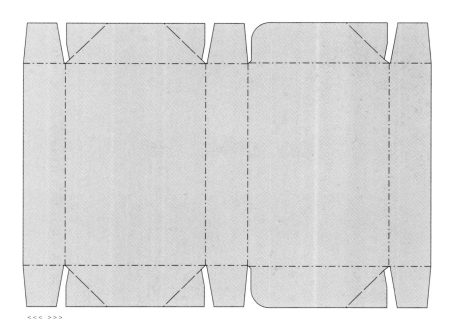

Packaging Materials

DESCRIPTION	TYPICAL USES	APPROXIMATE THICKNESS (MM)
White back folding box board	Novelty and luxury packs such as cosmetics, confectionery and other high-quality foods.	0.3–0.58
Folding box board reverse side cream	Food products (including frozen), medical packaging and cosmetics.	0.35–0.65
Solid bleached board	High-quality packaging used for cosmetics and the luxury trade.	0.285–0.49
Recycled solid white lined chipboard (minimum 75% recycled content)	Display outers and non-food products.	0.3–0.85
Pulp board	Used for low-cost products, special promotional packs or to emphasise an 'environmental' aspect of the pack.	0.3–1
Unlined A-flute corrugated	Used for packs which need no strength, providing a layer of protection for the product.	4
Single face A-flute corrugated	A currently fashionable pack for fast-moving consumer goods, with good crush resistance and tactile qualities.	4.2
A-flute corrugated (33 flutes per linear foot)	A pack for very fragile goods with great shock absorbency.	4.5–4.7
B-flute corrugated (47 flutes per linear foot)	High shock absorbency packaging with optimal levels of crush resistance.	2.1–2.9
C-flute corrugated (39 flutes per linear foot)	High-level shock absorbency packaging (greater than B-flute).	3.5–3.7
E-flute corrugated (90 flutes per linear foot)	Thinnest corrugated packaging used in instances where a narrow gauge of corrugation is required.	1.1–1.2
Double wall corrugated (B & C-Flute)	Used to protect fragile goods and to increase the strength of cartons containing heavy objects.	5.6–6.6
Multi-layered solid bleached board (waterproof lined)	Food and drinks packaging.	0.8–1
Acetate	Used to provide a barrier to touch and safety in transport while allowing the product to remain visible.	0.3–1

Icon key

MATERIALS

solid chipboard

corrugated cardboard

acetate

multi-layered

waterproof board

ASSEMBLY

glued

not glued

self-erecting

other fixings

SUITABLE USES

food packaging

confectionery

gift

liquid container

pharmaceutical

transit

OTHER INFORMATION

one-piece design

two-piece design

product visible

possible Euroslot placement

environmentally responsible design

CD reference

<<< >>> grain direction

Line key

cut

crease

perforation

score

cut and crease

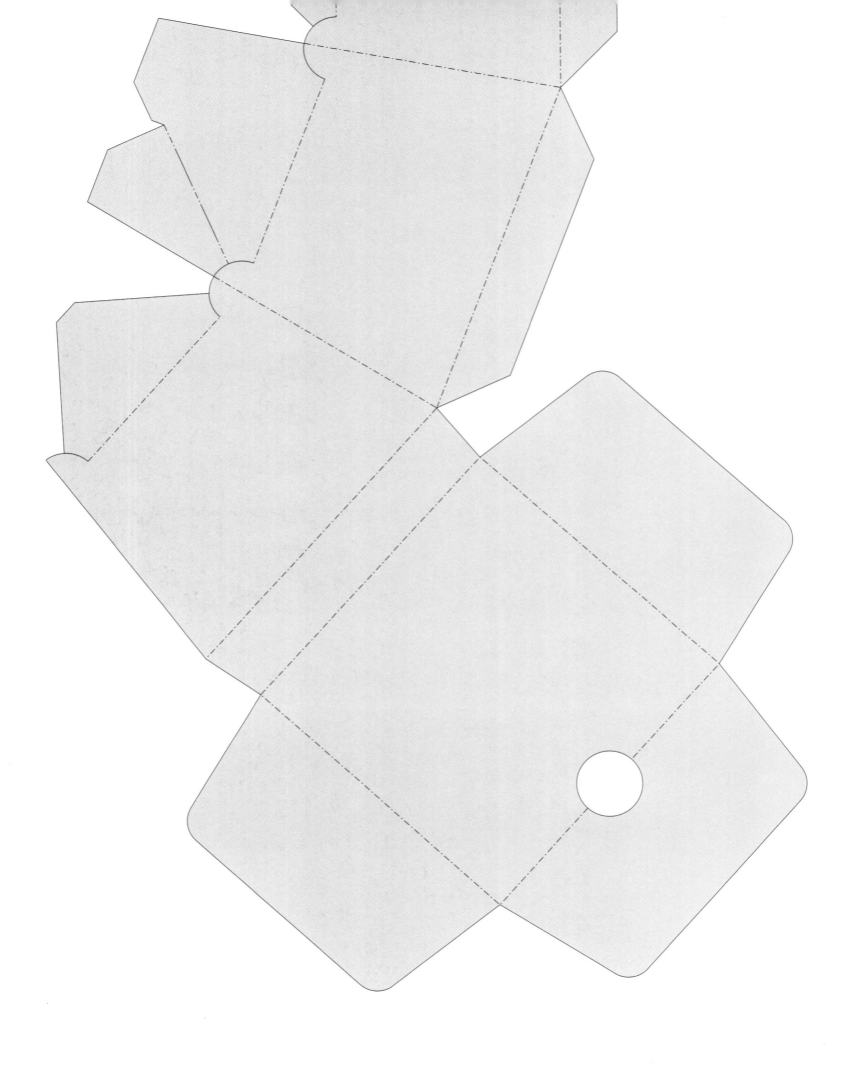

THE DESIGNS

Despite such a wide range of standardised and listed design styles there is still enormous scope for design inspiration and genuine innovation in this increasingly saturated market. Extremely clever, often simple designs can become market winners, thereby providing the client with a competitive edge that far outweighs the limited and temporary successes of advertising and marketing slogans. A successful carton design can forge a company image in the public mind and convey a class and quality that soon becomes the envy of its competitors. This can be seen in the numerous yet ever-failing lists of copies or poor imitations produced by competitors, in their attempts to share in the success of good design. Providing the designer recognises good design, they will apply for the necessary copyright or patent protection to prevent others reaping the rewards for a company's hard work and expertise.

The cartons featured in this book are principally chosen to allow the reader to apply their creative skill or technical knowledge across a broad spectrum of carton design, so that they can reach a design solution for their own needs and requirements.

The CD provided with this book has the necessary information for the majority of the designs featured to be downloaded into computer-aided design software and used to produce or adapt the designs for the reader's benefit. The data stored on the disk can be used to redraw the packaging dimensions, provide a sample cut by a computer-aided machine and die-cut for final design – all in a matter of minutes. (Some of the designs featured here are covered by copyright or patent restrictions and therefore cannot be detailed and reproduced on the CD-ROM.)

This book is written to inspire and stimulate the designer and manufacturer, it aims to act as a catalyst in the creation and production of exciting and innovative packaging design. The range of designs are by no means comprehensive, they merely demonstrate what can be achieved or may be considered when seeking design solutions from the very broad field of carton packaging possibilities. Some are simple, complex, or bland; others are inspiring, practical, or novel; but all fundamentally portray the spirit of carton design and the vast range of its potential.

Whilst many of the characteristic demands of industry are limiting and restrictive to the design process, it is down to the designer to continue to produce creative and exciting work, thereby continually pushing the boundaries of manufacturing, and furthering past achievements in design. We would not have reached the stage we are at today if designers and manufacturers had not endeavoured to extend the perceived limits of the past, and whilst we continually strive for success in the marketplace or in the field of design, we must never forget the purpose of re-designing. If a new solution achieves less than its predecessor, then its purpose and usefulness need to be questioned. Re-designing for the sake of it is not a responsible route forward. Ultimately all decision-making throughout the packaging process is accountable to the environment in which we live. Without this nothing can be achieved.

This book is intended to encourage the development of the design process, by blending examples of successful designs from the past and present with thought-provoking innovative examples to inspire and inform future design decisions. Much of the success of design today is in the field of waste reduction and in increasing packaging efficiency by using less material, and this is certainly a key target for designers of the future. The packaging designer – with a knowledge of materials, printing and manufacturing – is well-equipped to deal with the challenges that face an increasingly pressured packaging industry.

ACKNOWLEDGEMENTS

This book would not have been possible without contribution from the following, the authors wish to thank: Stevie McCrorie at Cullen Pulp Products for providing continual support, Berkshire Print and Packaging, Bonar Cartons, CGM Ltd., Danapak, Delta Print and Packaging, Field Group, GCM Boxmore, If Cardboard Creations Ltd., Mayr-Melnhof Packaging U.K., P.I. Design International, Van den Bergh Foods, Robor Cartons for providing samples of their carton designs; The students studying Packaging Design at Surrey Institute of Art and Design who worked so hard to produce their designs; Alida Packaging Ltd., British Aerosol Manufacturers' Association, Brooke Bond Foods Ltd., The Can Makers, Coca Cola Great Britain, H. J. Heinz Company Ltd., Kraft Jacobs Suchard, Reckitt and Coleman, Sara Lee, Tetra Pak UK, for their company literature; Evode Ltd., INCPEN, The Institute of Packaging, PIRA and Pro-Carton for all their support in providing valuable literature and advice.

Special thanks also go to the editorial and production team at RotoVision SA, particularly Kate Noël-Paton, whose creative input made this book possible, and to James Campus for his superb design.

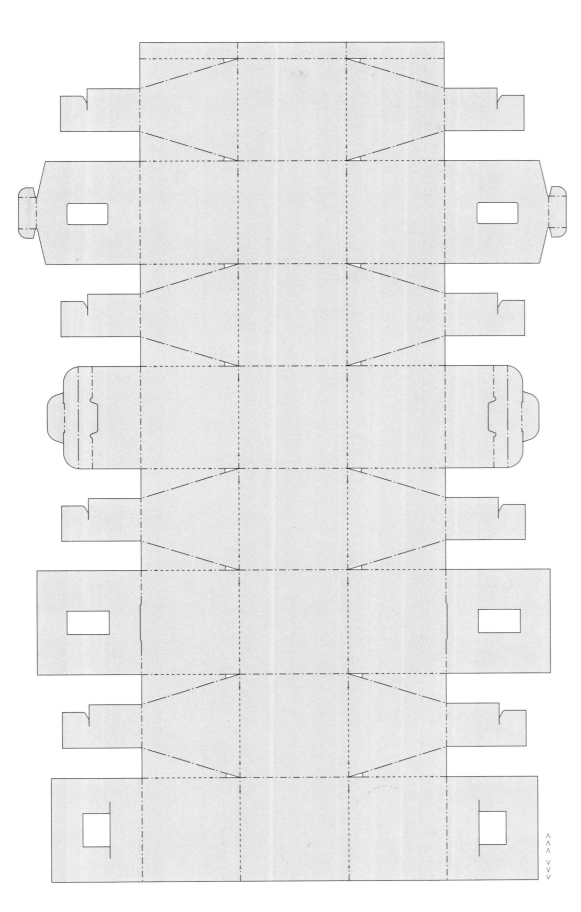

M.M. Packaging

A multi-formed and perforated carton. Through a series of semi-complex folds and tucks, this template takes on the rounded form that comes close to a sphere in carton board. This is good for novelty items and the multi-sided shape provides substantial opportunity for interesting graphics to be applied.

NEAR-SPHERICAL CARTON 29

This pyramidal carton is similar to the following example but uses a different form of closure. Instead of a simple lid, it includes a closing mechanism on each side section. This functions by pushing down one of these top tucks and then the others, in sequence, spiralling inwards.

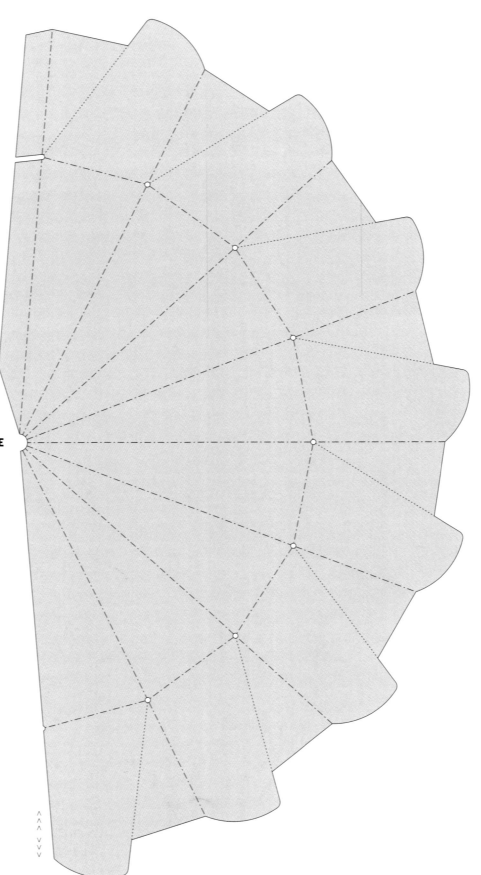

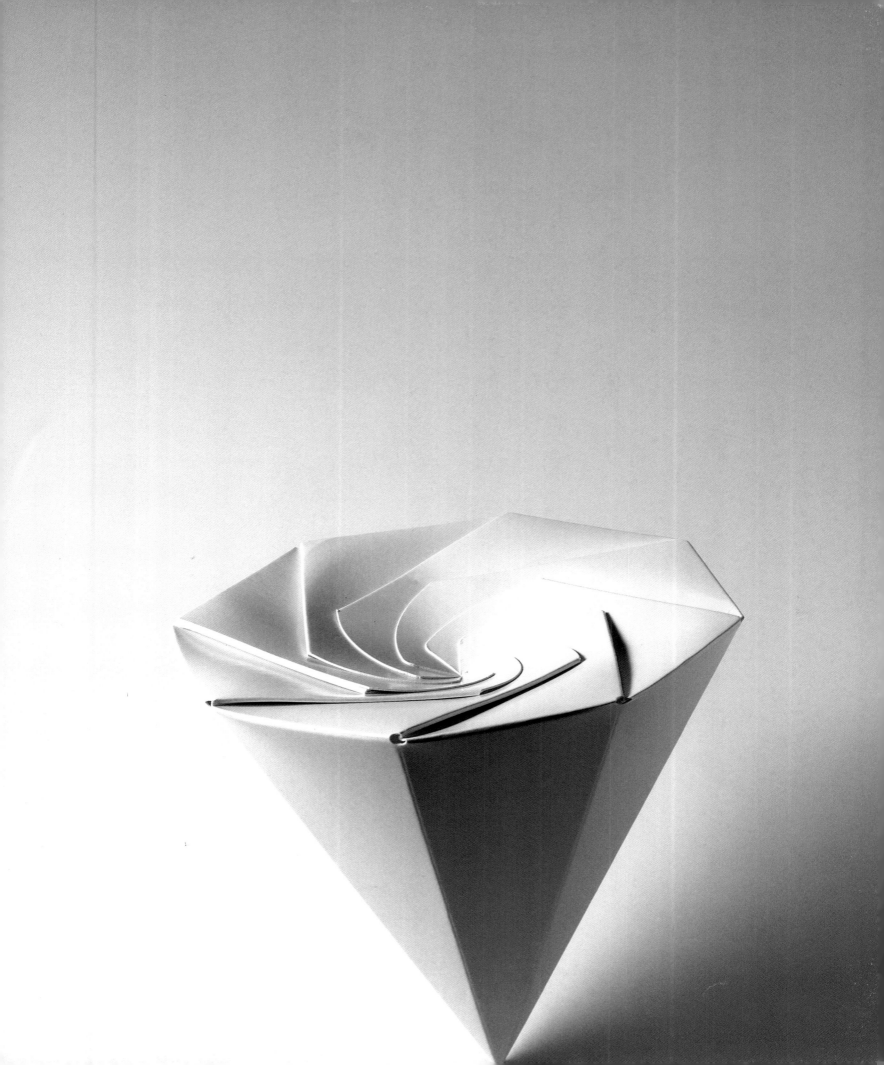

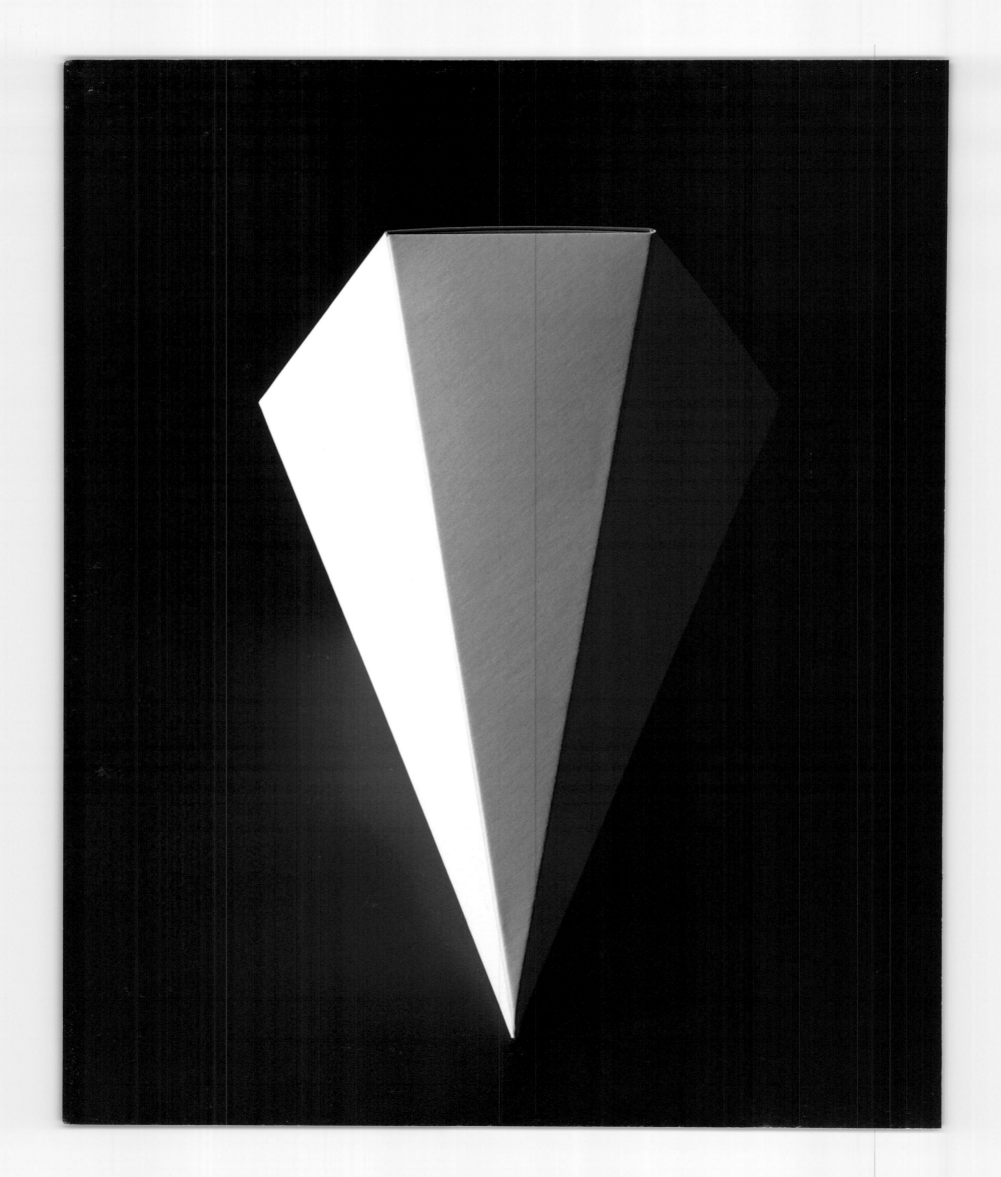

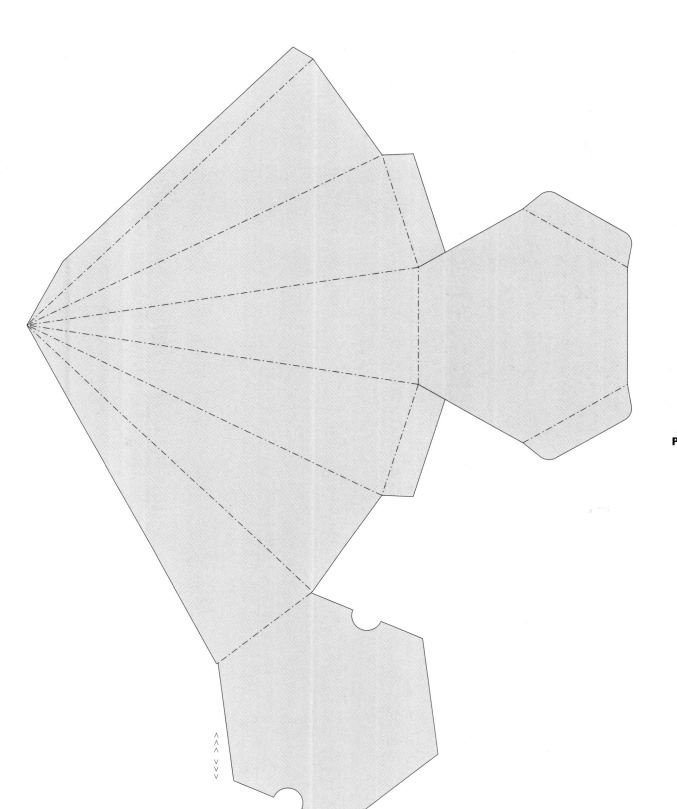

The tapered sides and glued tuck flaps create a pyramid-shaped carton, the inter-mediate slip and lid is optional depending on product requirements. The designer also has the option of increasing or decreasing the number of sides of this carton by altering the side sections and therefore the shape of the base.

PYRAMIDAL CARTON 33

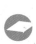
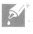

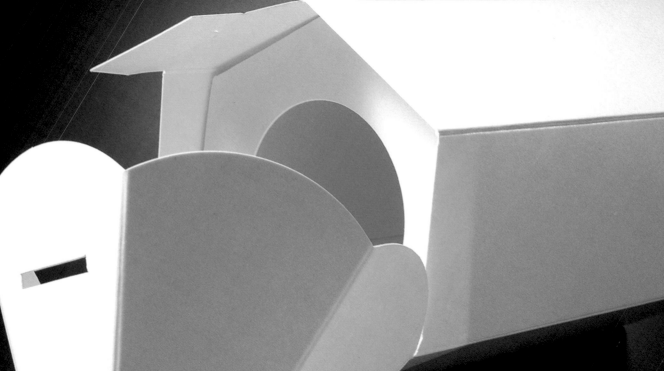

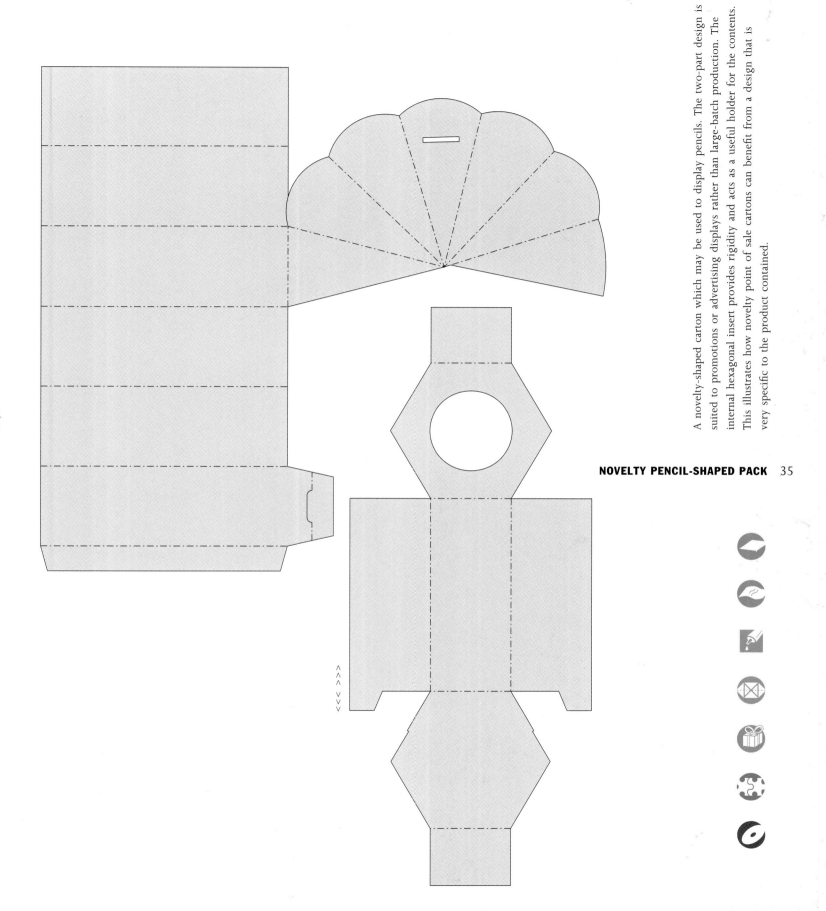

A novelty-shaped carton which may be used to display pencils. The two-part design is suited to promotions or advertising displays rather than large-batch production. The internal hexagonal insert provides rigidity and acts as a useful holder for the contents. This illustrates how novelty point of sale cartons can benefit from a design that is very specific to the product contained.

Danapak

This is glued along the main tuck flap and stapled together at the ends, with a few ingenious folds the carton forms a cracker with a storage section in the middle. This design is suitable for novelty or luxury confectionery items, additional use of materials or features could raise the perceived quality of the item contained within.

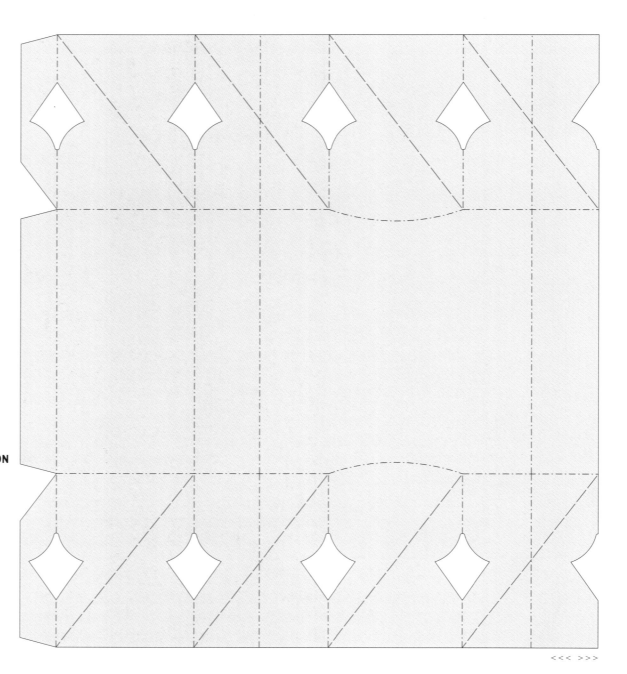

<<< >>>

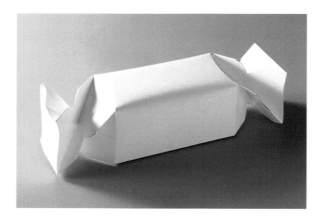

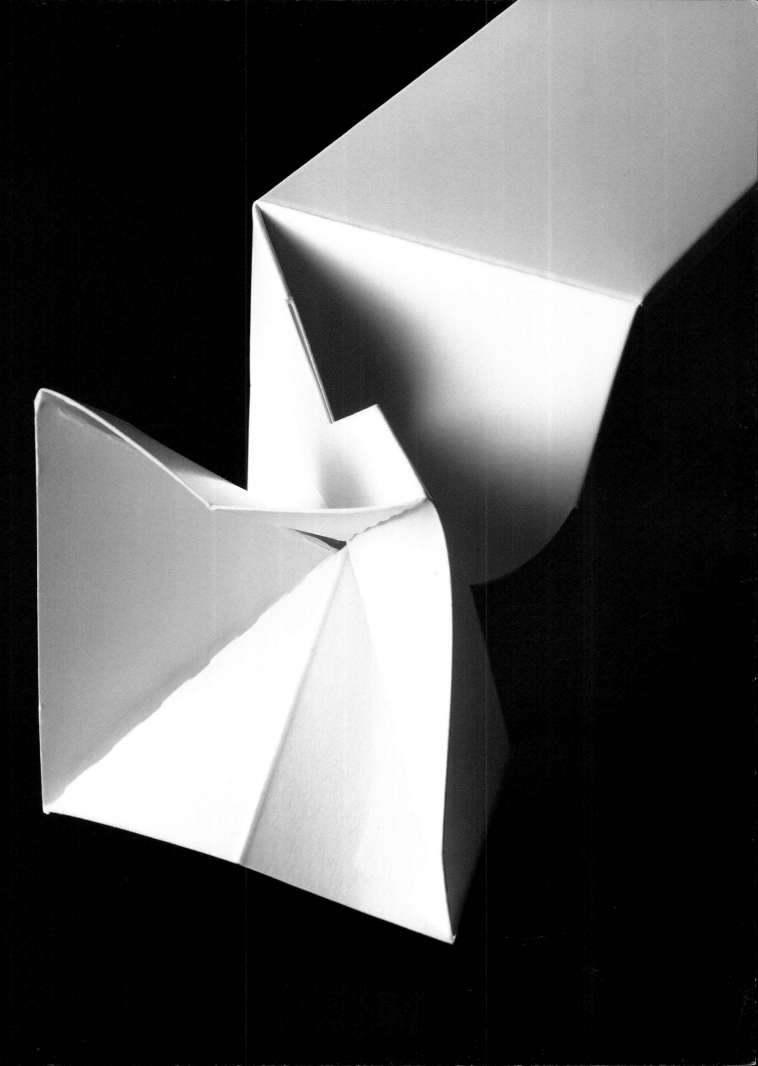

This carrier-style carton with contoured and tapered sides is easily flat-packed and erected by pressing the sides, which in turn constructs the press-lock base. Entry is achieved by squeezing the upper-sides of the carton, thereby forcing open the aperture at the top. The window display panel is specially cut to follow the contours on the front face of the carton.

ENVELOPE-BASE CARRY CARTON

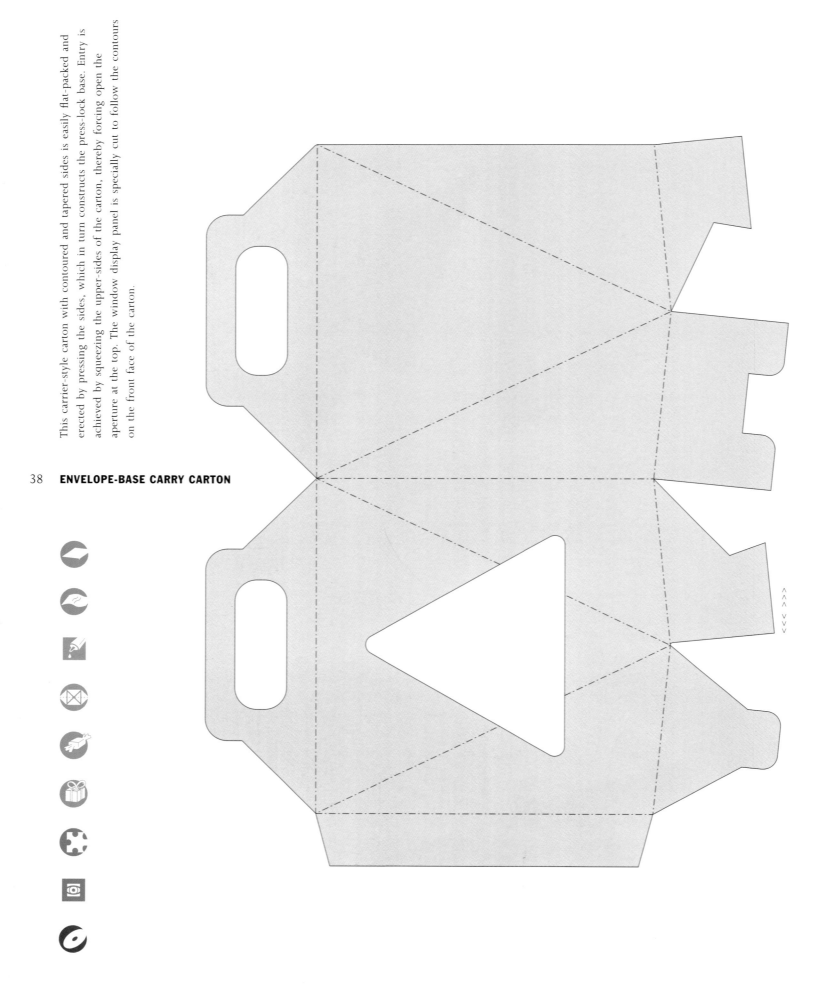

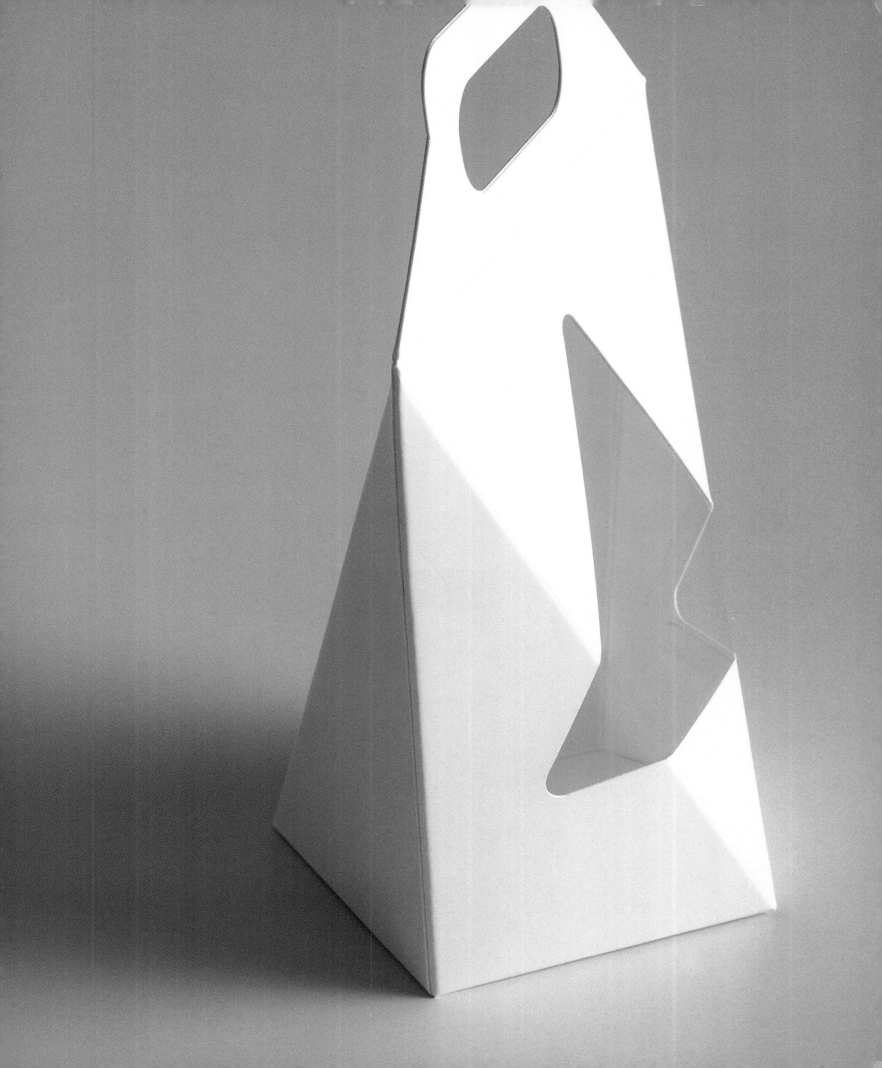

A cardboard bag with a crash-lock base for use in promotions and for packaging items such as lingerie and clothing. The product determines the required strength of the bag and the strength will depend on the thickness of the card used. This could be used as primary or secondary packaging with the material used greatly affecting the perceived quality of the product or retail outlet that provided the bag.

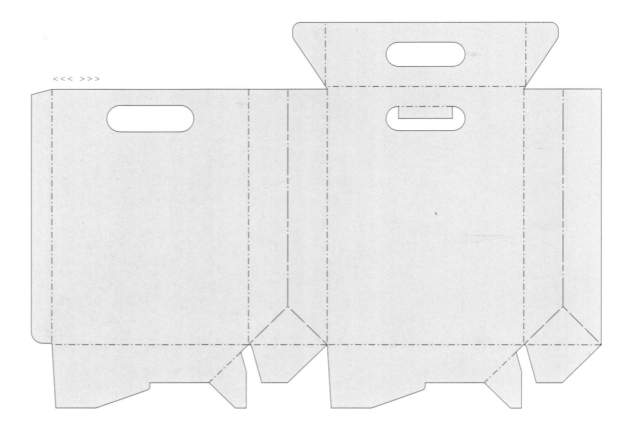

<<< >>>

40 **GUSSET-SIDED CARRY CARTON**

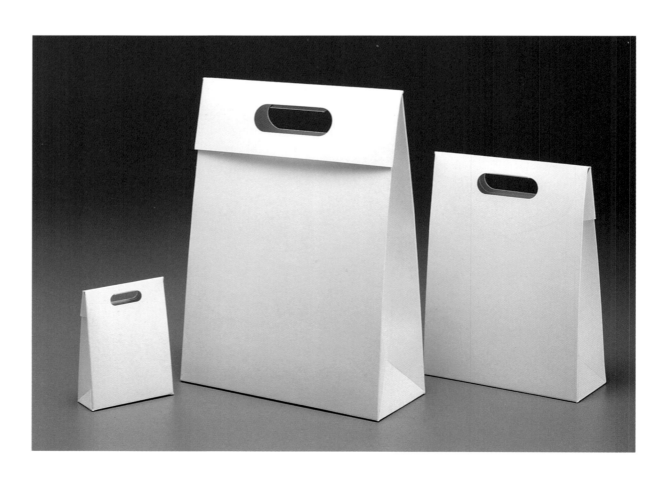

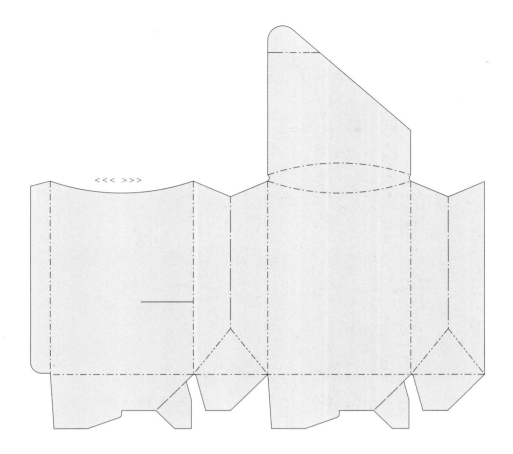

This carton, with a crash-lock base, cushion top and tuck-flap closure, is designed for gift and luxury items. The use of cord creates a carry-handle and completes this stylish and sturdy carrier. Produced in quality material with the attention to aesthetic detail made a priority, this carton is not merely a transportation pack, but also an attractive package that adds perceived value to the product presented within.

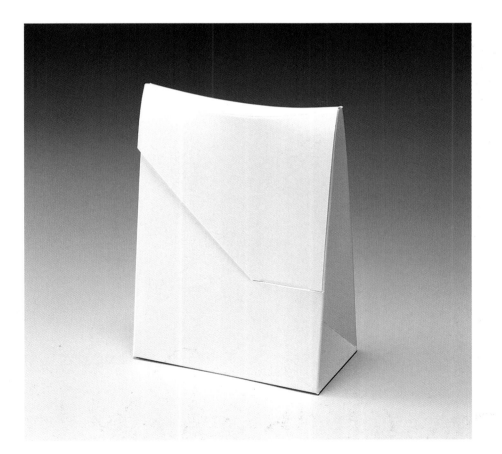

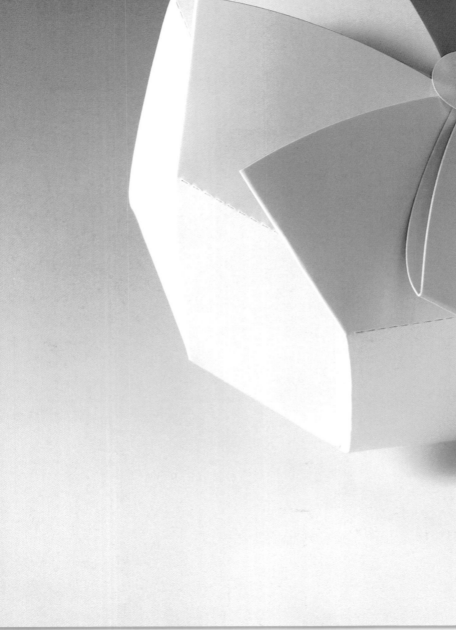

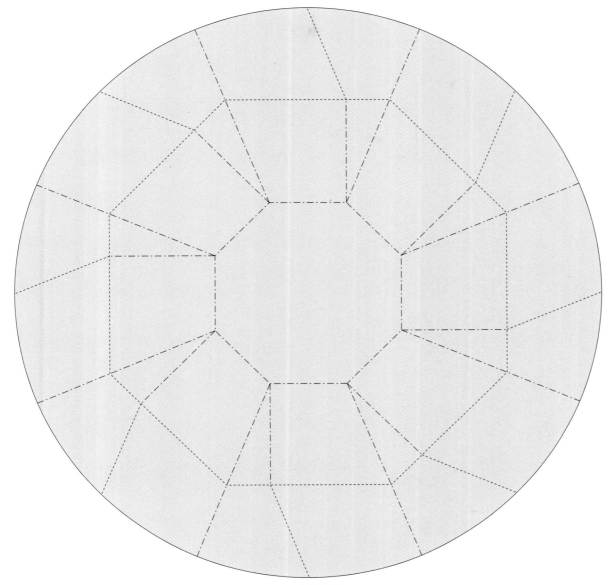

<< >>

CGM Ltd

An innovative carton derived from the ancient art of Origami. This example is octagonal in shape and erects through a series of complex folds and creases to form a rounded box with an attractive frilled closure on the top surface. The complexity of the creasing would demand extra time and skill in production. This is an outstanding piece of paper engineering that creates a box from a single disc of card.

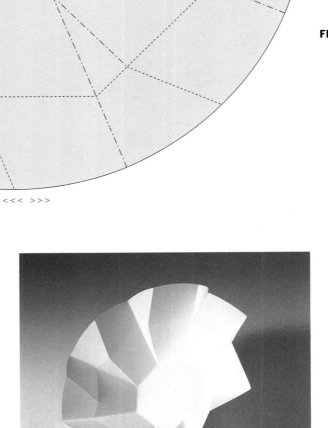

An inspirational carton with a star-shaped opening that might provide a decorative container for food, confectionery or luxury items; it would also be suitable for expensive limited edition products, or point of sale promotions. The use of different coloured or textured cards would create interesting variations to this carton. The folding of this complicated piece of Origami is illustrated below.

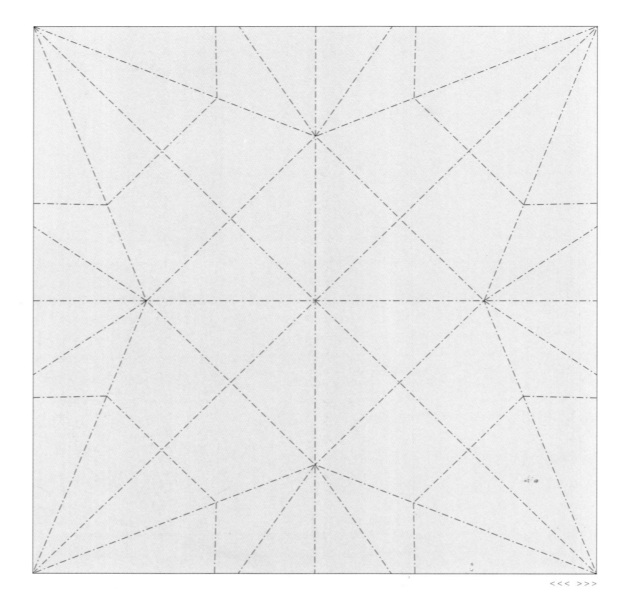

Claire Sheldon – Surrey Institute of Art and Design

<<< >>>

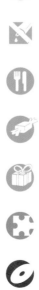

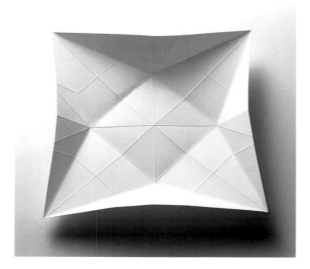

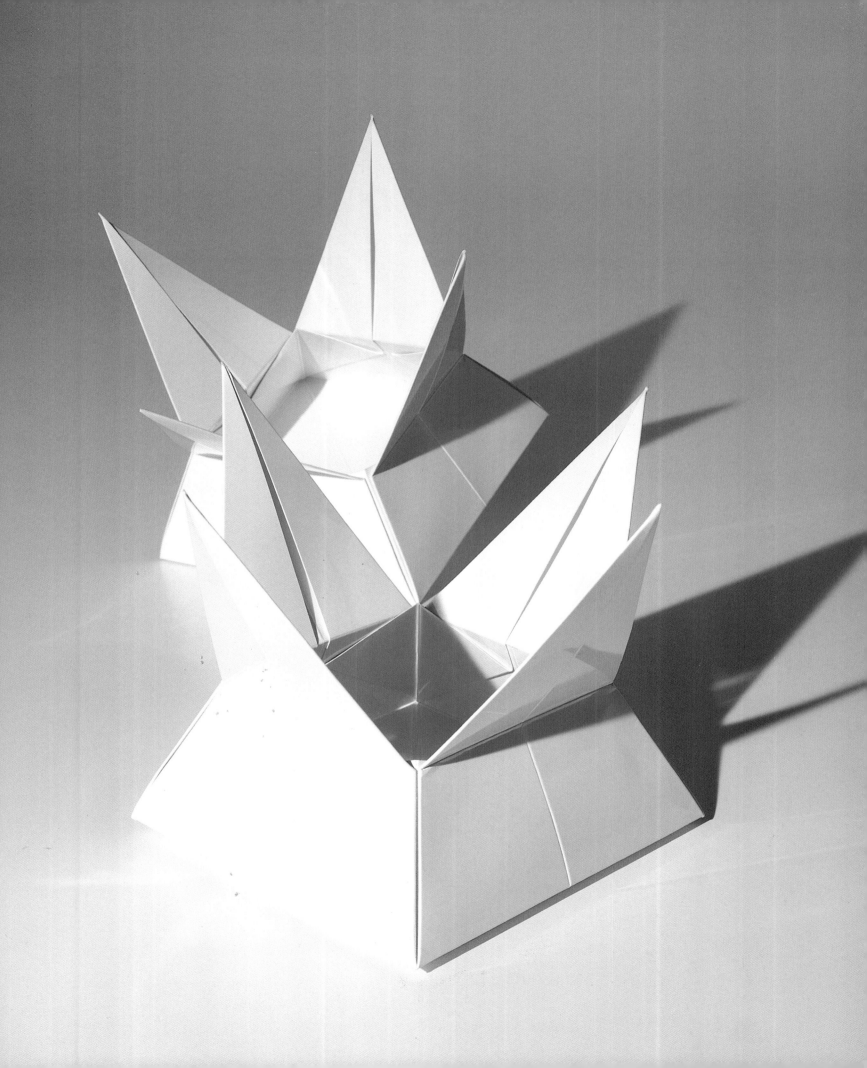

This carton features a hexagonal lid and base and erects by gluing each of the six tabs. The twelve sides of the carton fold in to form a crystal shape, whilst the hexagonal lid provides access to the contents. This is a good example of packaging for luxury items such as quality confectionery or other gifts.

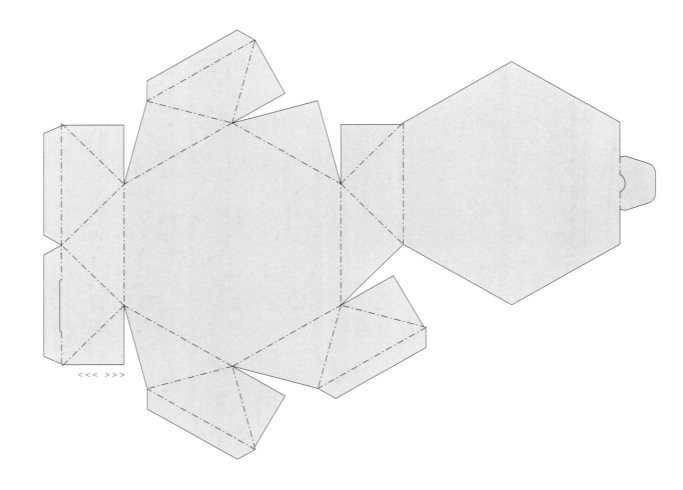

<<< >>>

DODECADON CARTON

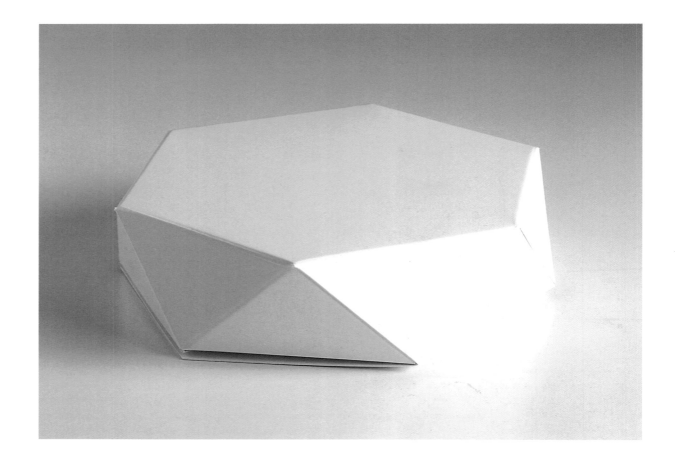

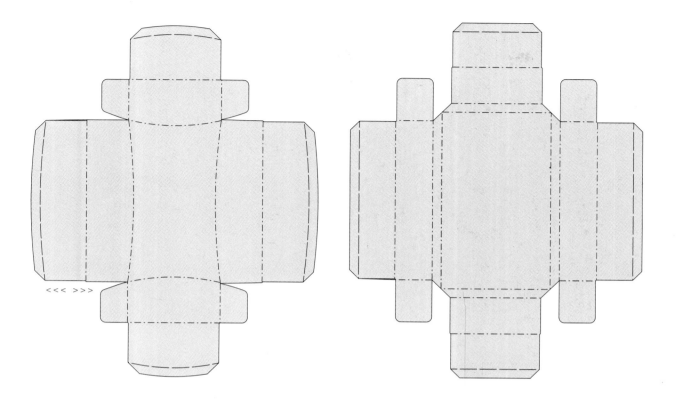

This two-piece carton has a curved, double-walled lid and a flanged base which creates a bevelled lip, giving a degree of luxury or speciality to the package. The flanged base sets the carton apart from others and creates its own space on the shelf. It also provides a platform on which to press down when removing the lid. This might be a particular consideration for the packaging of products for people with special needs.

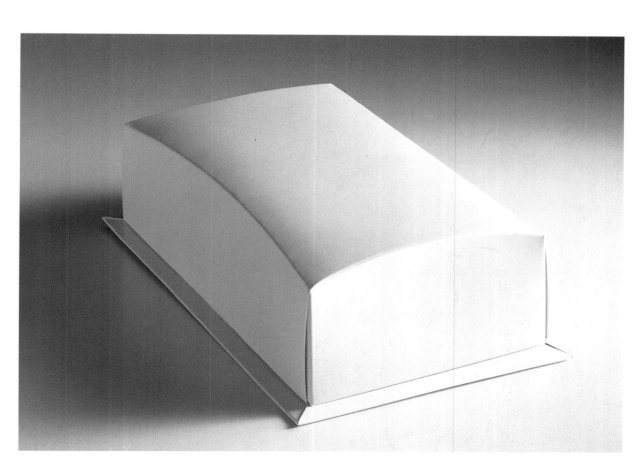

A scored carton with a crash-lock base which can provide three very different shapes. The first is a carton with folded-in sides and a pitched-top lid. The second has a flat top with 'ears' on either side which can be folded down, and the third option is the primary design which has a flat top and reversed tapered triangular sides.

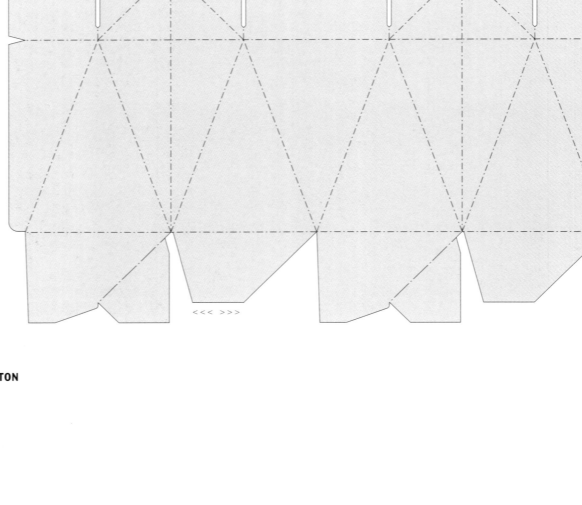

<<< >>>

CGM Ltd

48 **MULTI-SIDED TAPERED CARTON**

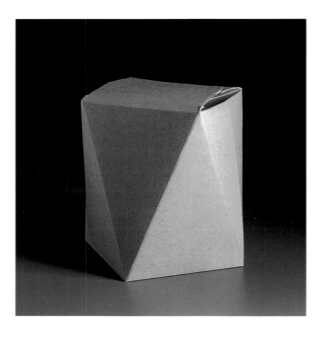

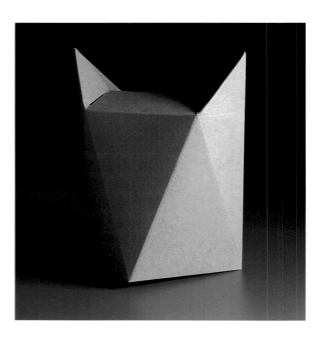

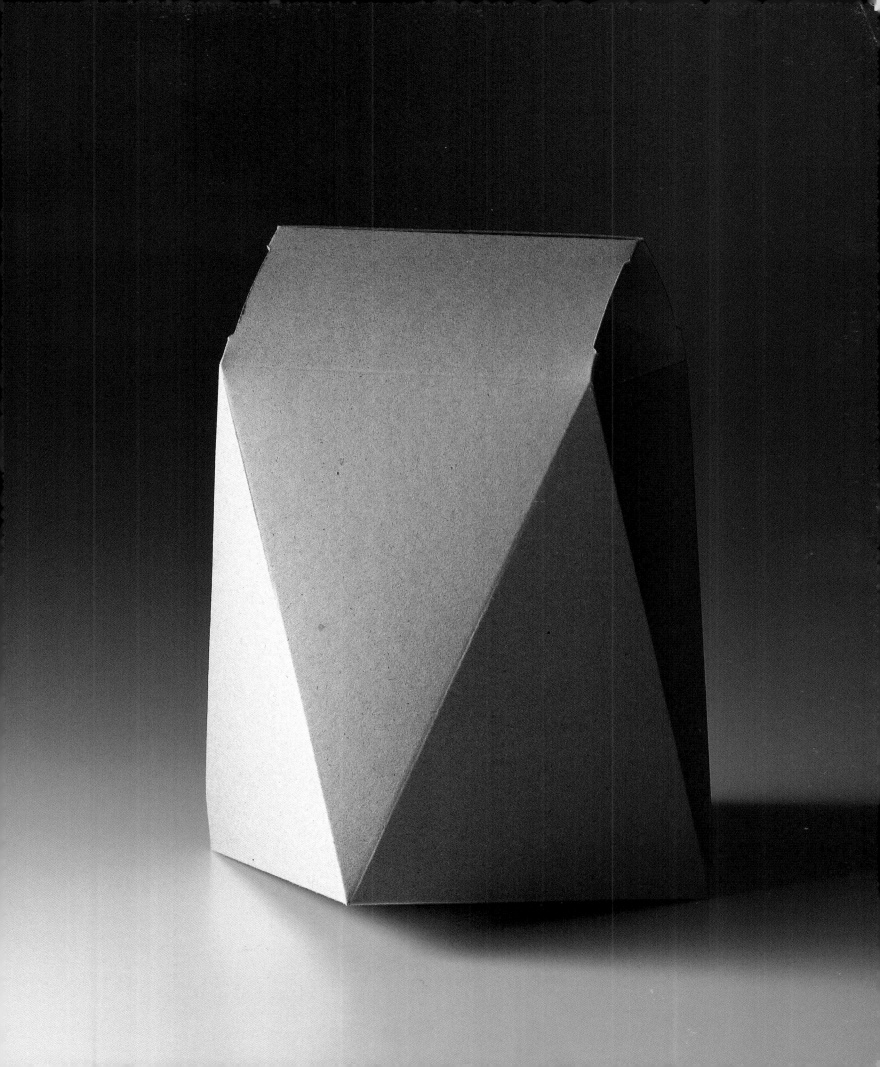

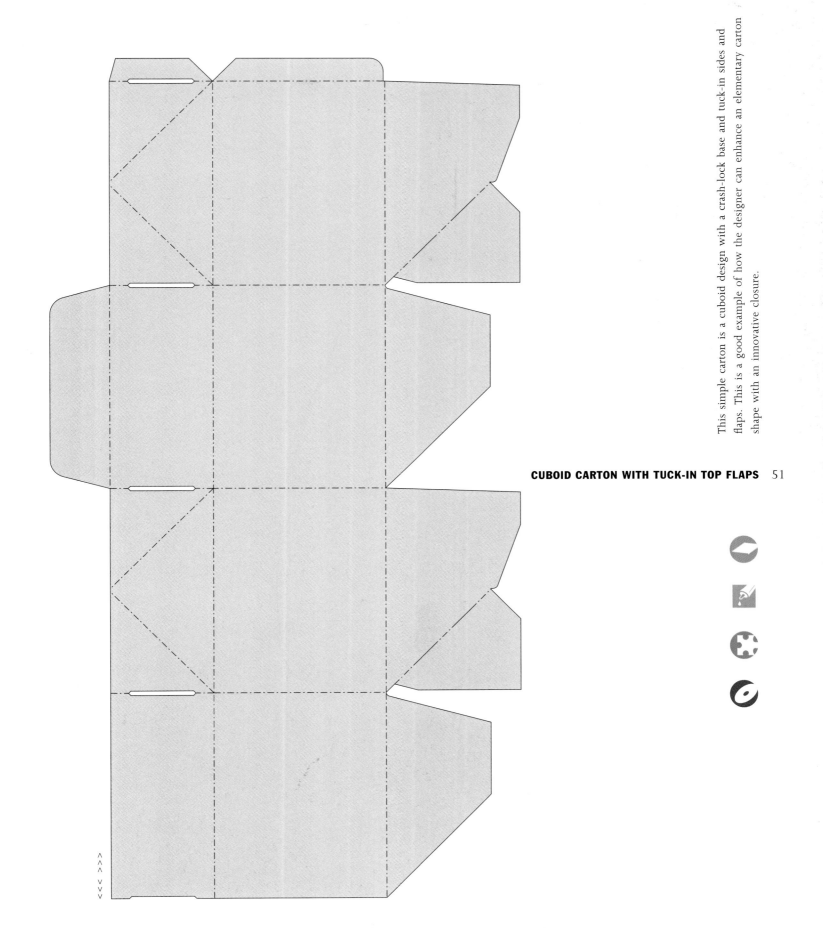

This simple carton is a cuboid design with a crash-lock base and tuck-in sides and flaps. This is a good example of how the designer can enhance an elementary carton shape with an innovative closure.

CGM Ltd

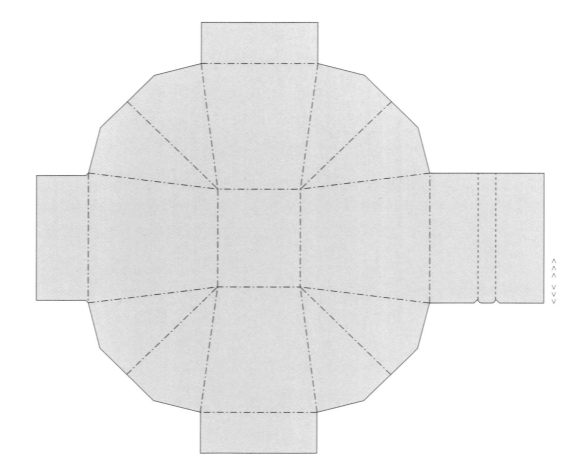

A cupped container with tapered sides and a larger surface for the top than the bottom, this is ideal as a dehydrated food container with a waterproof-lined inner layer. The design allows water to be added to the contents to provide an instant snack. The design of the folds prevents leakage and requires the use of a multi-layered material to obtain the waterproof properties necessary. In this instance solid bleached sulphate board with a polyethylene terathalate (P.E.T.) lining has been used.

52 **WATERTIGHT TAPERED CONTAINER**

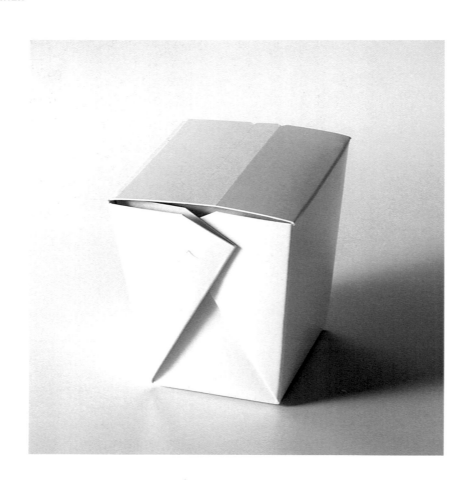

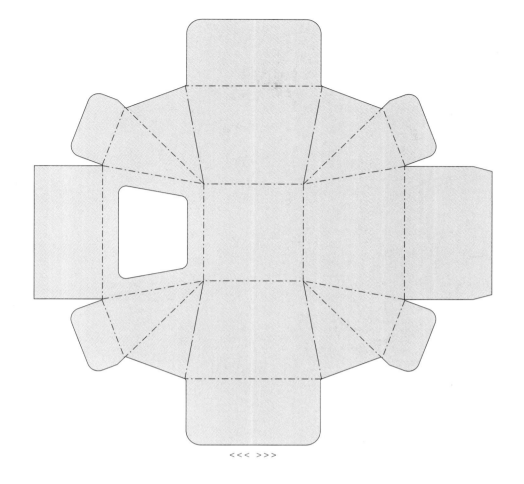

<<< >>>

This is base-glued with tuck-in flaps to form a tapered square carton. The acetate window glued onto the inside of the die-cut shape is an option, all the edges could provide a window to reveal the product within. The score lines can be decreased in number to produce curved sides and corners.

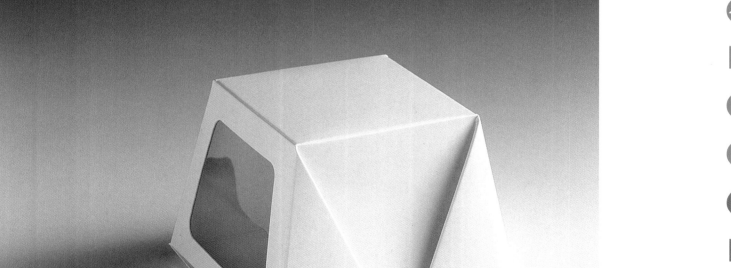

A tray that creates an image of thickness and rigidity by using tapered hollow sides, this tends to be used as a container for confectionery and gift items. Special locks clip together on the sides of the corners to support the structure. The lid with dust flaps is optional, but if removed this fourth side should be adapted to replicate the remaining sides.

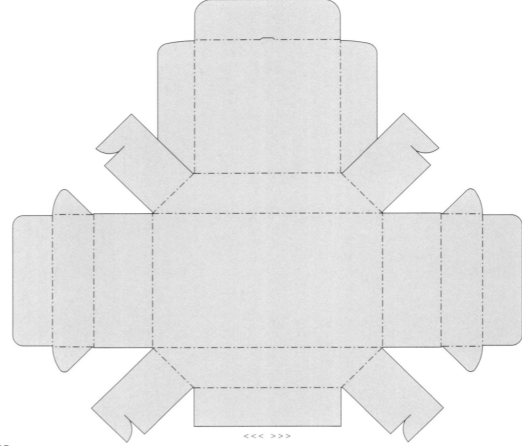

<<< >>>

54 **ANGLE-SIDED TRAY WITH TUCK TOP**

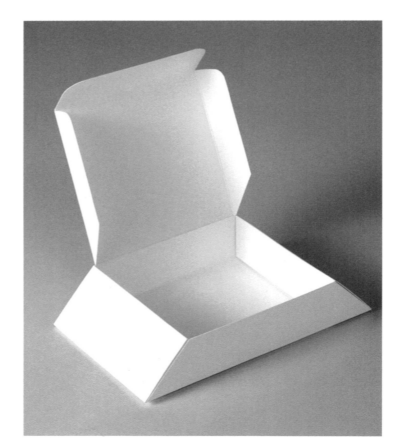

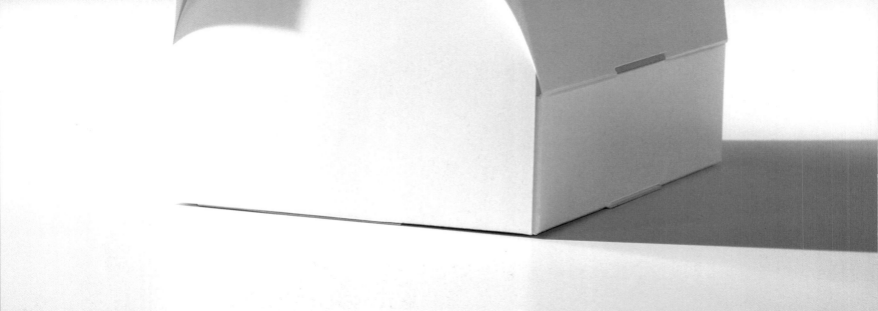

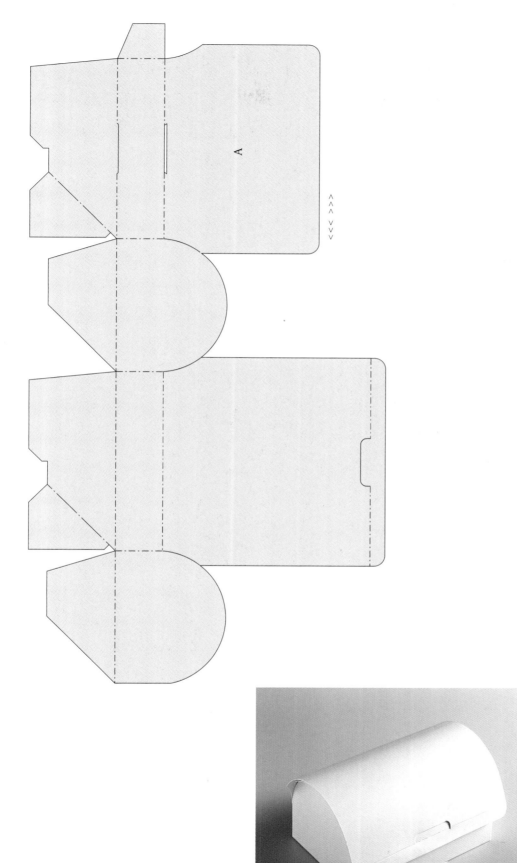

An example of how a standard four-sided carton can be given a more attractive appearance using a curved, semi-cylindrical lid. Flap 'A' provides greater strength for the lid and protection for the product contained. The closure between the sides and the lid is not very tight, therefore this carton would not be appropriate for products requiring high levels of protection. Possible uses include take-away cartons for decorative food products, in which the raised lid would provide additional space for the product inside.

ARC-TOP CARTON 57

This simple design is a basic container with tapered sides and a narrow base. Access to the product is through the pitched lid at the top of the carton, which in this case demonstrates how a handle can be incorporated into the design, as an option to enhance the performance of the package.

PITCHED LID AND TAPERED SIDES

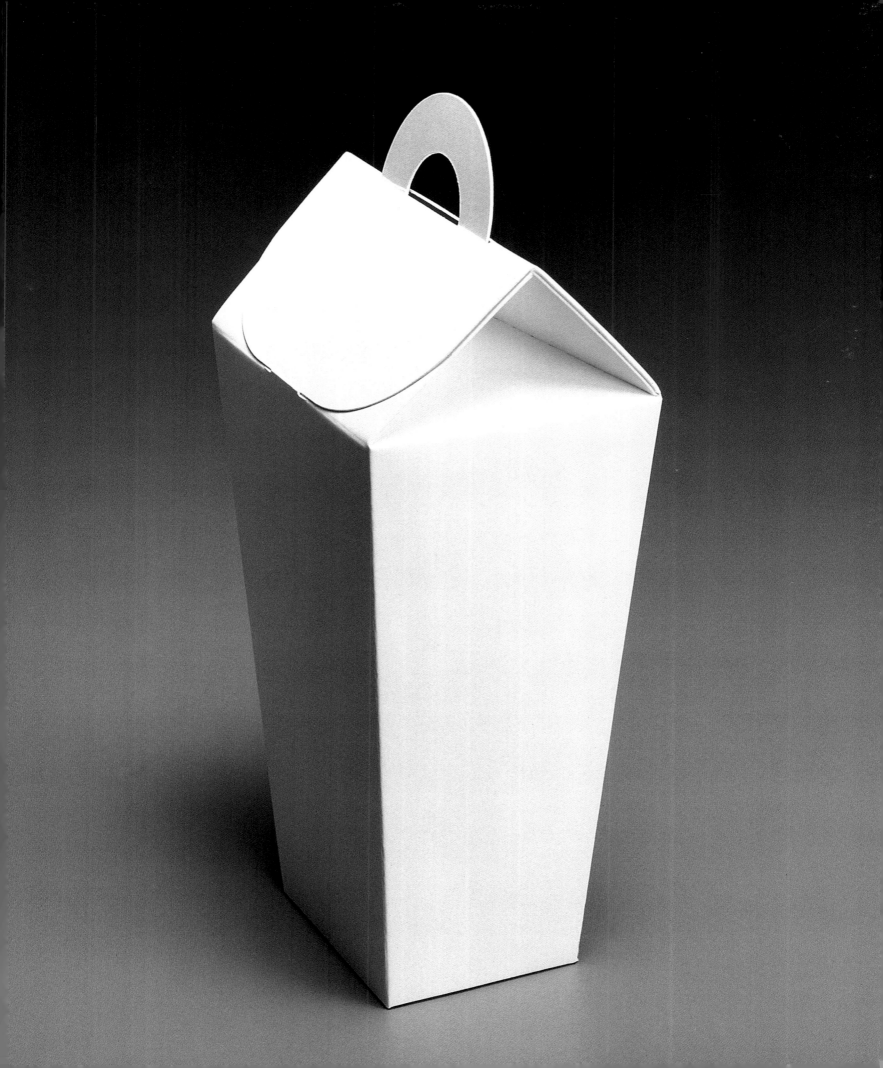

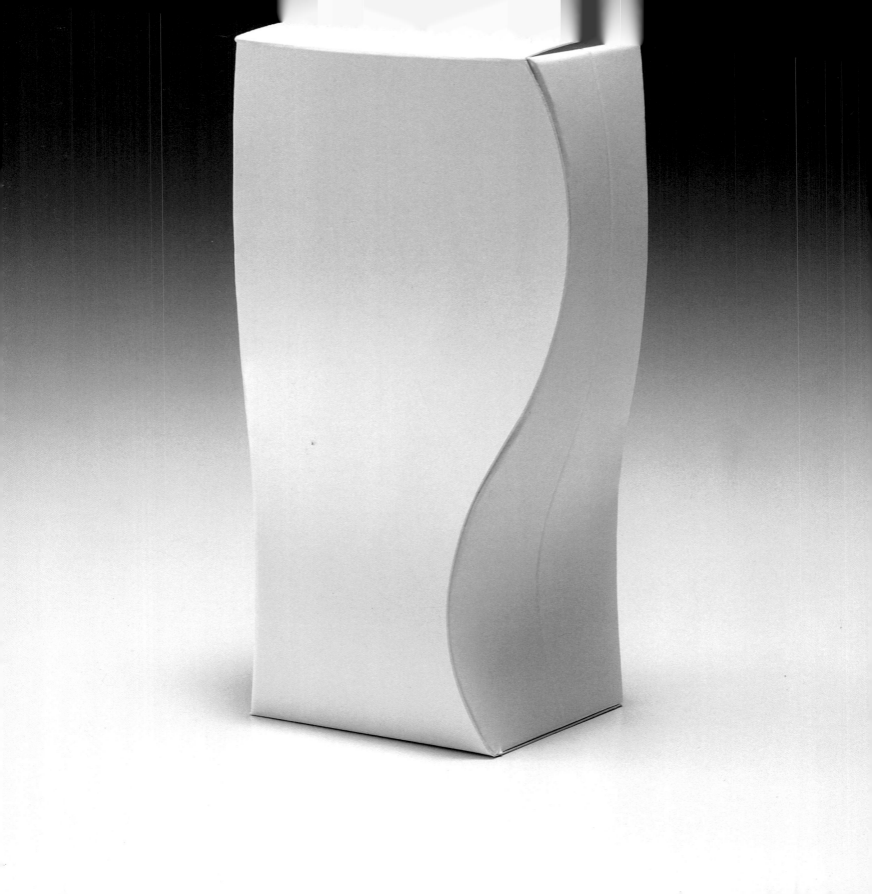

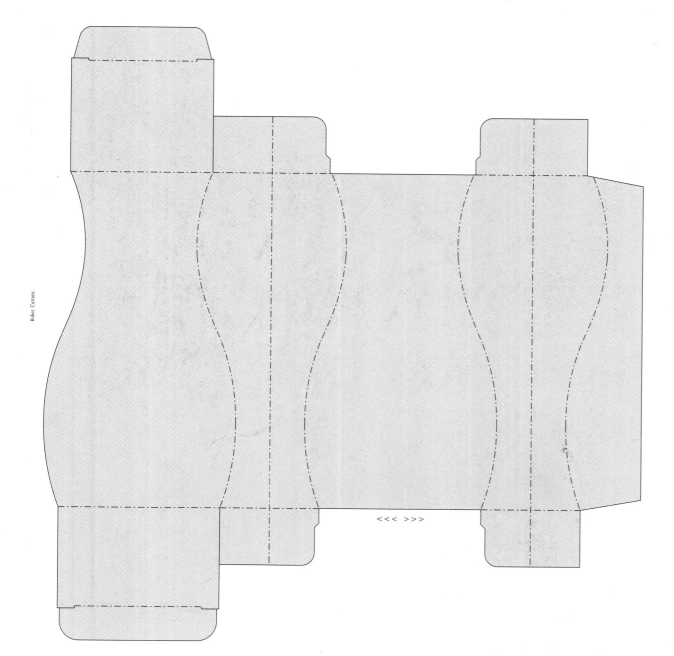

Robot Cartons

<<< >>>

This tuck-end carton makes good use of curved surfaces to create an attractive upright container. The curves and contours provide a visually appealing form that would be an ideal container for fabric, gift items or confectionery. Glue is required in the construction of this container but it does flat-pack, the container is erected by pressing the sides.

MULTI-CURVED CARTON 61

Introducing contours to cartons produces interesting shapes which are visually inspiring, they can also be adapted to accommodate a Euroslot or pull-strips. This carton is good for the storage of soft items such as clothing or a number of small pieces such as confectionery or a jigsaw; it is easily erectable and can be stored in a flat-packed state.

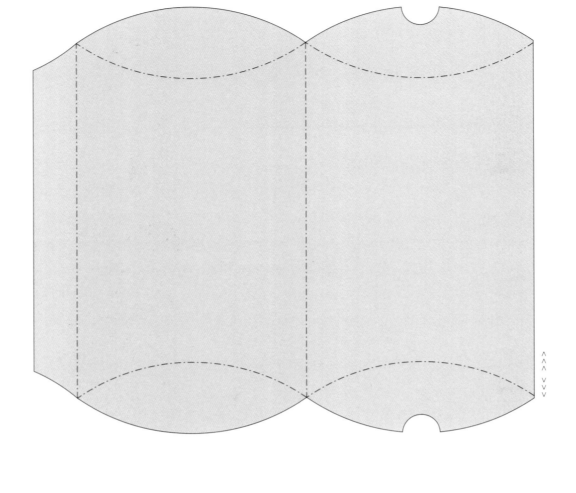

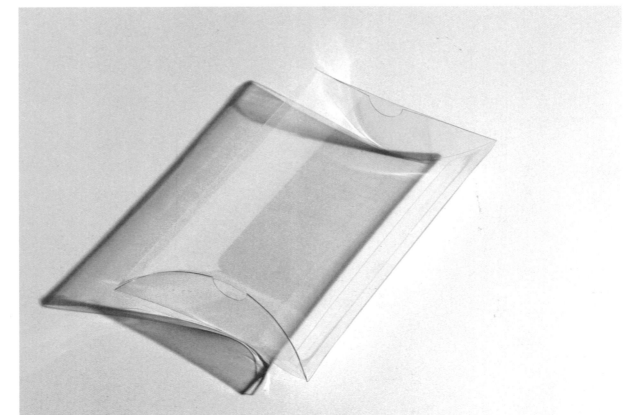

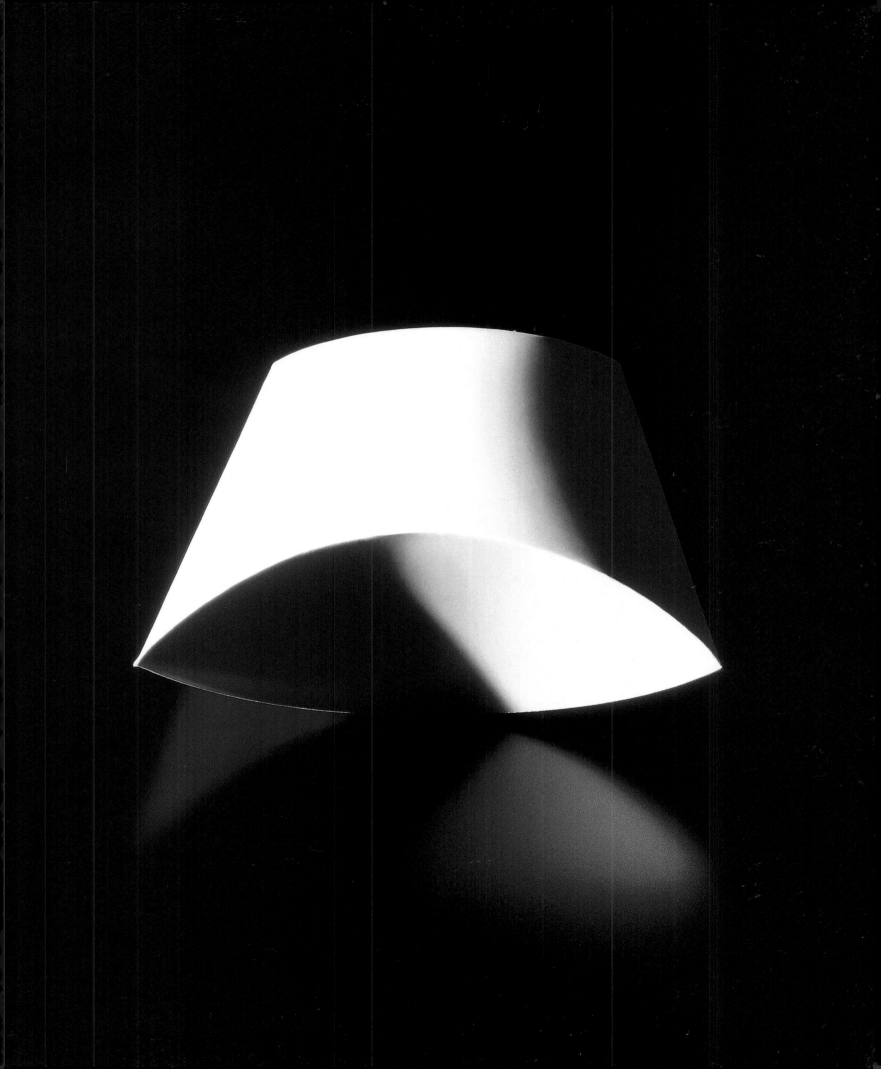

A novelty container for presenting and displaying products, this comes in two sections. The four-sided base container has tapered edges, pedestal feet and a clear acetate display lid, shaped in a pyramidal form for stylish presentation of the product contained within. The use of acetate in the lid provides a window, which hinges along one side of the base.

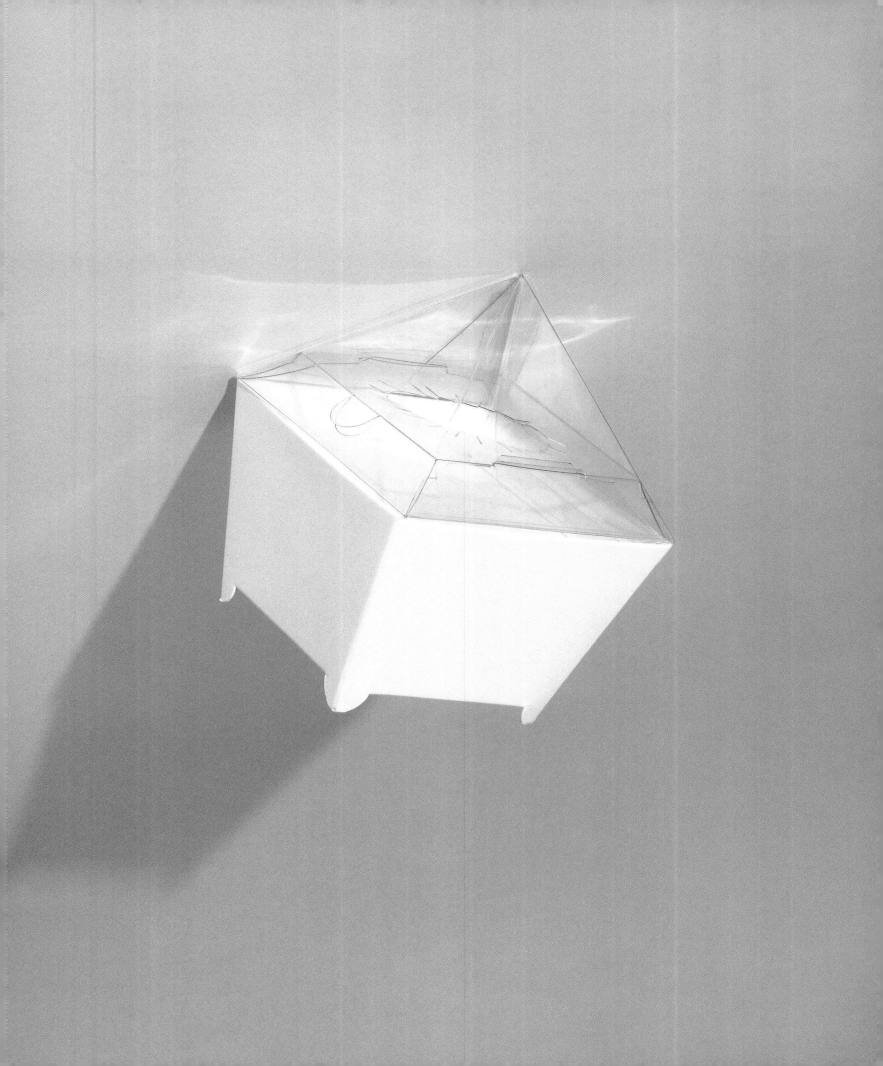

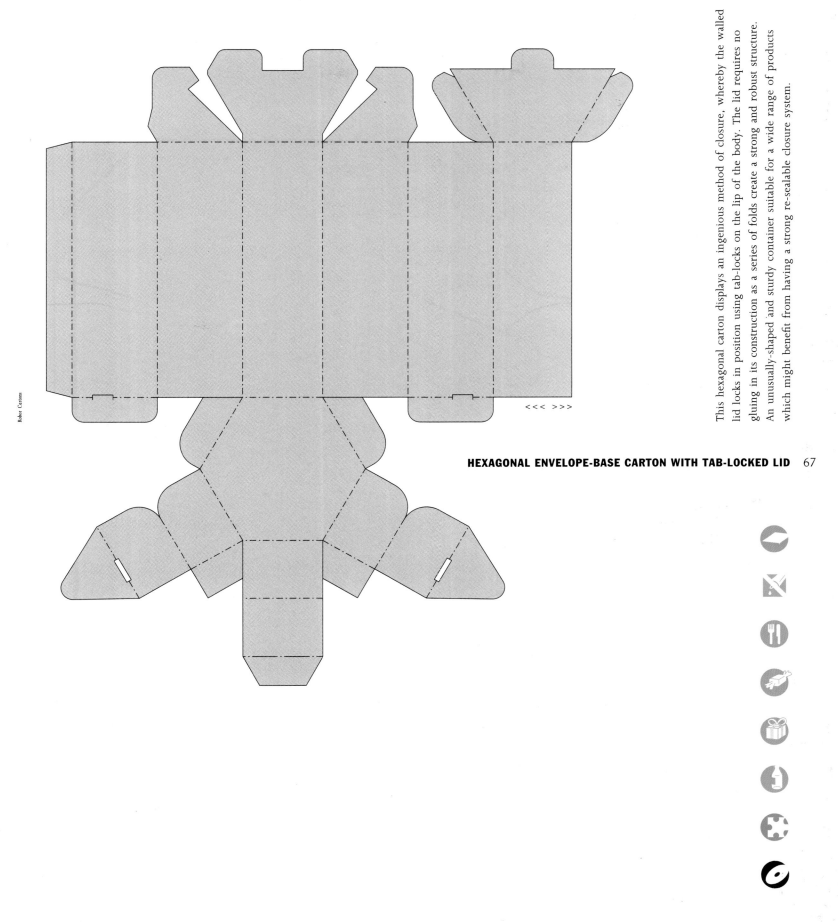

This hexagonal carton displays an ingenious method of closure, whereby the walled lid locks in position using tab-locks on the lip of the body. The lid requires no gluing in its construction as a series of folds create a strong and robust structure. An unusually-shaped and sturdy container suitable for a wide range of products which might benefit from having a strong re-sealable closure system.

HEXAGONAL ENVELOPE-BASE CARTON WITH TAB-LOCKED LID 67

A sloted disc-top closure carton with crash-lock base. The notched circle segments interlock with the slits to form a 'clover leaf' design. This design is suitable for gift products where the process of opening the package is interesting and revealing. The shapes of the interlocking segments could be varied to provide a number of different shapes when closed.

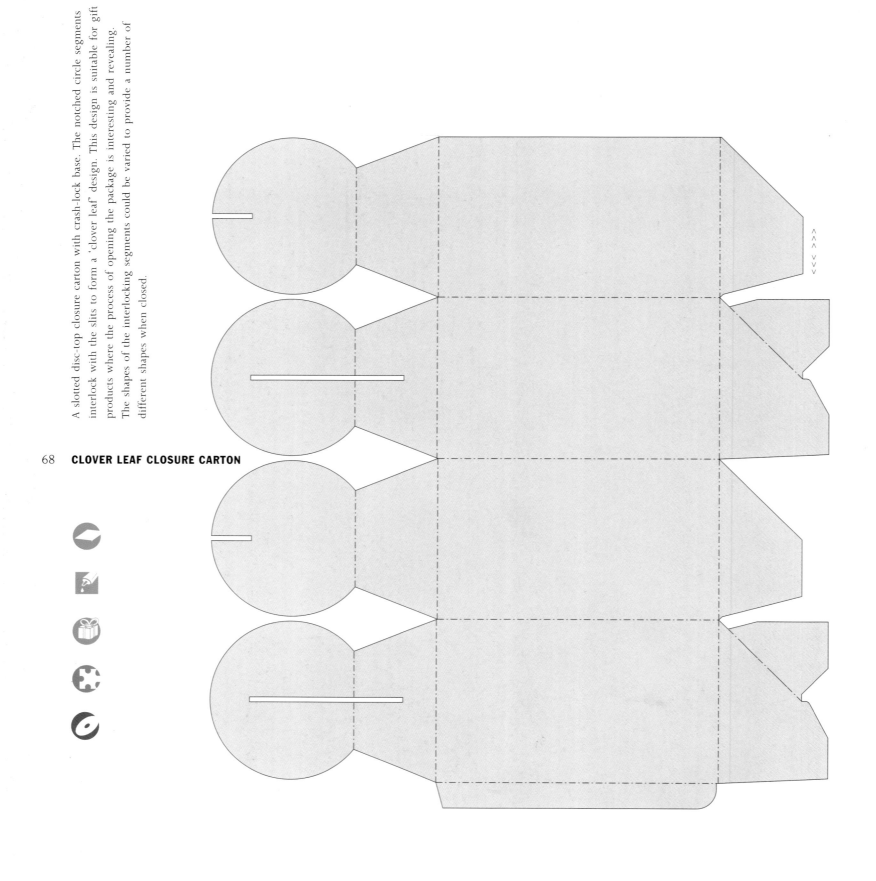

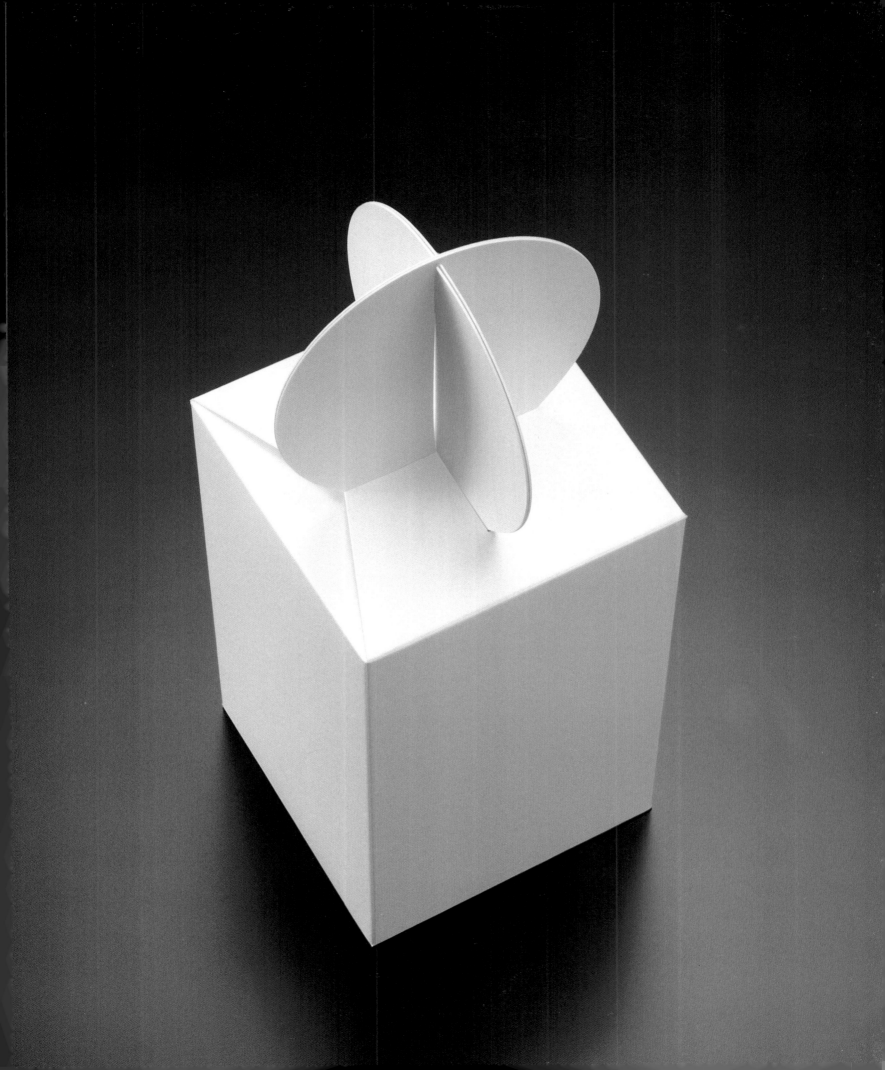

A six-sided carton with flaps which are reverse-tucked, this allows for a square aperture in a hexagonal shape. This might be used in instances where the product requires specific containment within the package, despite the lid being open. The score lines can be softer to reduce the angular appearance of the sides.

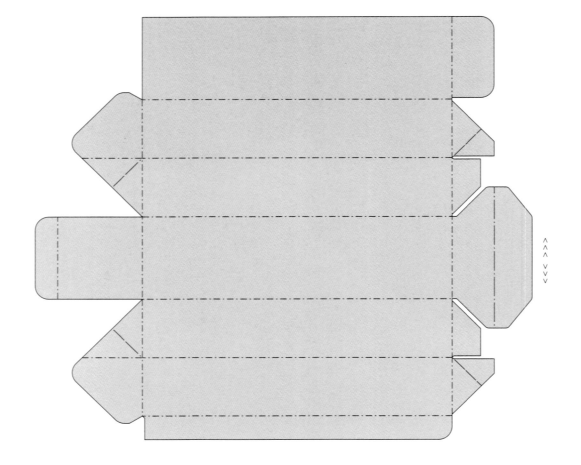

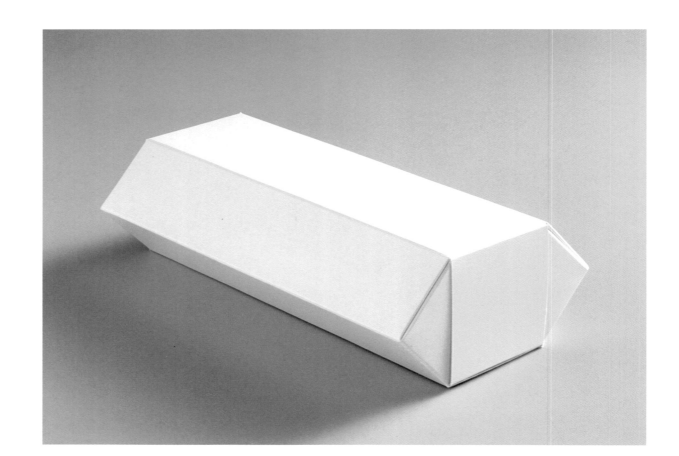

M.M. Packaging

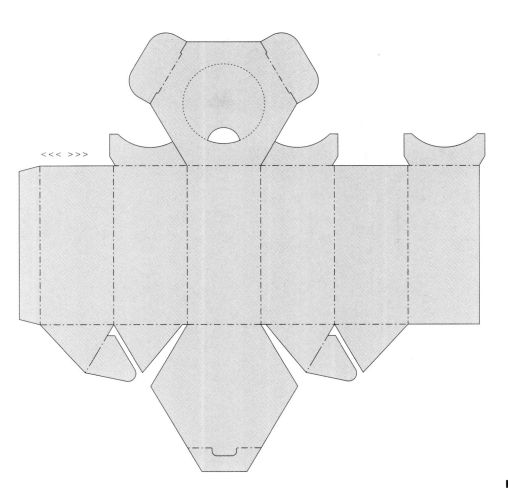

<<< >>>

A six-sided container with a glued crash-lock base and push-down bottom flap which is an adaptation of a bellows (gusset) tuck. The top flap straight tucks have slit-lock tucks and the shaped perforation on the top face allows the contents to be accessed. It can be used for bulk display of tall objects such as pens, pencils or even bottles. With six equal sides there is a good opportunity for the application of graphics.

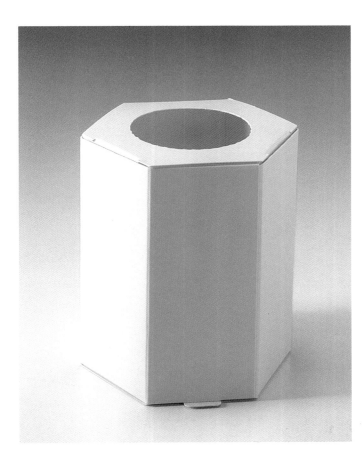

Designed to hold a fragile item, such as a glass bauble, this two-pack carton is constructed from a single piece of card using no adhesive. The complex folds and slots allow a second, identical, carton to interlock with the first in order to create a four-pack carton. This type of design reduces the costs of machining and cutting found in other designs of multi-packs. The adaptable profiles of the die-cut holes determine the shape that the product will fit into.

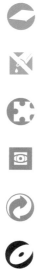

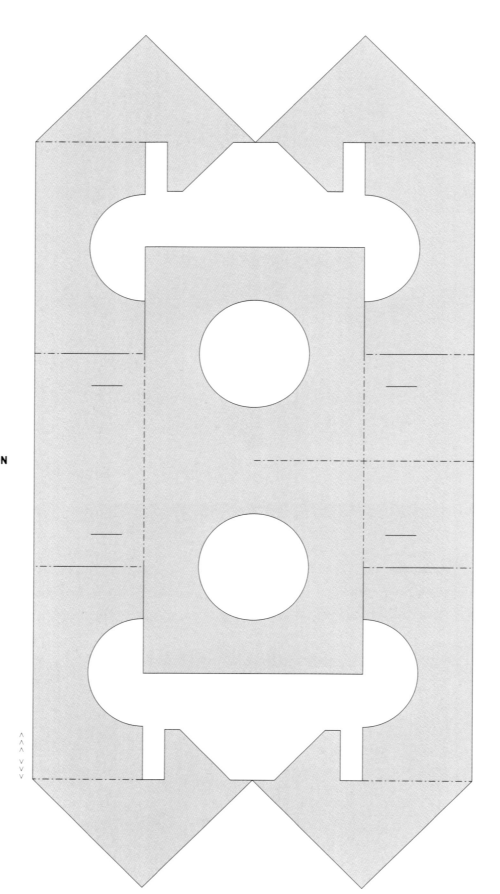

Andrew Robson – Surrey Institute of Art and Design

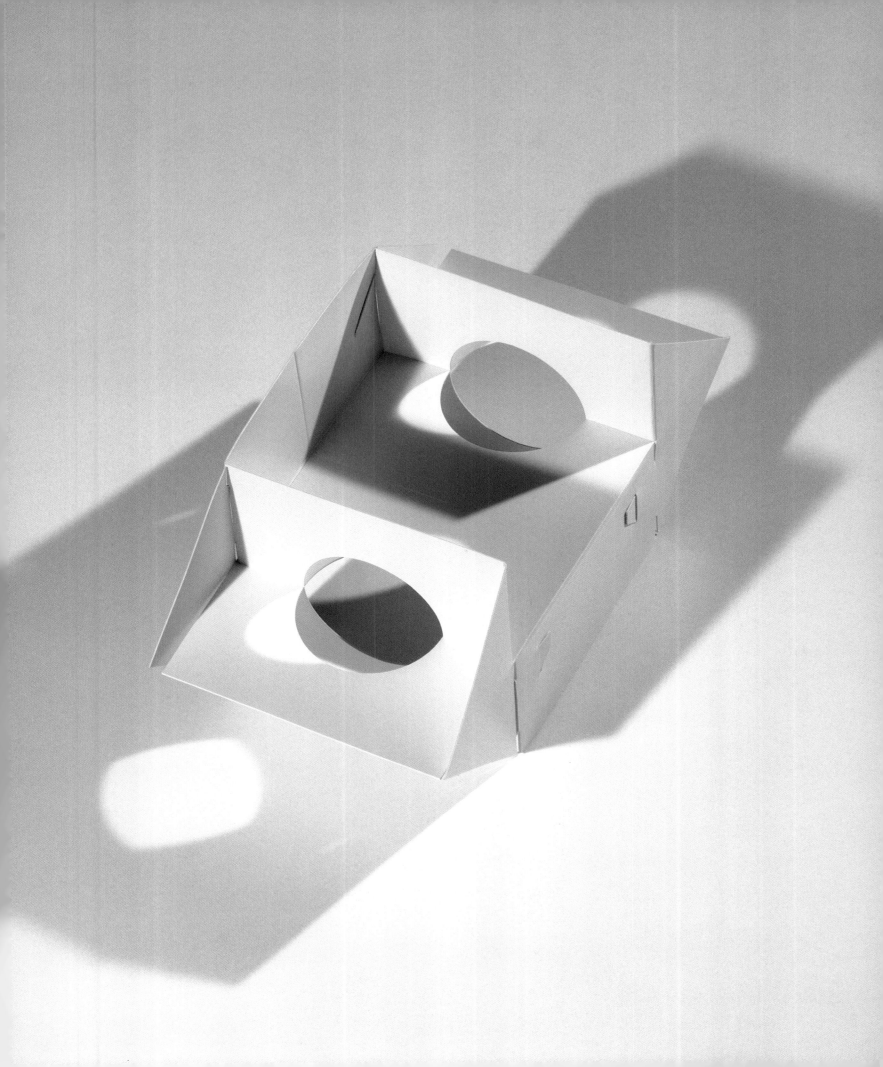

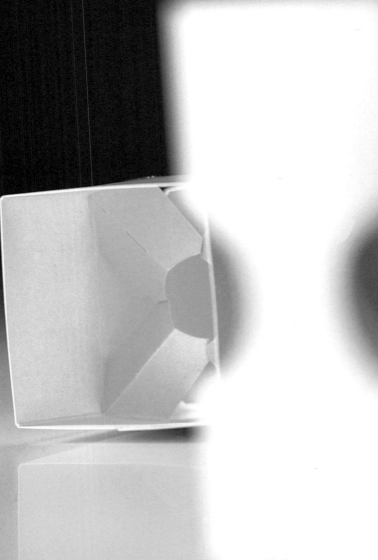

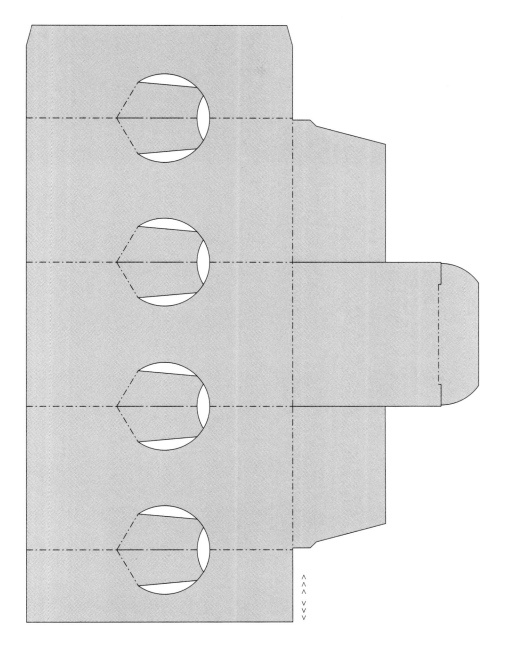

A one-piece carton which provides storage and safe handling of a fragile item. Cut-out sections within the part-cut circles are creased to fold inwards and provide support for the bulb inside. This is an example of a good design feature preventing the need for inserts or additional parts, this principle can be applied to fragile, round, pharmaceutical products. The carton can be manufactured from card, corrugated board or acetate, but is dependent on the weight of the product and its resistance to the exterior environment.

LIGHT BULB CARTON 75

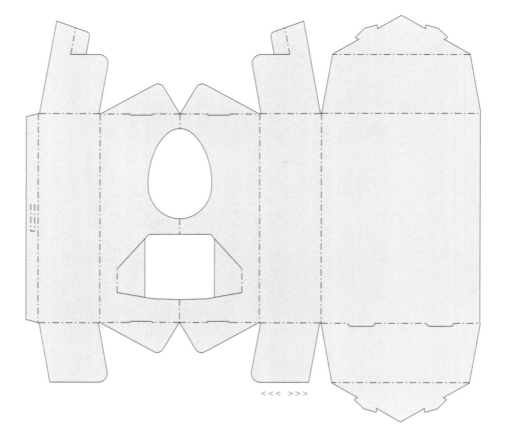

A popular carton for Easter eggs. Despite the huge variation of designs and sizes the fundamental design principles remain relatively constant. Constructed from a single sheet, the back of the carton is larger than the front. The front flaps fold inwards to be held securely in place by dagger locks; further stability is achieved by fold-in tabs on the side top flaps. The die-cut holes in the front hold the products securely against the back wall of the carton and the dagger locks provide security for the consumer when used in conjunction with a tamper seal that breaks when opened. Display windows can be any shape or size, but the designer must appreciate that the larger the window, the weaker the structure will become.

Berkshire Printing Co. Ltd

76 **CONFECTIONARY EGG CARTON**

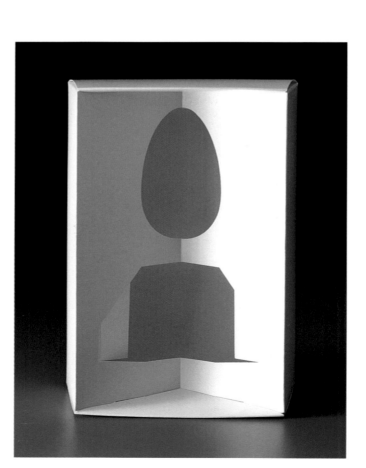

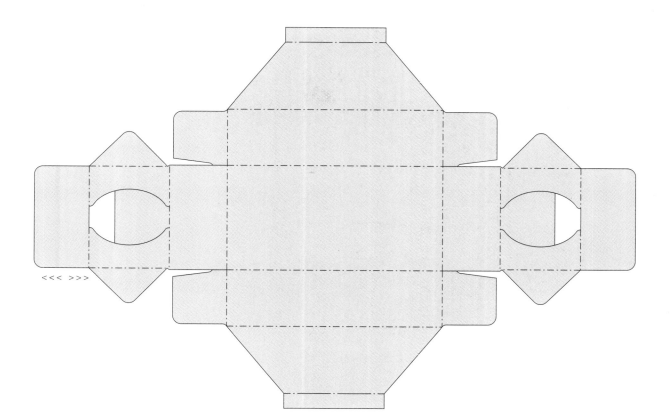

A rectangular carton with a cut-out frame, which enables consumers to see and touch the product contained in the package. Recent examples have encased cosmetics, bottles and sports equipment. The designer needs to consider the effect of exposure on the product. If, for example, it is sensitive to touch, pressure or direct light, this package might be unsuitable. An ideal package for focusing attention on the product itself.

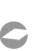

A single glued flap made from a single piece of card forms four-sided closure for a roll product. The cut-out flap on the central circular section is used to hold the roll in place simply by being pushed in which prevents the product from rolling out. An ideal point of sale unit for rolls where it is difficult to provide consumers with flat areas of graphics.

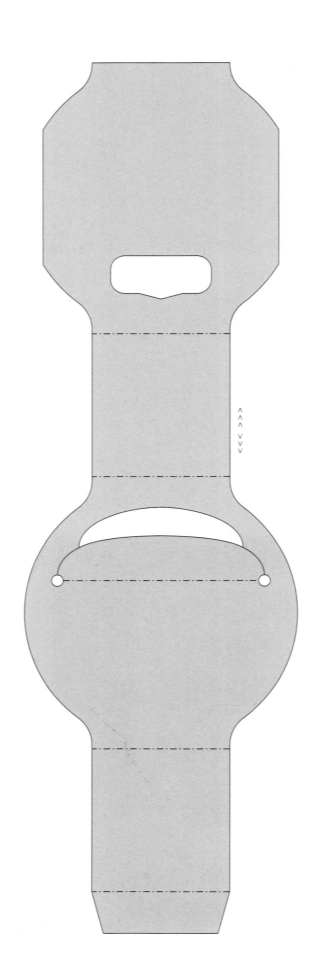

G.C.M. Boxmore

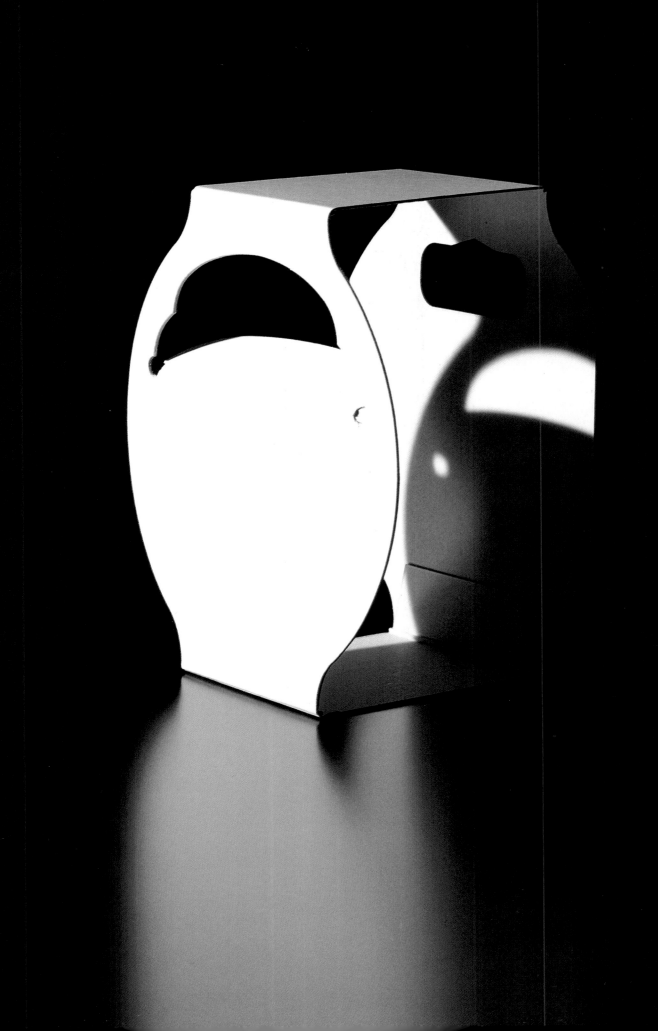

An ingenious storage sleeve for compact disks which, when opened, offers the disk to the user in a convenient and controlled movement. The folded segments along the score-line hold the compact disk in place as the hinge of the case forces the compact disk out of the package. Other possible uses would be for other flat products needing a pop-up format.

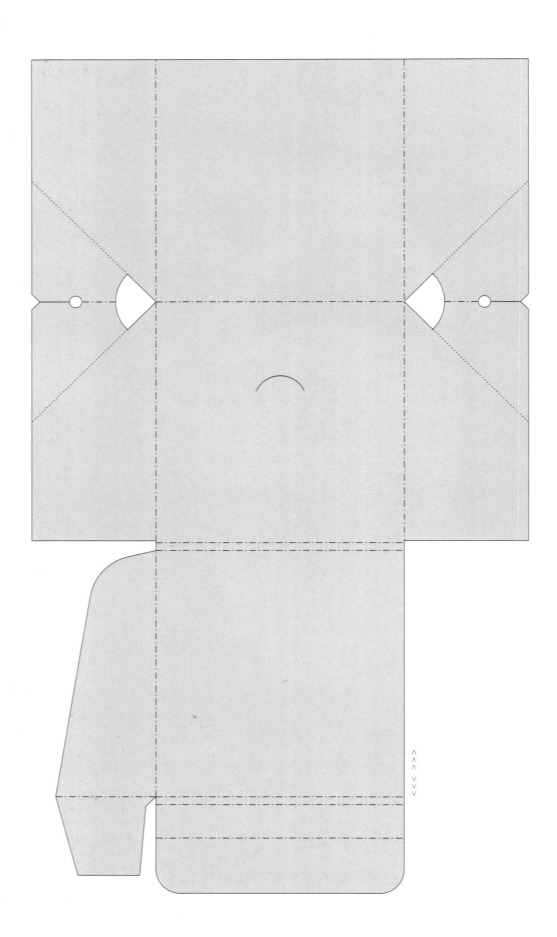

Patent Pending, Danapak

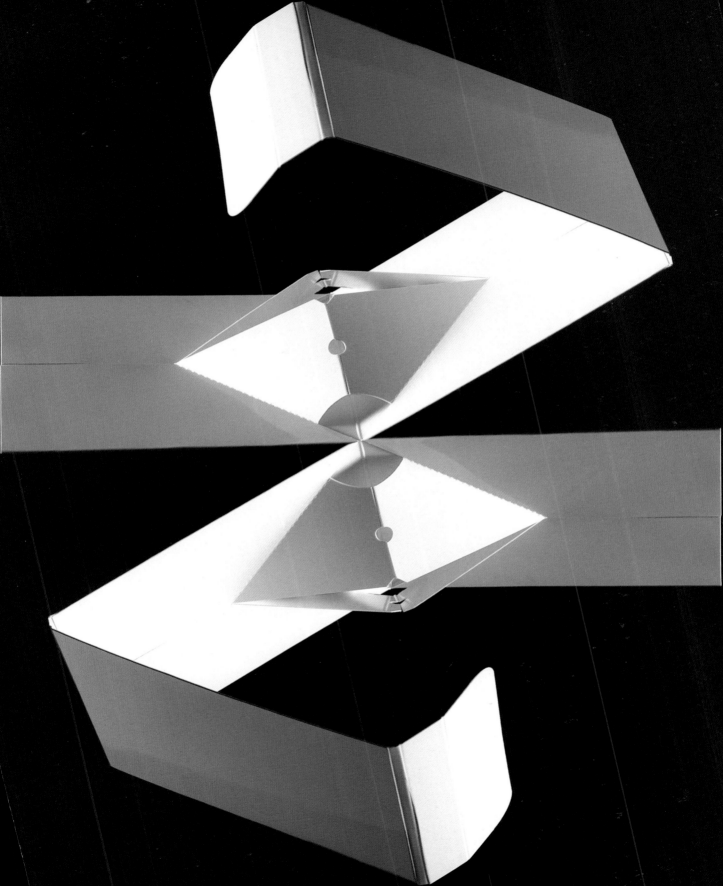

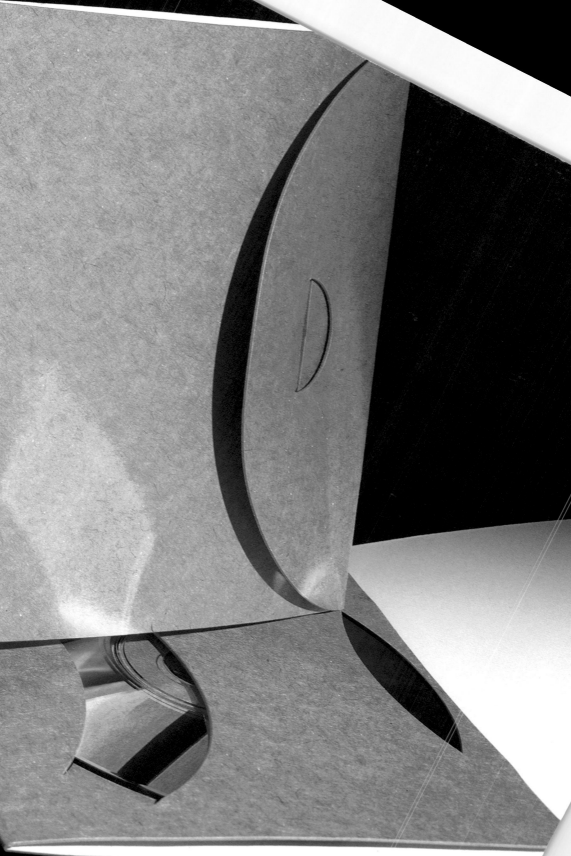

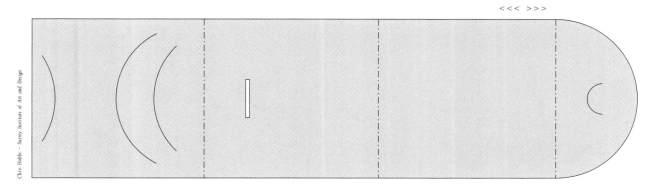

Chris Hobbs – Surrey Institute of Art and Design

This simple carton for the storage of flat, fragile objects was originally intended to hold a Compact Disc, but the principle of the design could be used for a range of different products. The product is contained in a die-cut strap and slot, and is then protected by the rest of the folded package. This provides an attractive sleeve that mounts the product whilst providing ample space for graphics if required.

The type of material used determines the level of protection given, for example corrugated card would provide exceptional protection for a fragile glass item.

WALLET SLEEVE 83

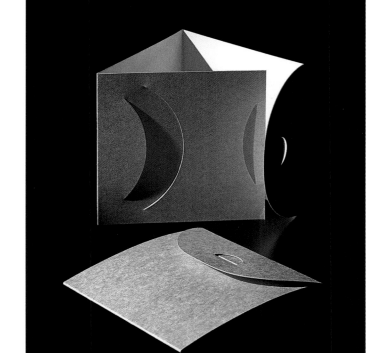

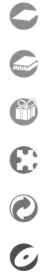

This skillet carton has an extended lid-flap which opens to reveal a display recess. Die-cut from a single sheet, this tray provides a specific compartment for the product inside. The internal flaps that form the frame also add to the rigidity of the structure as well as helping to protect the product. This design only requires one side of the board to be printed.

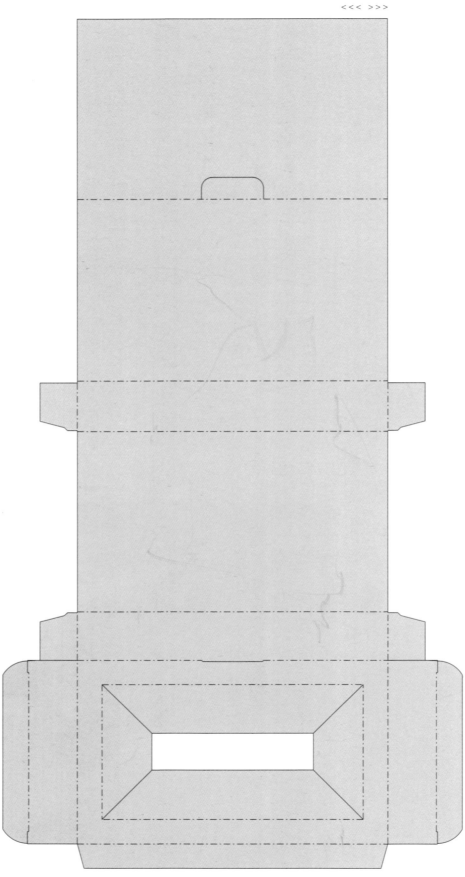

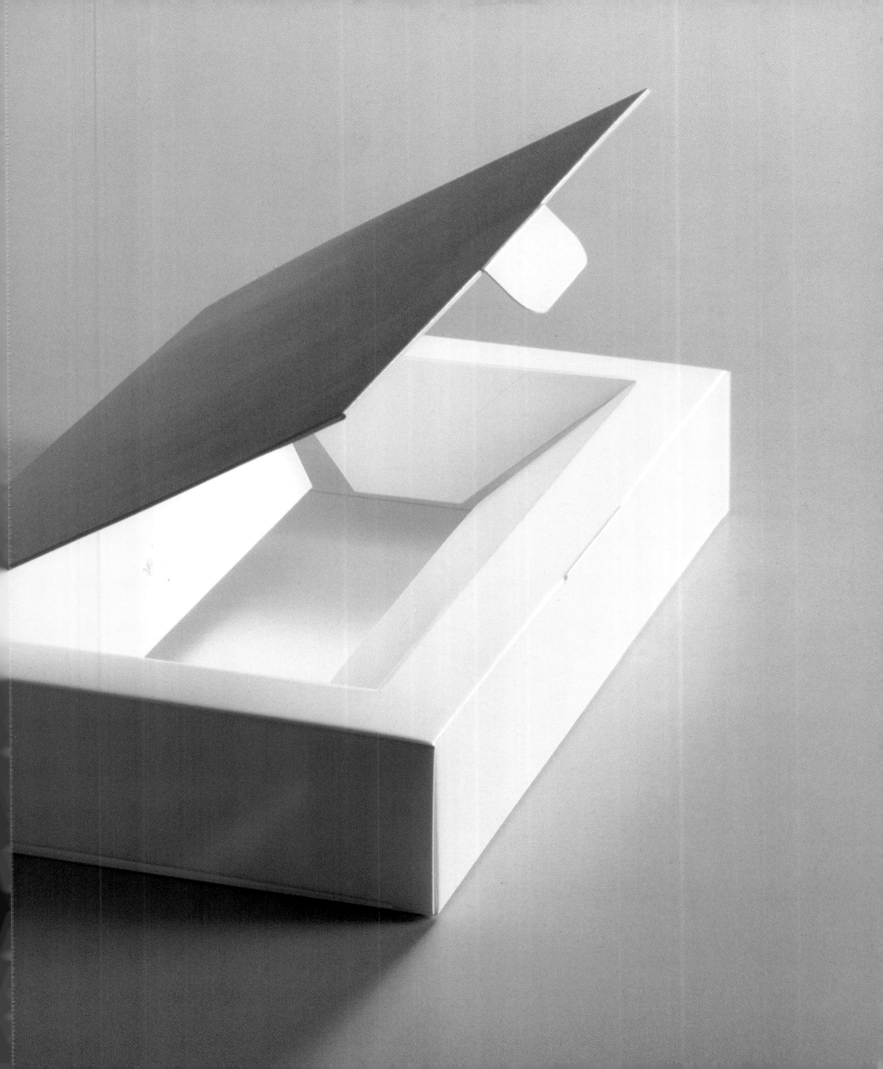

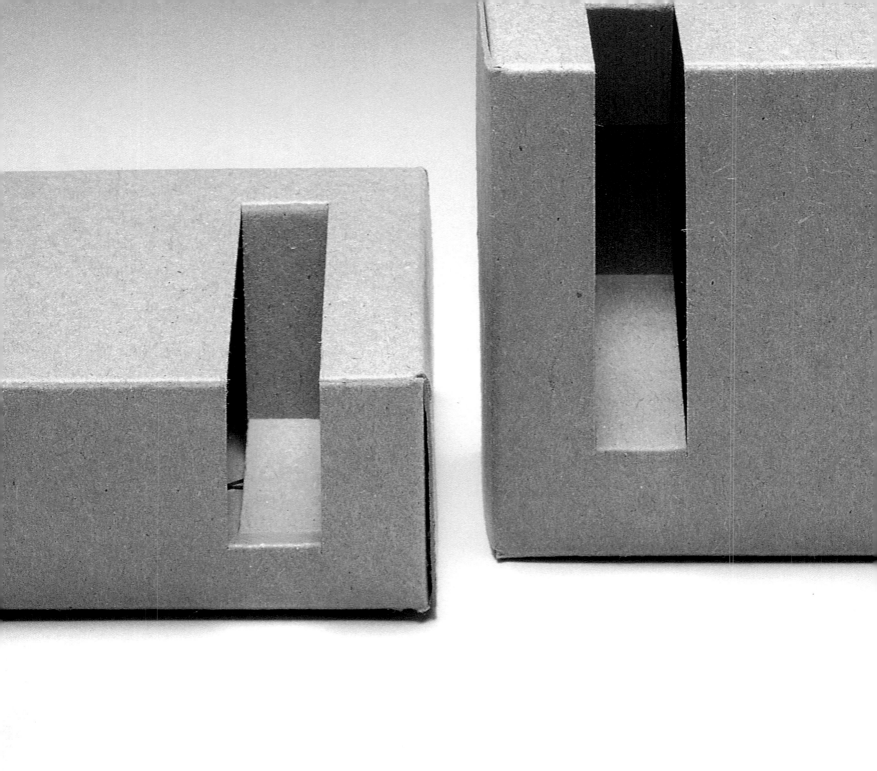

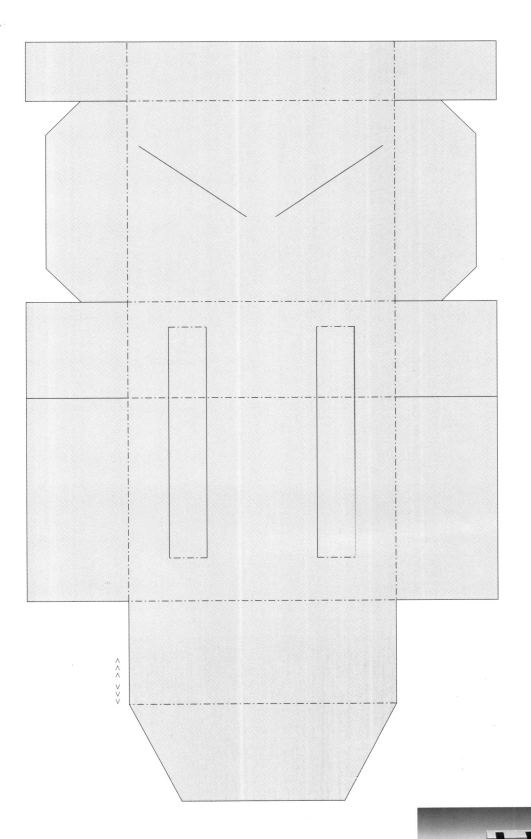

The design of this carton uses the weight of the product to hold the structure together without needing any form of adhesive. The straps are cut from the same piece of card and used to contain the product whilst allowing the consumer to touch and feel it. Originally designed for containing soap, this package also allows the customer to smell the product – considerations such as these must be taken into account when designing for a specific product.

SELF-SUPPORTING CARTON 87

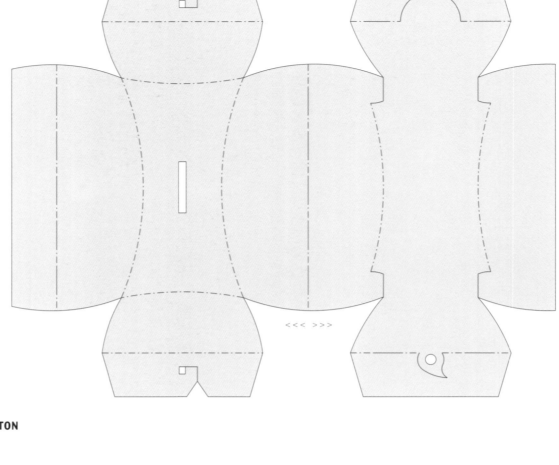

A promotional display carton with novelty appeal. Internally connected with a rubber band, it requires no assembly and erects through squeezing the sides. The elasticity of the rubber band pulls the ends to erect the carton. With use of graphics and minor additional design features this carton could be made to look like an animal or car, for example.

<<< >>>

ONE-SQUEEZE NOVELTY CARTON

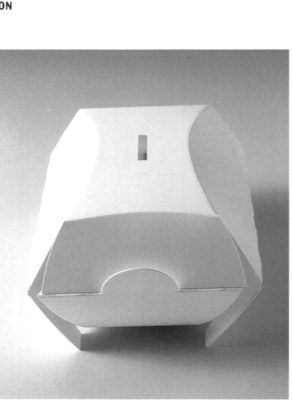

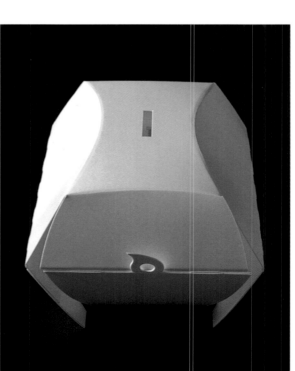

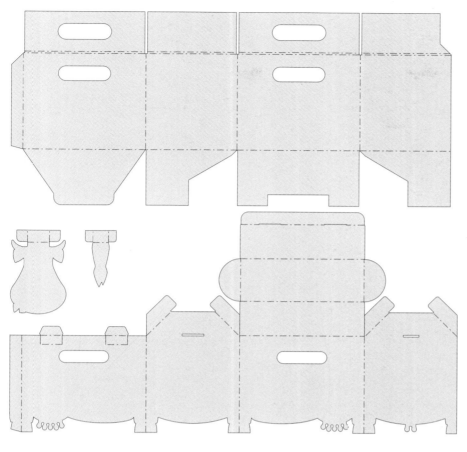

A corrugated cardboard storage container for children. This is a good example of how the use of printed graphics and minor additional card pieces can enhance a simple design. The storage box comes in two parts and could vary in size and dimension depending on requirements.

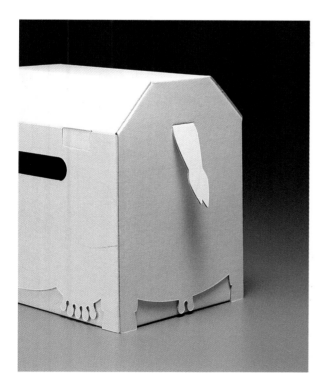

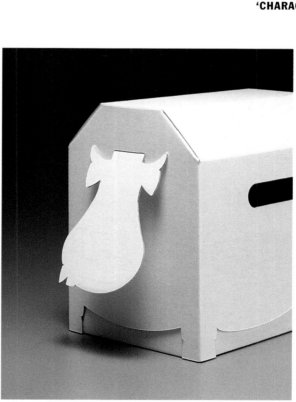

90 **FOUR CORNER GLUED SKILLET-ENDED CARTON**

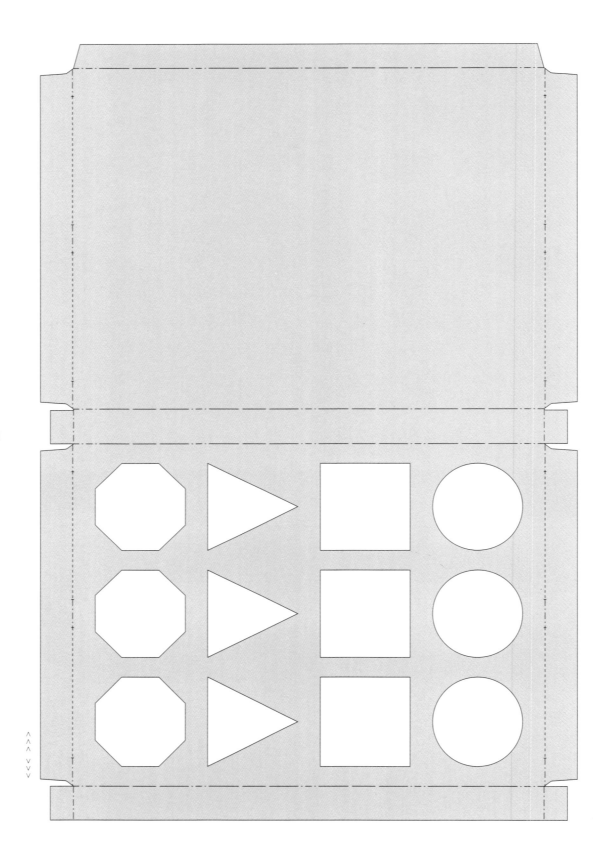

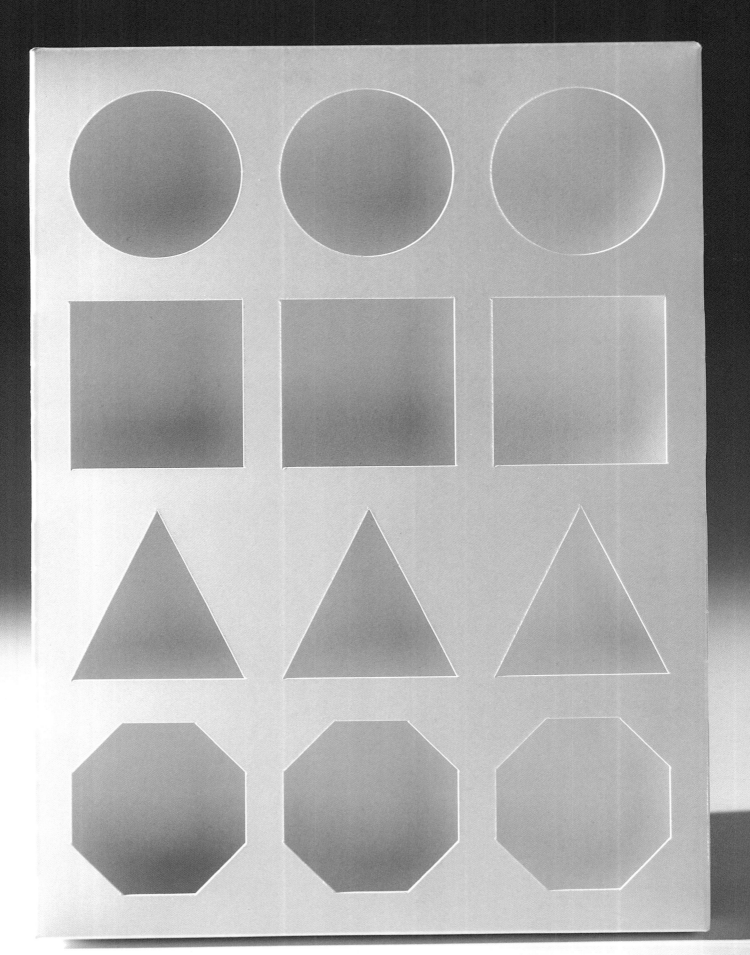

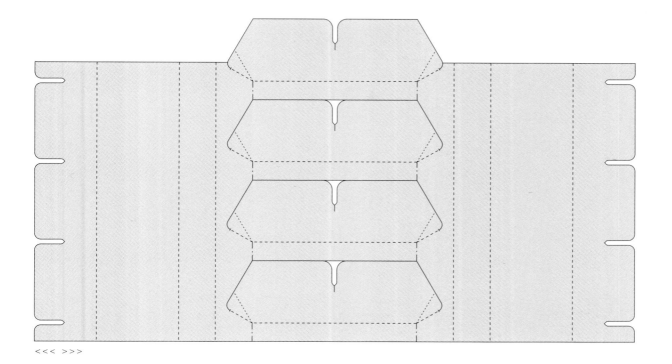

A tray carton for the display of groups or ranges of products. The shape of the die-cut spaces may be altered depending on the fit of the product to be displayed. This is an effective way of presenting a whole range of products whilst also providing point of sale information applicable to the whole group. No glue is required in the construction of this multi-unit carton.

MULTI-COMPARTMENT TRAY 93

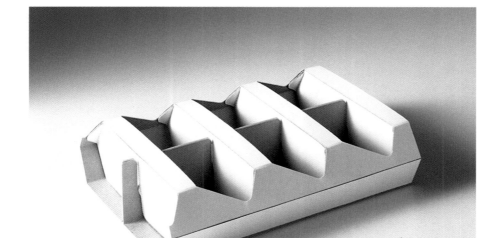

A two-piece segment-shaped carton with one curved and tapered side and two vertical flat sides. The simple lid-closure fits in place by sloting through a slit on the container and wedging itself in the taper of the rounded side. An appropriate shape for consumable products sold in segments, such as cakes or cheese.

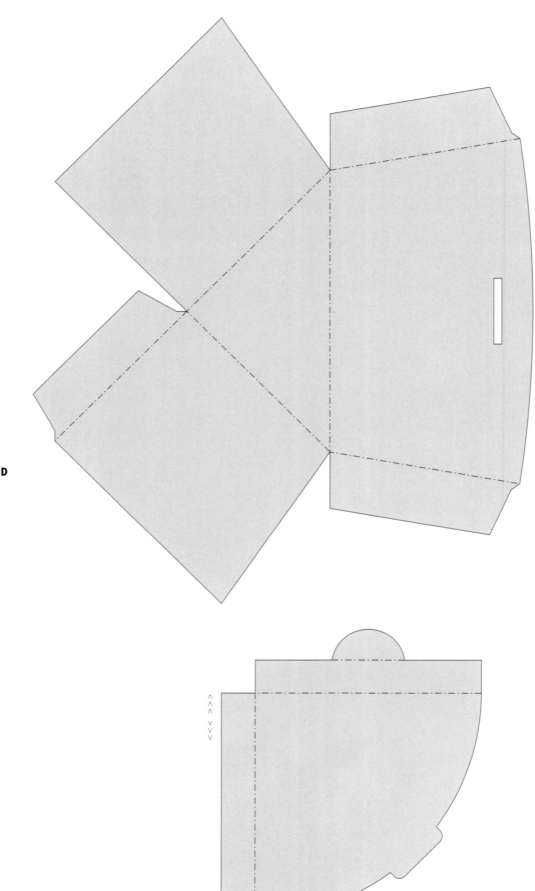

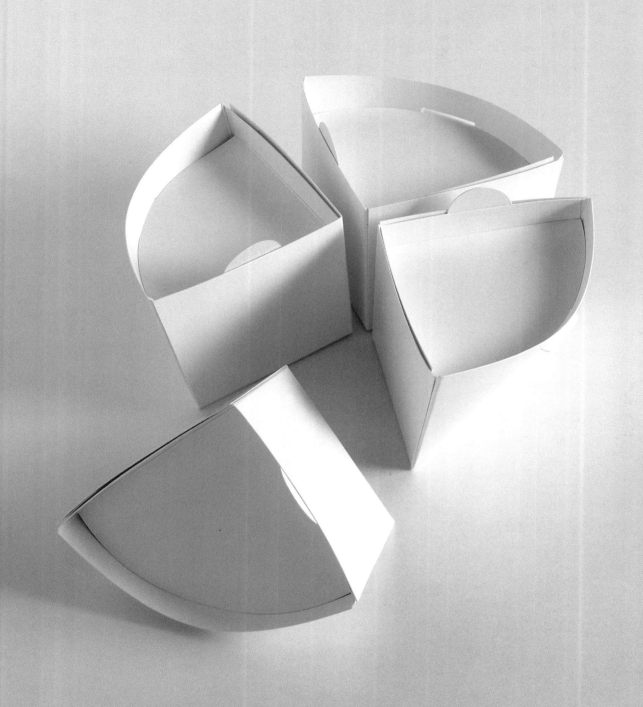

A multi-glued container for hygienic storage of food products. The octagonal shape makes this an efficient carton for circular goods. One application of this carton uses a specially designed heat-distribution pad inside the container to distribute the heat equally to the product in a microwave oven. The product is removed from the container and is placed on top of it. When cooked in this way, the action of the distribution pad coupled with the height mean the product is heated efficiently. This is a good example of design aiding the use or preparation of the product.

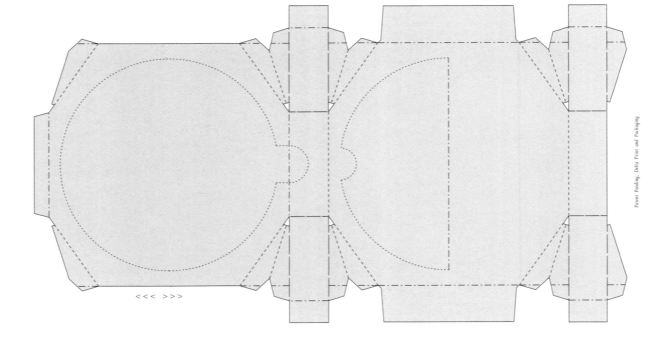

Patent Pending, Delta Print and Packaging

<<< >>>

96 **OCTAGONAL CARTON**

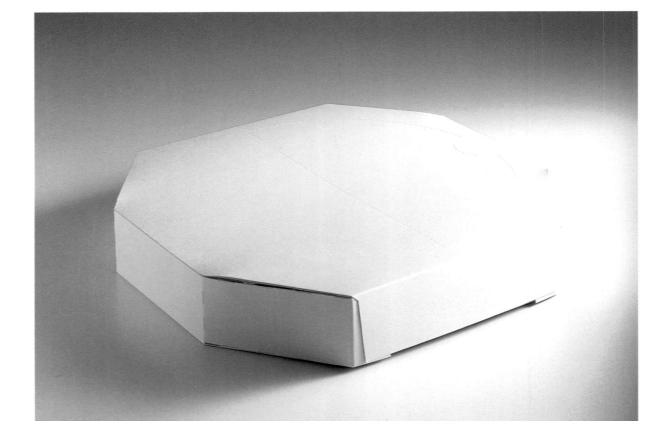

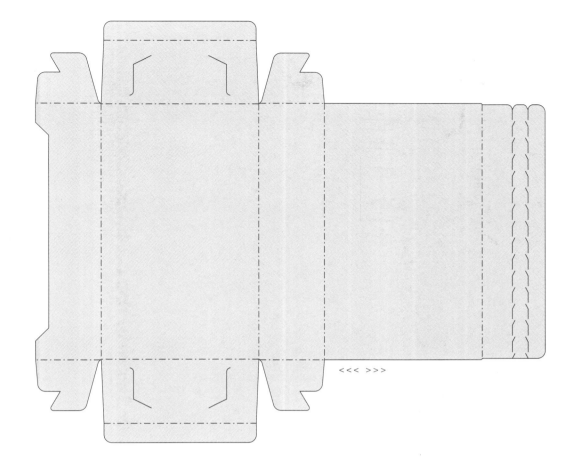

<<< >>>

The pull-strip is commonly used in cartons to prevent tampering as the strip provides an irreversible method of opening. To ensure the pull-strip's accuracy, all the flaps must be glued, or have locking closures, to prevent access to the product via another entrance. Pull-strips can be applied to many different types of carton.

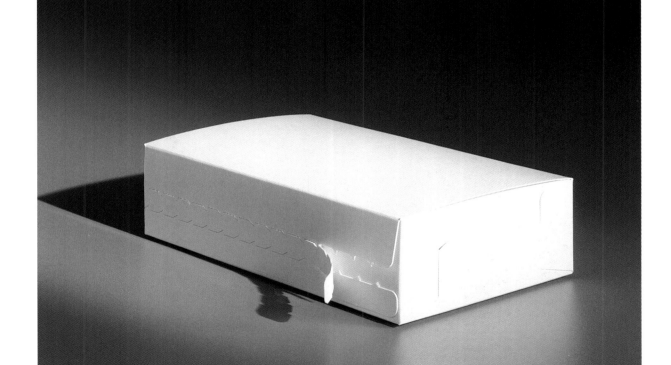

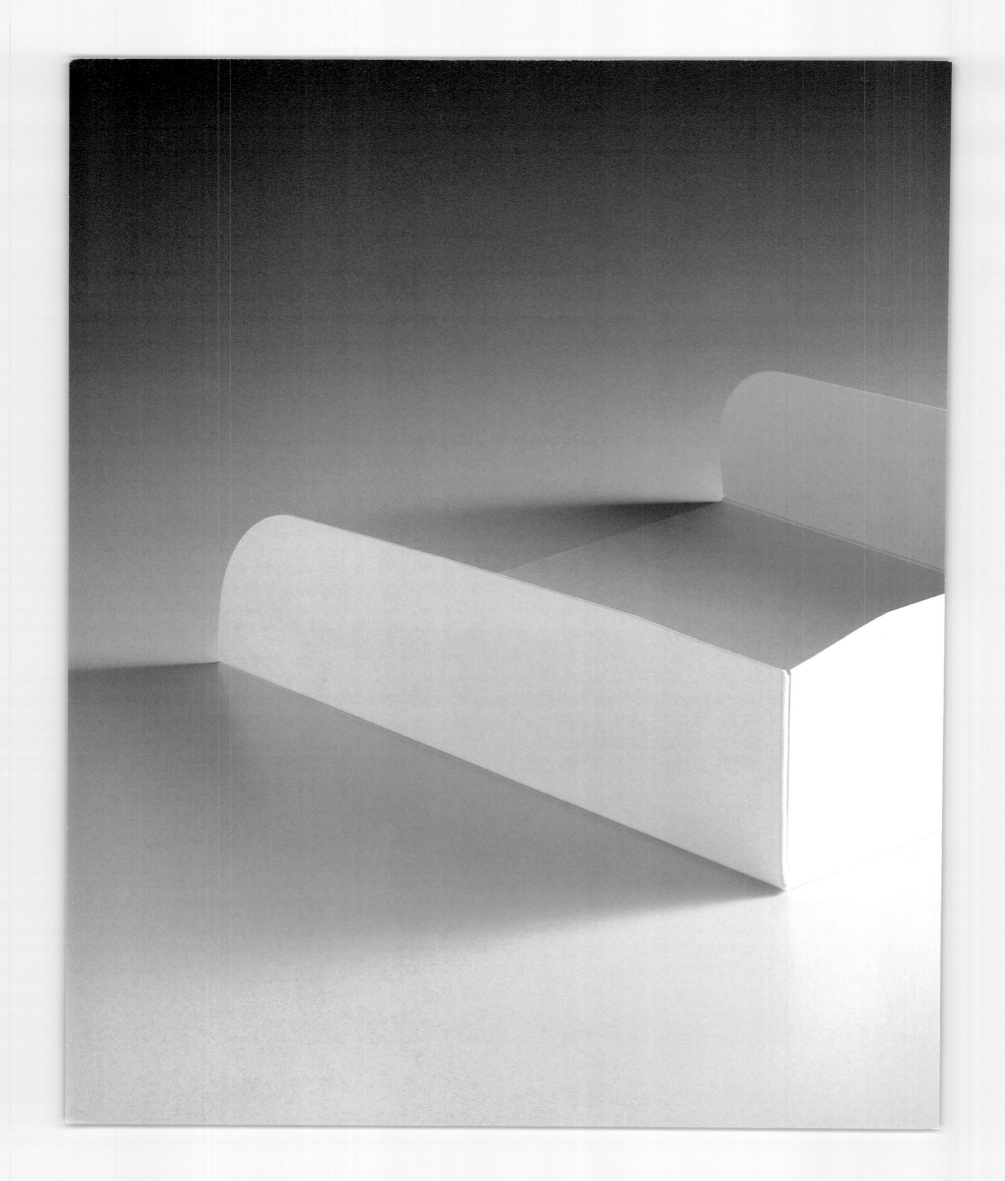

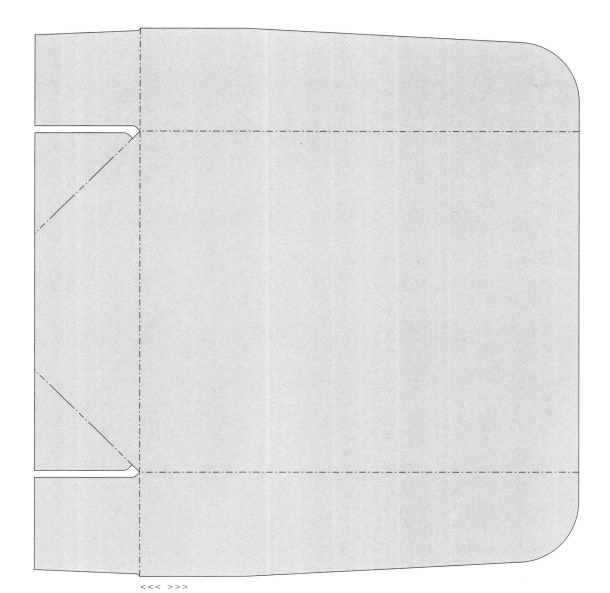

<<< >>>

This is a simple tray designed to support a group of products on a display shelf. The rear and sides can be larger to include point of sale graphics, up to and over the height of the products contained. With glued flaps and score lines the tray can be collapsed easily and quickly for flat-packing.

OPEN-ENDED TRAY 99

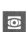

A basic carton which provides a point of sale accompaniment to awkwardly-shaped food products. This provides partial protection for shrink-wrapped products, but more importantly it provides a visual barrier for the consumer in the form of a graphics platform. A good use of minimal material.

THREE-SIDED DISPLAY TRAY

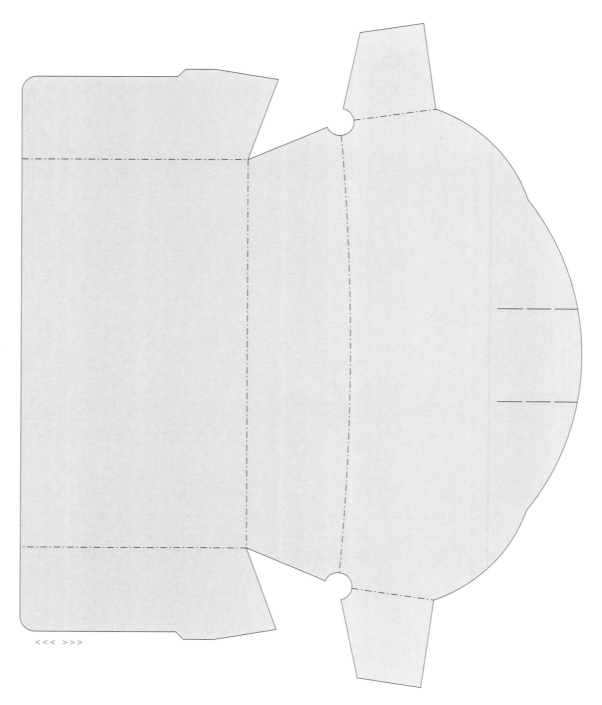

<<< >>>

Patent pending. Fields Packaging

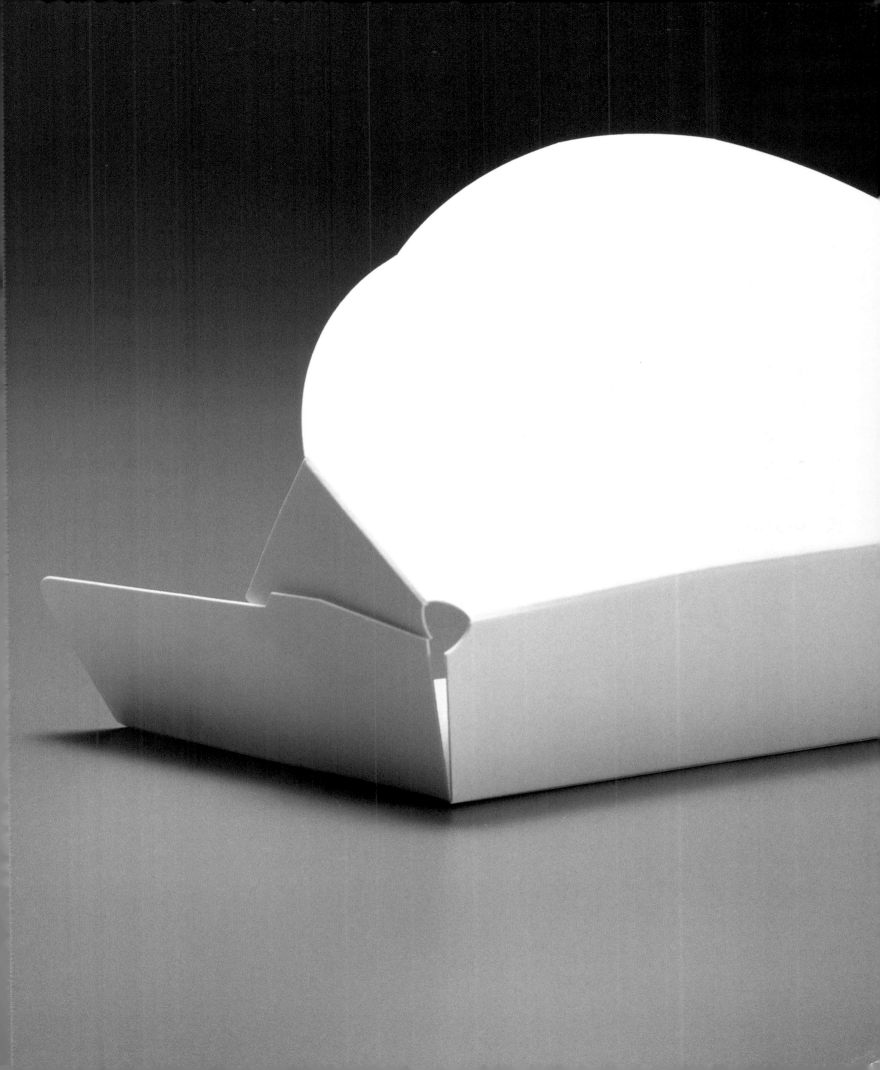

A web-cornered glued food tray with flanges typically associated with use in the take-away food market. The flanges on the sides create a lip, to hold hot food with without being scalded. The tapered sides prevent food from being trapped in the corners and allow easier serving from the container. The use of special material is essential for this carton to provide water-resistance and rigidity when full of hot liquid. Cartons with tapered sides are excellent for saving space in transportation and storage as they can be stacked, which might be an important consideration in some applications.

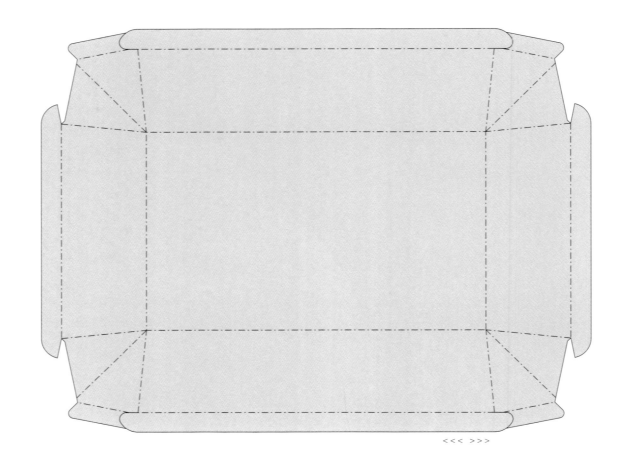

<<< >>>

102 **FLANGED TAPERED TRAY**

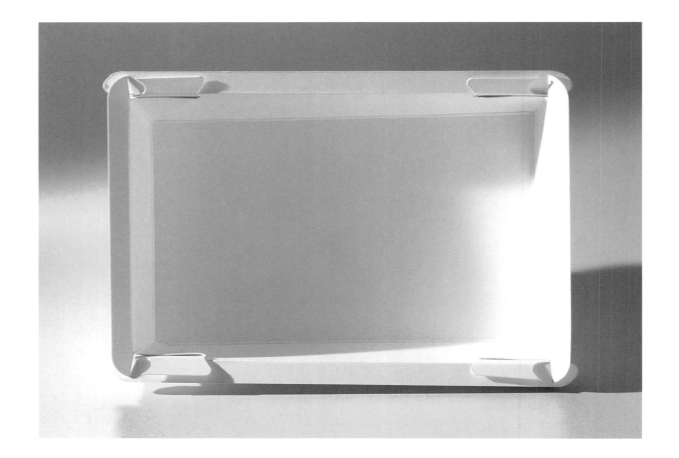

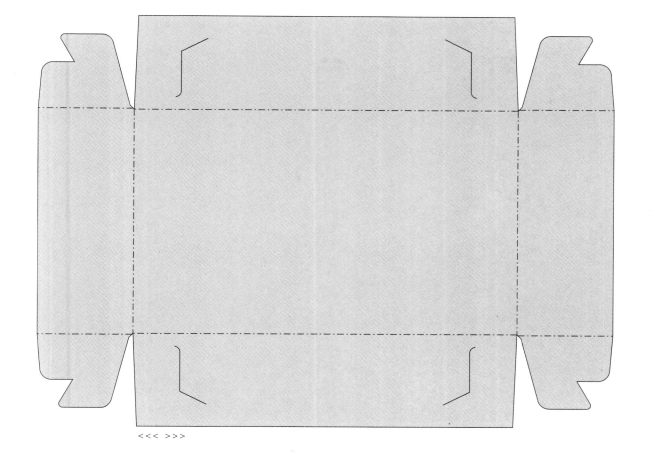

<<< >>>

A machine-erected four-sided tray with corner locks used for general purposes. It does not need any glue in its construction, but uses the tongue and slot on the corners to create the sides. The tray can be formed into a container with a lid by using one tray as the base and a slightly larger one for the lid.

A simple easy-erecting carton used for the storage of many items which are later to be shrink-wrapped whilst in the carton. The sides also act as an adequately rigid barrier for the contained product when removed from the shrink-wrap. The sides of the tray are strong when pushed outwards because they are designed to fold inwards – there are many different variations in the way this is achieved. The creases allow the tray to be flat-packed and stacked; the tray self-erects just by lifting the sides.

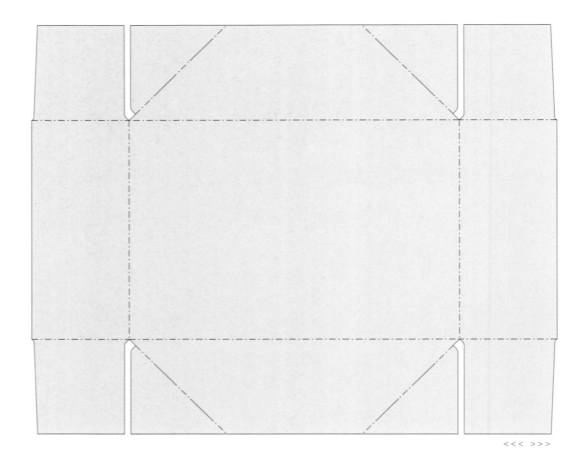

<<< >>>

104 **IN-FOLD/OUT-FOLD FOUR CORNER TRAY**

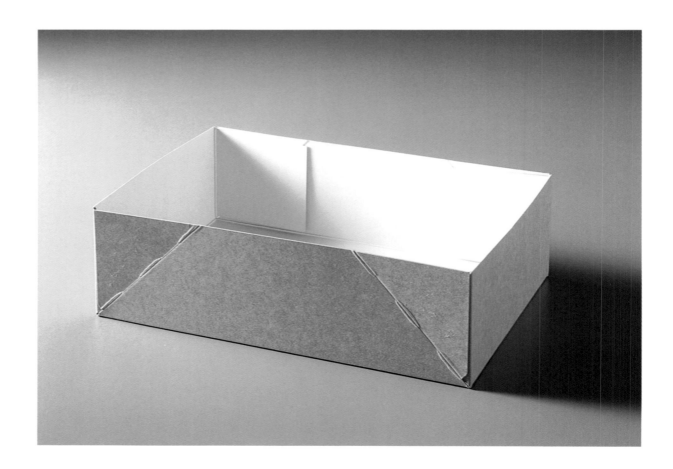

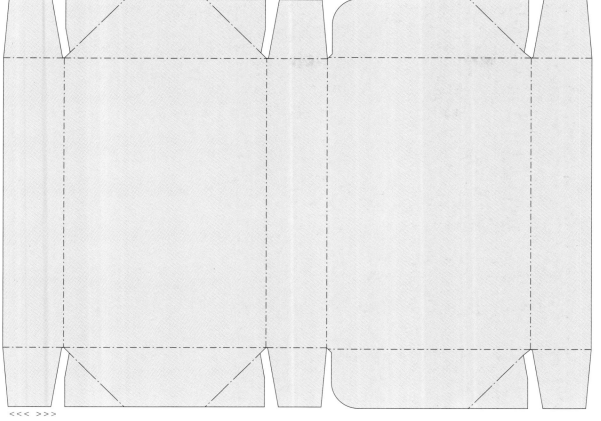

A carton with in-fold hinge walls which incorporate the lid along one side. This simple carton with a combined lid demonstrates another type of tuck/closure pattern. When the carton is opened fully it forms an extended tray with side walls. As a closed carton, it provides a fast and effective container mechanism suitable for the fast food industry – grease-proof, or moisture-resistant card would need to be used for this particular application.

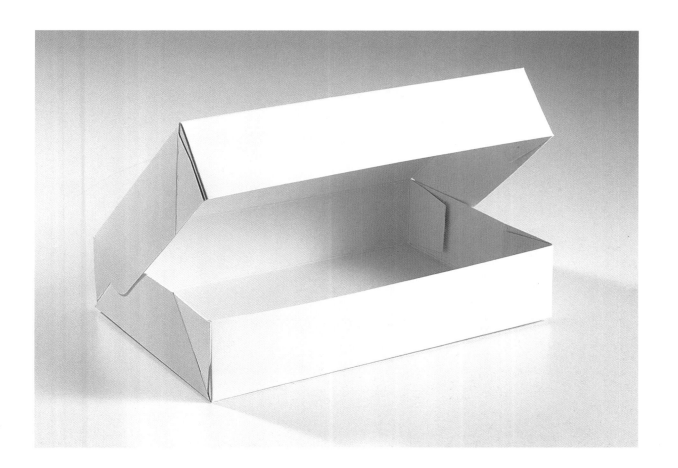

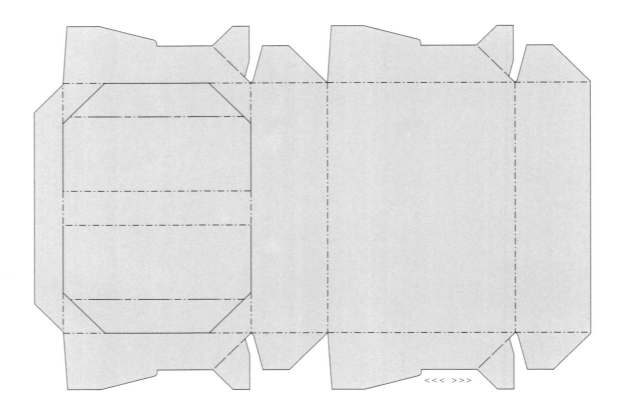

A useful carton to support two or more bottles, or similar upstanding items securely, this carton also provides a useful flat surface for point of sale graphics or promotions. The height of the carton will be determined by the height and composition of the product being contained, and the print on the product must not be obscured by the carton. The support arm across the carton provides a useful divide to separate the products and prevent them from clashing against each other, as well as giving a degree of rigidity to the carton.

SEGREGATED TRAY

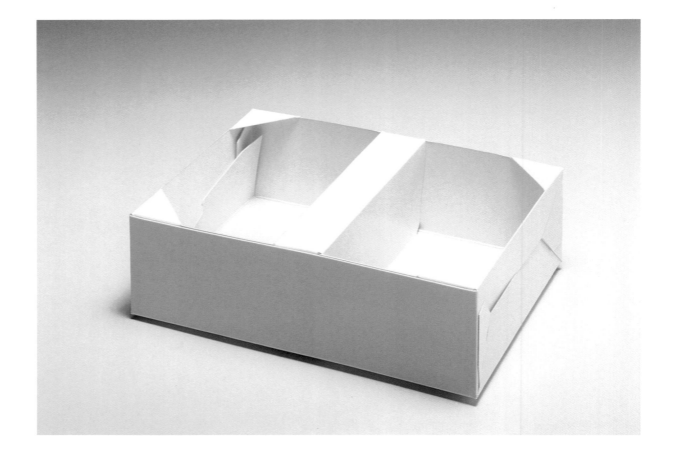

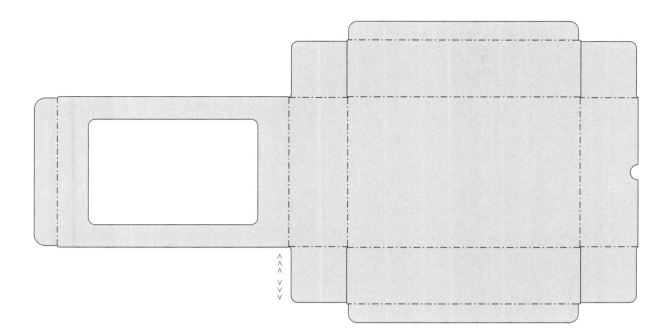

Due to its relative lack of strength this carton is suited to the storage of light products such as clothing. The inner flaps on the side of the carton prevent the product from becoming trapped or escaping out from under the lid. The use of a window in the lid provides the consumer with a visual reference to the product, although the size of window may affect the strength of the container.

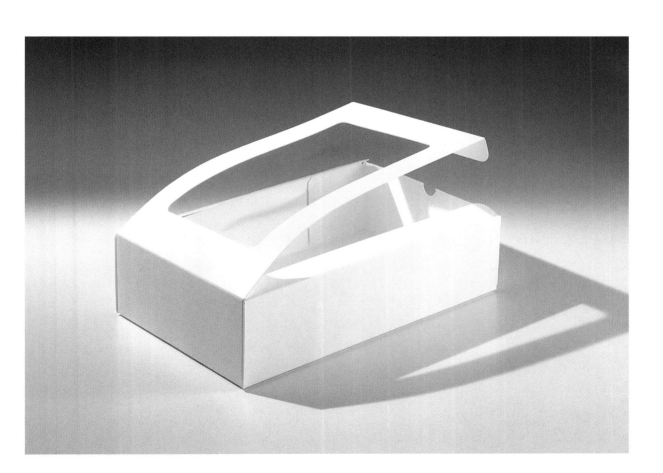

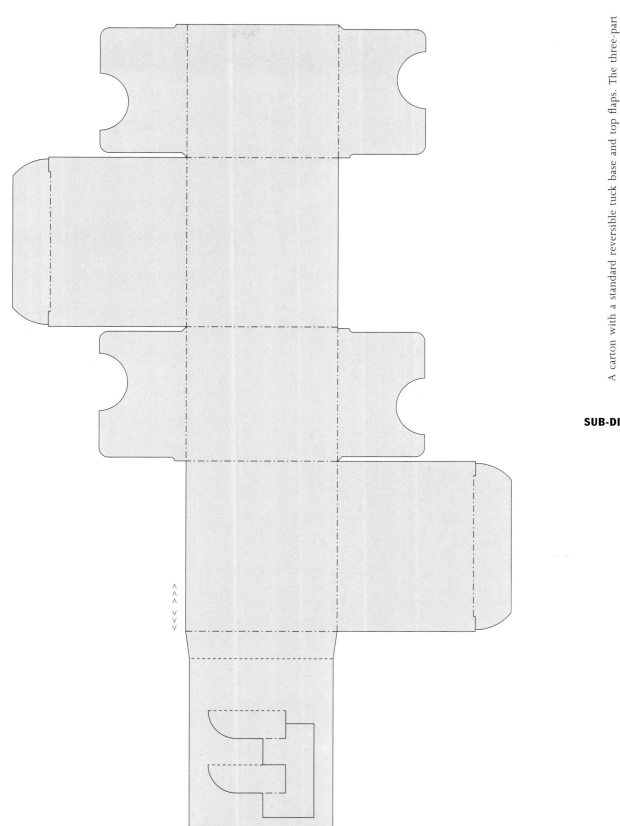

A carton with a standard reversible tuck base and top flaps. The three-part compartment is partitioned inside using cut-out sections, clever use of these die-cut sections provide variation in an otherwise simple design without using additional material or component parts. This design is useful for holding delicate accompaniments to a main product. The cut-outs in lid flaps might clasp the neck of a bottle.

SUB-DIVIDED CARTON 109

An example of how a straight tuck carton can be given added value by having fully overlapping flaps at the access to the contents. It also provides a barrier to the product on which graphics or instructions could be applied.

FULL OVERLAP-TUCK CARTON

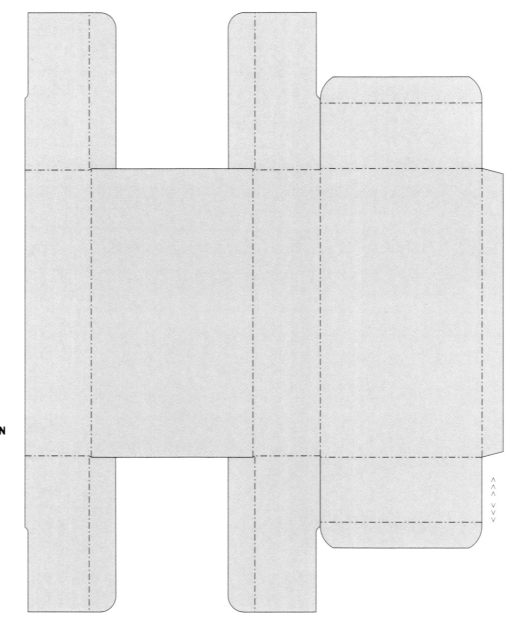

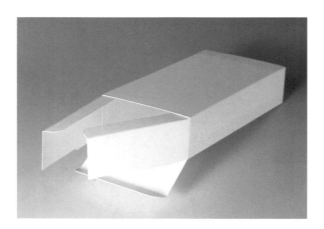

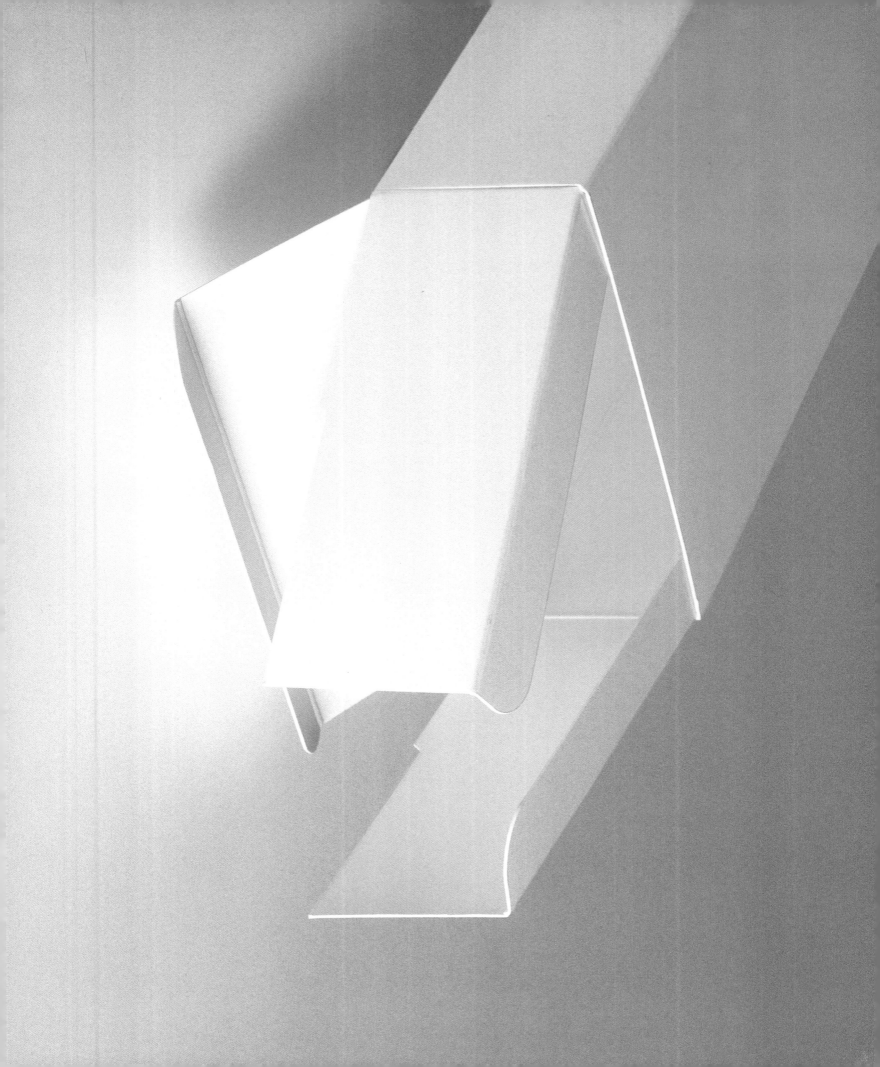

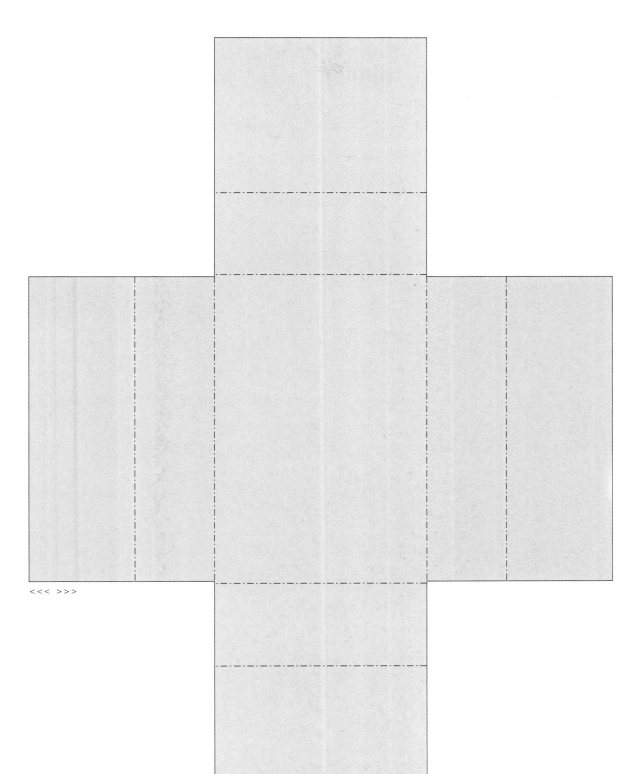

A corrugated carton used for transporting product units safely – as such, it trad-itionally functions as a secondary package. It could be used for primary packaging but the thickness of carton board would limit the size and scale of the container. Corrugated board would normally be used for its shock-absorbency and strength. This carton is typically sealed with adhesive tape/hot melt adhesive/staples.

TRAY WITH CRUCIFIX
FLAPS TO MEET
113

<<< >>>

This tray has fold-over glued sides and fold-over ends. To increase the tray strength, a thicker or more rigid material might not always be the best solution; by doubling over the sides and ends all the faces can be strengthened in a different way. This type of design allows graphics to appear on the inside of the tray whilst only printing one side of the card. The tray could be glued, or 'T' shaped ends could be added to ensure that the flaps do not open out. However, generally the weight of the product carried ensures this does not happen.

114 **FOLD-OVER TRAY**

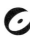

<<< >>>

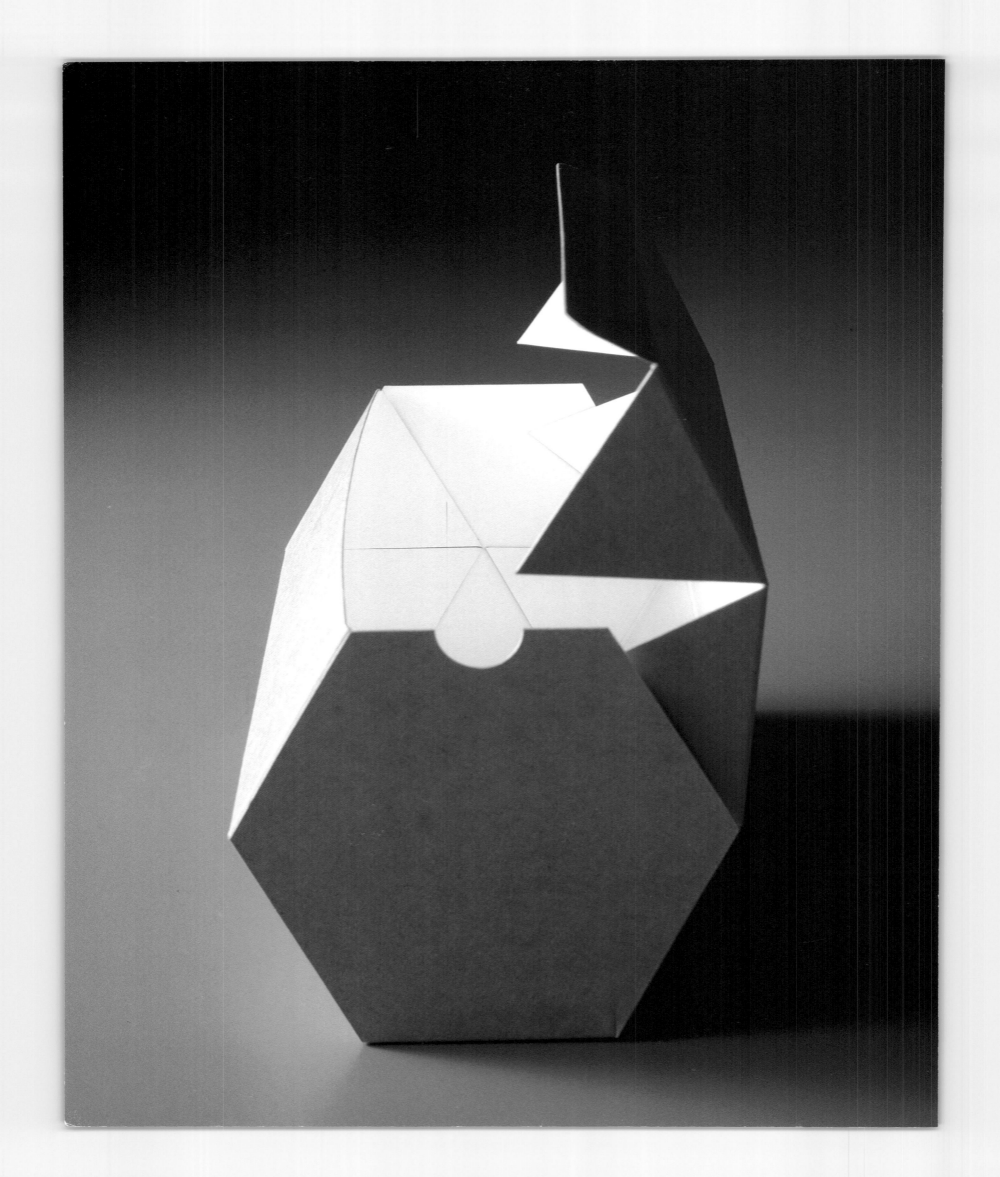

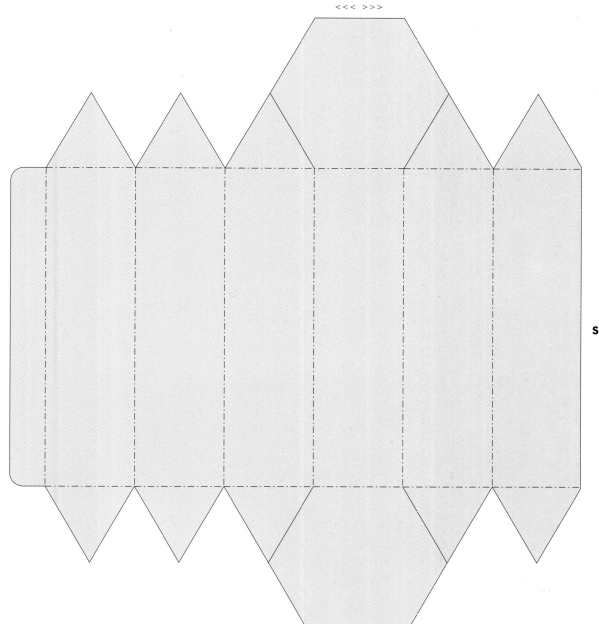

<<< >>>

This is a simple, yet effective, variation on the regular design of rectangular containers. The hexagonal shape makes the carton more eye-catching and provides a more interesting shape on the shelf. The orientation of this carton could be either vertical or horizontal. In the vertical state, it might be effective for containing bottles for special-edition products. The length or number of sides are easily changeable in this carton.

SIDE-ENTRY HEXAGONAL CARTON 117

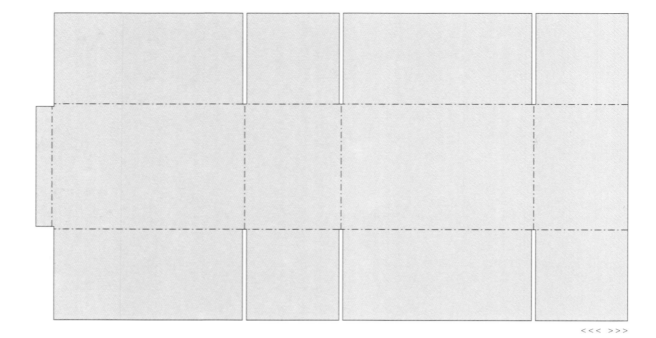

A particularly effective carton for heavy items, as the base and the lid are double thickness, due to their overlap. This uses B-flute cardboard which is the most popular material for providing the greatest shock-absorbency and crush resistance. This is primarily used for secondary packaging, although design alterations could broaden its applications.

<<< >>>

FOUR FULL FLAPS SKILLET

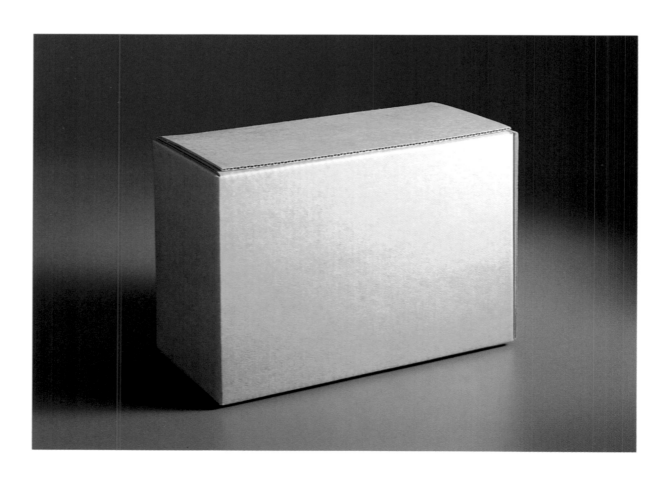

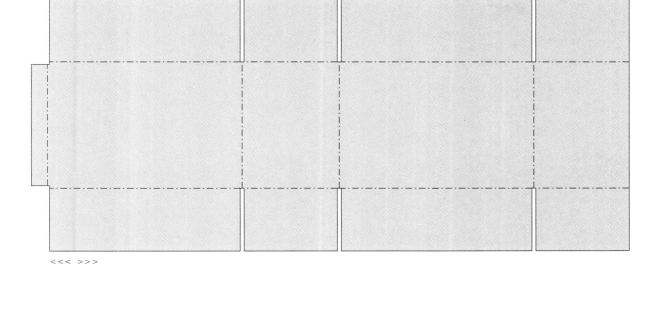

<<< >>>

A traditional transit carton normally used as secondary packaging. Due to its simplicity and structure, it tends not to be used as a point of sale package. Excellent strength properties mean that this container is used for packaging anything from small cartridge products to television sets. Its proportions are easily manipulated to required dimensions and scale.

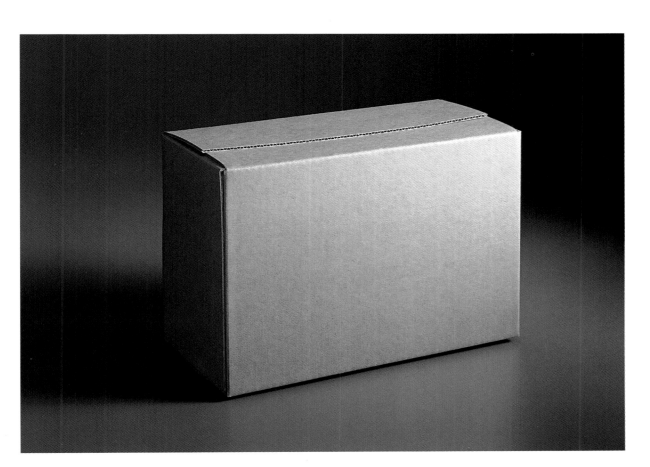

This two-part container has four flaps to meet on both the base and the lid, and the lid is full length. It can be manufactured with shorter sides to ease removal or placement, although full-length sides give better protection against side impact. B-flute corrugation provides shock absorbency, whilst the outer face provides a surface which can be printed on using line art or letter press printing methods. More complicated designs can be pre-printed using flexography or rotogravure methods which use kraft, white clay-coated kraft, or clay-coated bleached liner materials.

<<< >>>

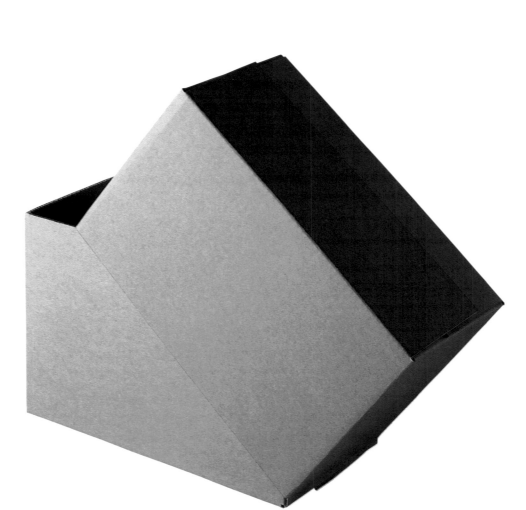

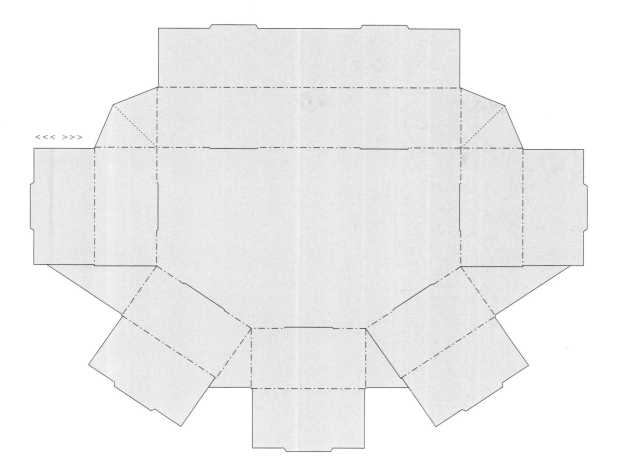

<<< >>>

An example of a tray that uses folds, rather than glue, to form its structure and strength. The tuck-flaps fit through recesses in the base formed by the pedestal feet. This is a particularly useful design for trays that require construction by hand in large batch quantities.

SELF-ASSEMBLE ANGLED FRONT TRAY 121

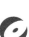

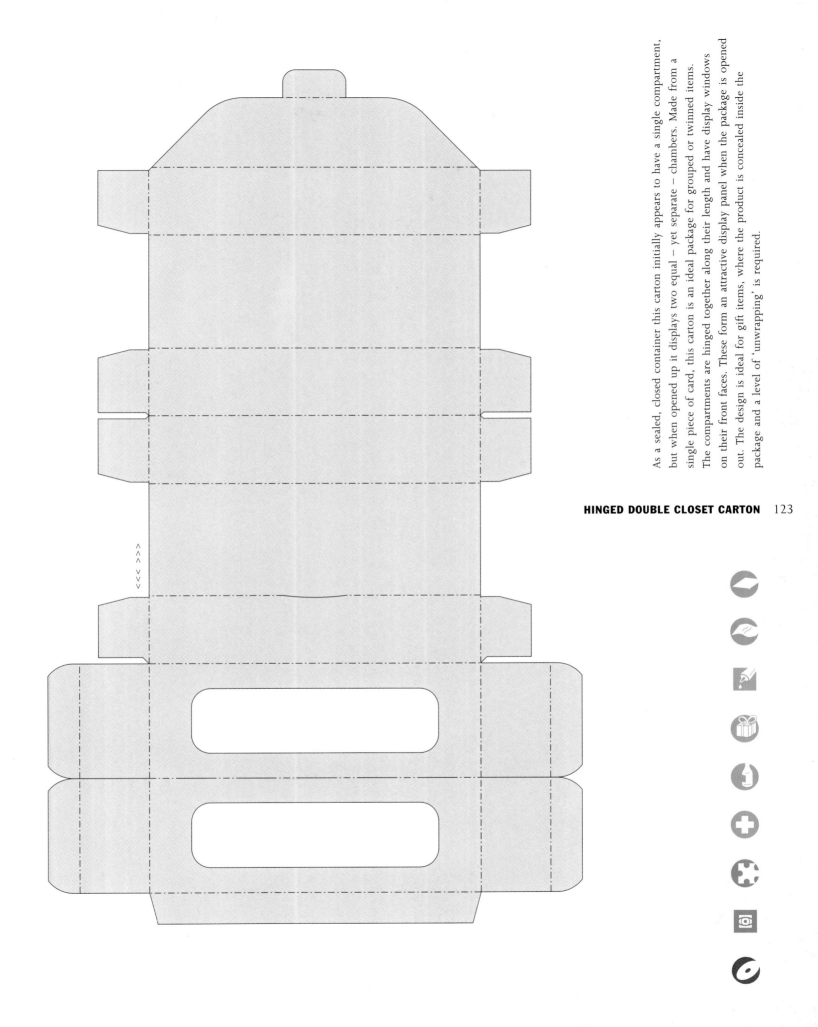

As a sealed, closed container this carton initially appears to have a single compartment, but when opened up it displays two equal – yet separate – chambers. Made from a single piece of card, this carton is an ideal package for grouped or twinned items. The compartments are hinged together along their length and have display windows on their front faces. These form an attractive display panel when the package is opened out. The design is ideal for gift items, where the product is concealed inside the package and a level of 'unwrapping' is required.

HINGED DOUBLE CLOSET CARTON 123

This is an effective transit carton, delivering goods safely to the point of retail. The carton may then be transformed into a point of sale unit by sliding the sides down to form a free-standing display of the product inside. The addition of graphics would provide information and aesthetic appeal, minor design alterations could allow many types of product to be contained in this way.

P.I. Design International.

124 **MERCHANDISE CARTON**

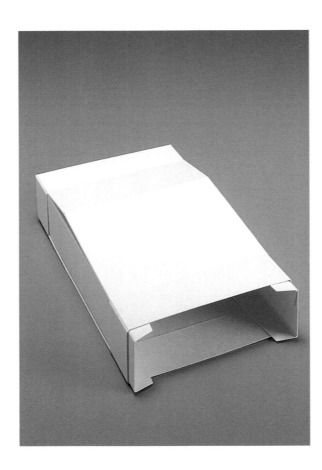

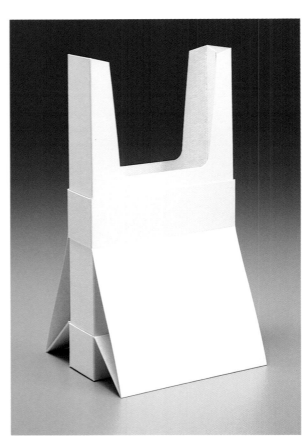

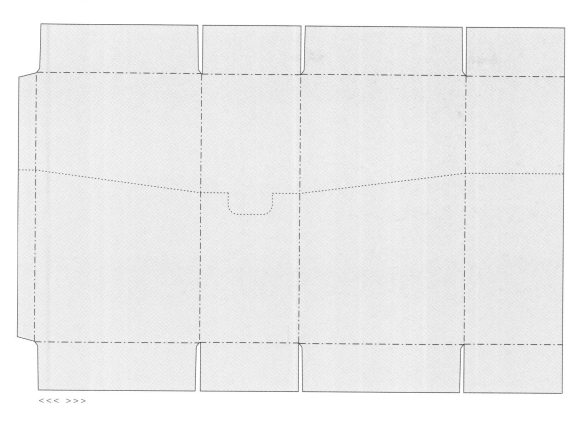

<<< >>>

A traditional transit carton used as secondary packaging that converts to a useful point of sale container. This is particularly suited for use on filling lines where automated taping machines seal the filled cartons as they pass along the production line. The flaps meet in the centre of the top and base of the carton and this allows an internal flat area which is especially suited to free-standing products. Applied perforations along a designated angle around the girth of the container allow the base of the container to perform as a point of sale support after transit.

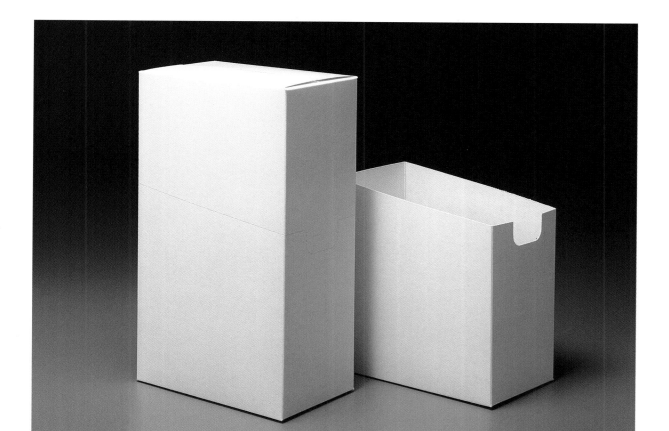

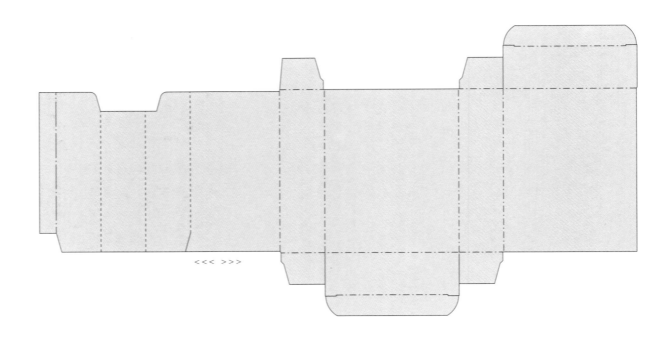

This is an example of how a simple design from a flat sheet can separate the items inside the carton. This reverse-tucked example has three compartments, but this could be increased or decreased with little effort, depending on specific requirements. It is ideal for products that need separation for a specific reason; to avoid contamination from neighbouring products such as soaps or to provide protection for fragile items such as light bulbs. Windows could be easily added to the front of each compartment to provide the consumer with a view of the products.

CARTON WITH INTERNAL COMPARTMENTS

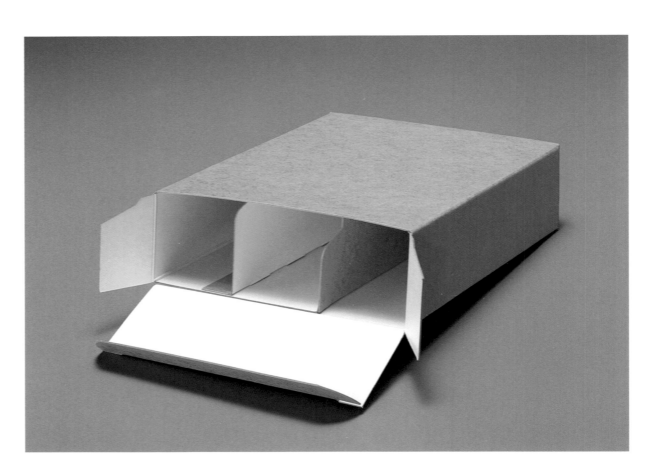

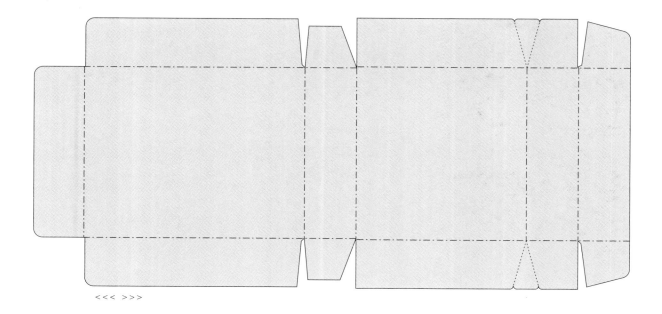

<<< >>>

This is a carton which allows access to the product by tearing away the end panel along designated perforation lines. Commonly used for small confectionery; other possible uses are for clothes which would need to be pulled from the carton. This type of opening is good for products that require a level of security or tamper-proofing. Attention should be paid to the amount of glue used around the entry, so as not to hamper access.

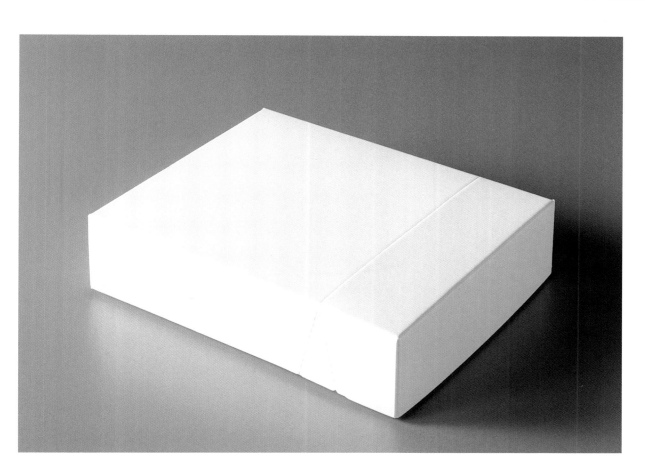

This is an example of how a simple closure can determine or transform the purpose of a carton. By scoring along the correct axis, the consumer is able to open the spout and gain access to the product. This container is most commonly used for detergents and breakfast cereals. The designer has the freedom to alter the dimensions of the container considerably, providing the dimensions of the aperture remain large enough for the product to pour out freely.

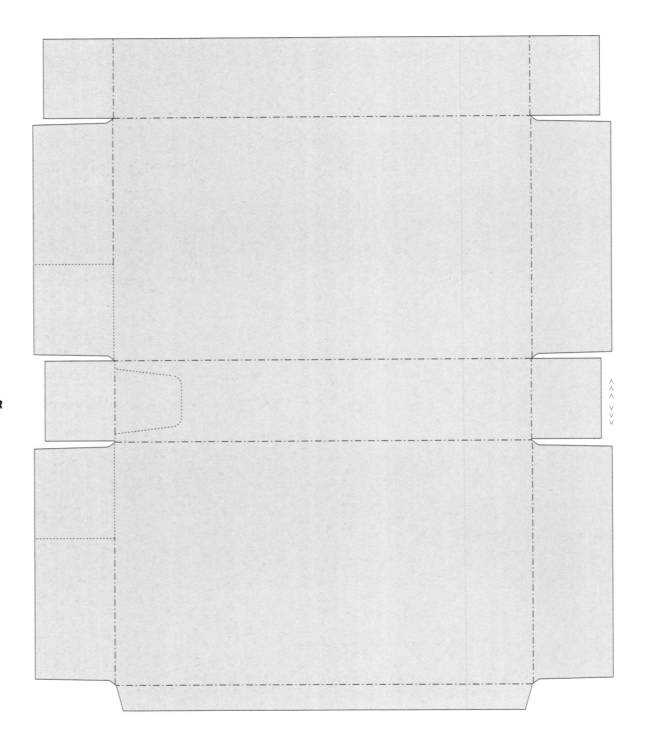

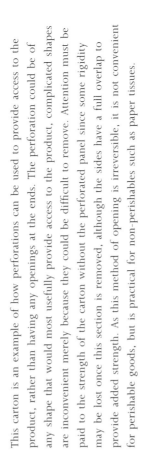

This carton is an example of how perforations can be used to provide access to the product, rather than having any openings at the ends. The perforation could be of any shape that would most usefully provide access to the product, complicated shapes are inconvenient merely because they could be difficult to remove. Attention must be paid to the strength of the carton without the perforated panel since some rigidity may be lost once this section is removed, although the sides have a full overlap to provide added strength. As this method of opening is irreversible, it is not convenient for perishable goods, but is practical for non-perishables such as paper tissues.

130 **PERFORATED CARTON**

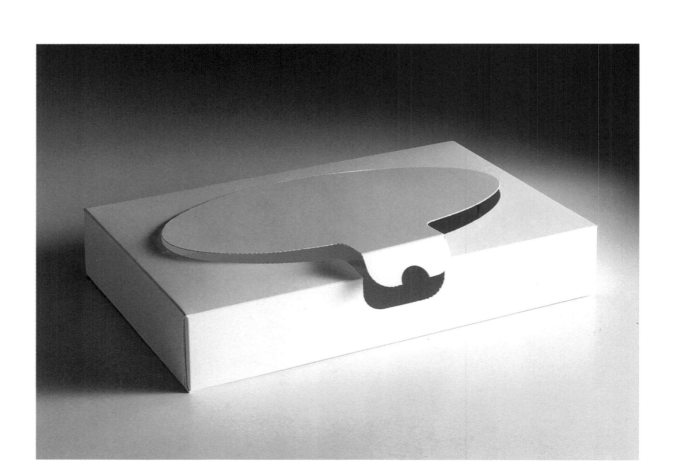

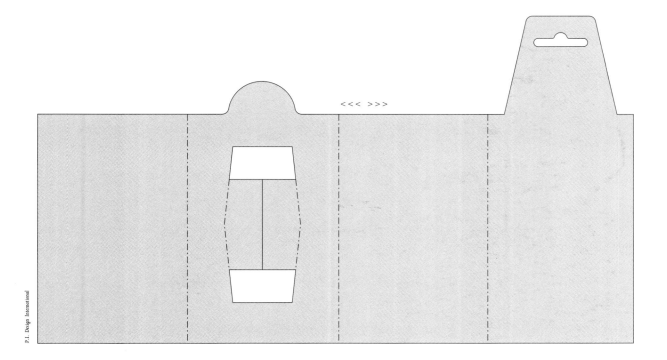

This carton allows the consumer to touch and feel the product it encases, whilst providing a point of sale display unit. Designed to display fabrics such as chamois leather, it uses a minimal amount of card to frame the product rather than contain it. The frame has a window through which the consumer can touch and feel a sample of the fabric, the rest of which hangs below. This demonstrates how a carton need not fully contain and protect a product to enhance the value and perceived quality of the display.

FABRIC DISPLAY CARTON 131

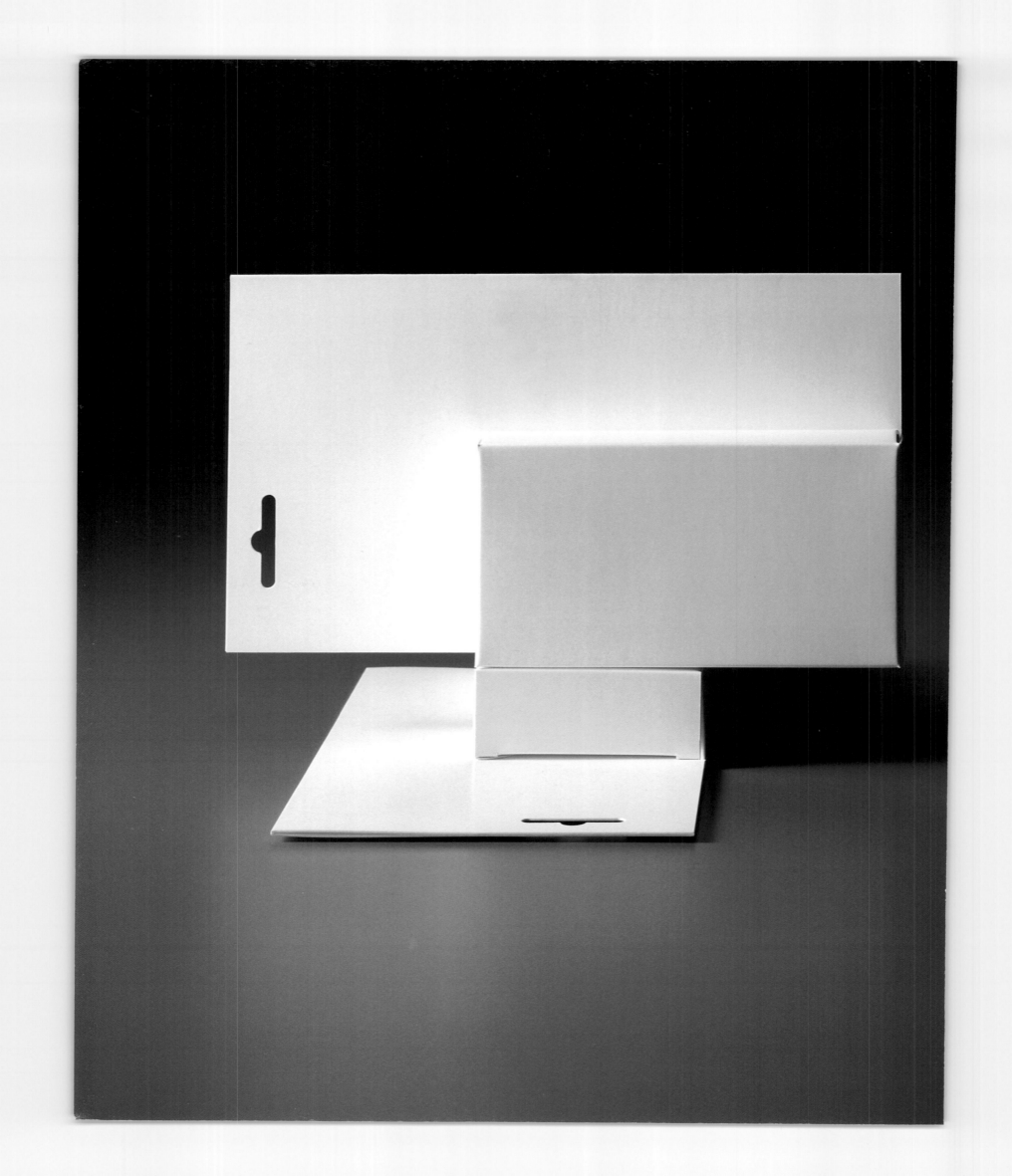

This design is a useful example of how additional point of sale graphics can be given space on a small product package. The oversized rear panel can be doubled over for extra rigidity, whilst allowing printing on just one side of the flat sheet before folding. Textual information relating to the use of the product might appear on the reverse of the panel, thereby preventing the need for an instruction leaflet inside the carton. The Euroslot is optional but attention must be paid to its position, this should be above the centre of gravity or the package would fail to hang straight.

A simple, innovative design for displaying long objects such as pens or tools. This design, cut from a single sheet of card, makes good use of material with very little waste from the die-cutting process. The profile of the pedestal is cut from the flat sheet before being folded to create a three-dimensional supporting structure for the product. The shape of the backing card or the pedestal could change to suit requirements.

134 **PODIUM MOUNT**

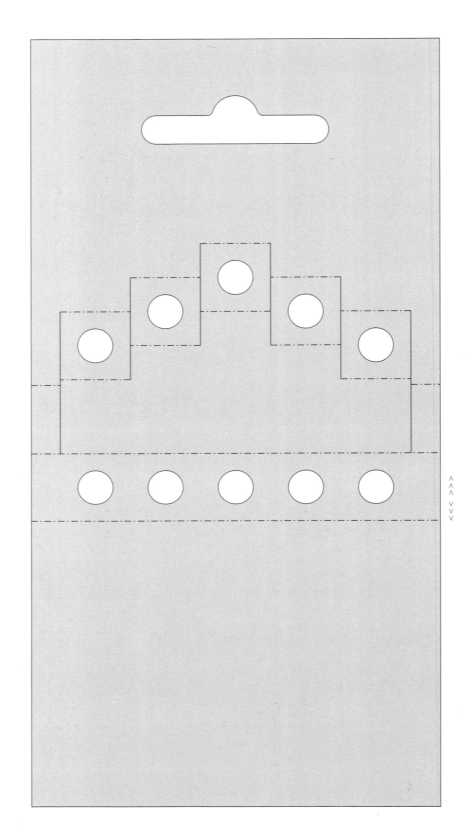

Marlow Chin – Surrey Institute of Art and Design

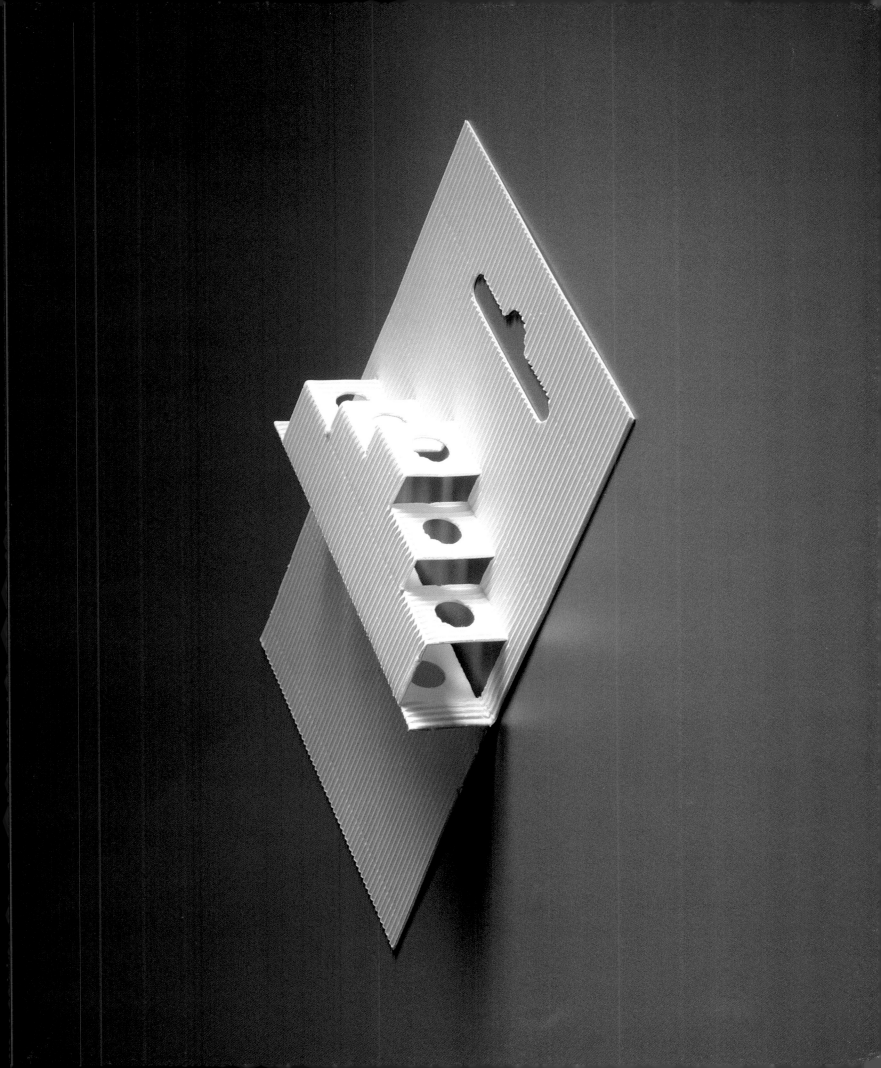

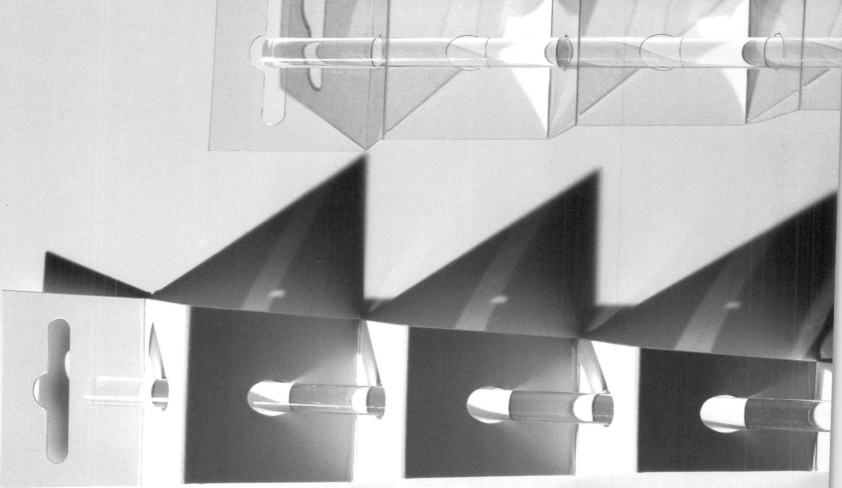

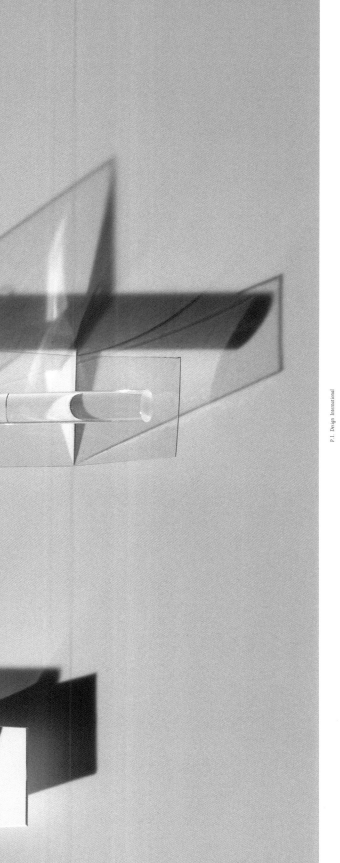

This simple display pack can be manufactured from any sheet material. The pack effectively protects the product whilst allowing the consumer to see and touch it, it is particularly suitable for long narrow items such as pens, cutlery or needles. This was originally designed to pack a new cardboard pen and therefore continue the environmentally-conscious theme of the product. One important consideration is that the holes be fractionally larger than the product's width, as the card will be at an angle and the holes consequently will be smaller.

CONCERTINA-SHAPED CARD 137

An inspirationally simple and attractive design to hold any kind of long object, this would be suitable for novelty or point of sale packaging. The backing card could be of almost any shape and contain point of sale graphics and a handle or Euroslot could also be added. The product is placed on the backing card before a strip of similar material is wrapped around in a spiral through the die-cut slits. The spiral effect provides an attractive method of containment, whilst the consumer is able to touch and visualise the product. No glue is required in the construction of this packaging.

> > >

< < <

138　**SPIRAL BINDING DISPLAY**

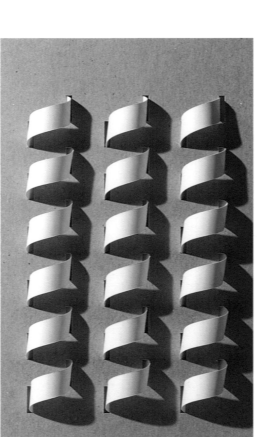

< < <　> > >

Lisa Gardner – Surrey Institute of Art and Design

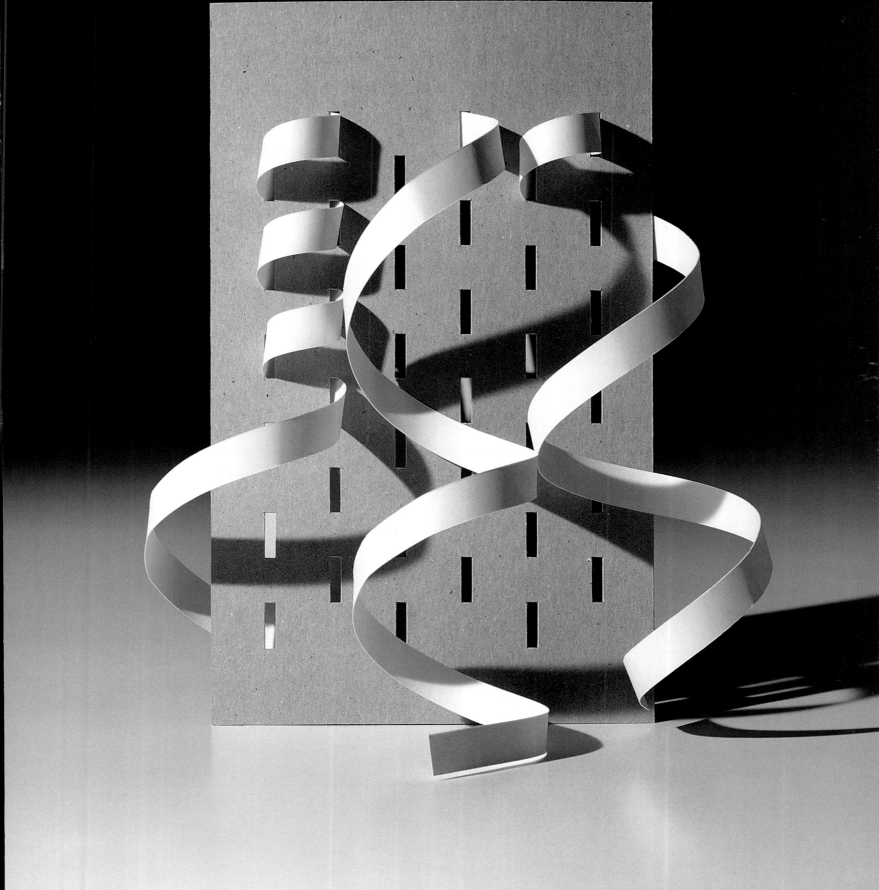

Originally designed to represent a safe for the sale of padlocks or other security devices, this demonstrates how a two-piece carton can provide an attractive and interesting method of containment. Requiring no adhesive, each carton is constructed to fit one inside the other, creating a double-walled internal compartment with tuck-flaps contained by an outer cube with a framed entrance and double-flap lid. This innovative design demonstrates the potential complexity of integrated two-piece packaging; with interesting opportunities for use of different materials.

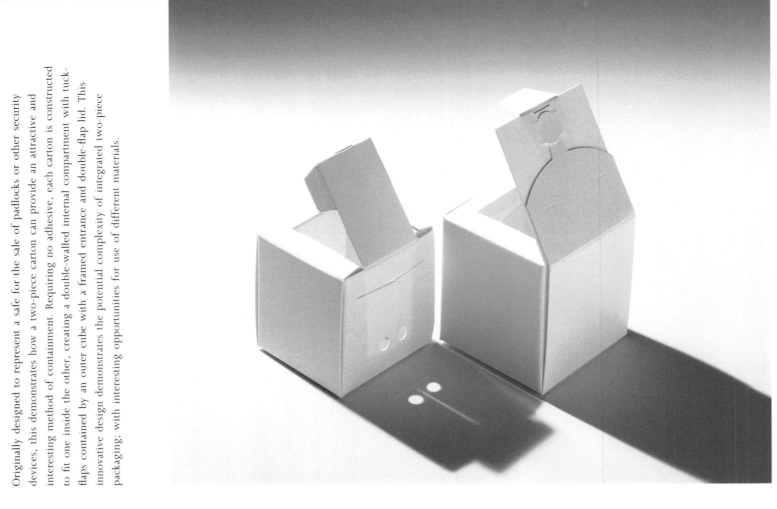

NOVELTY 'SAFE' CARTON 1

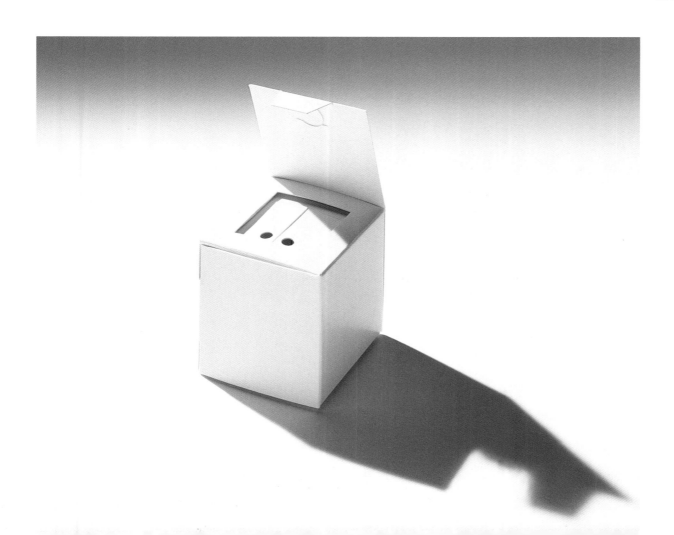

Neal Manning – Surrey Institute of Art and Design

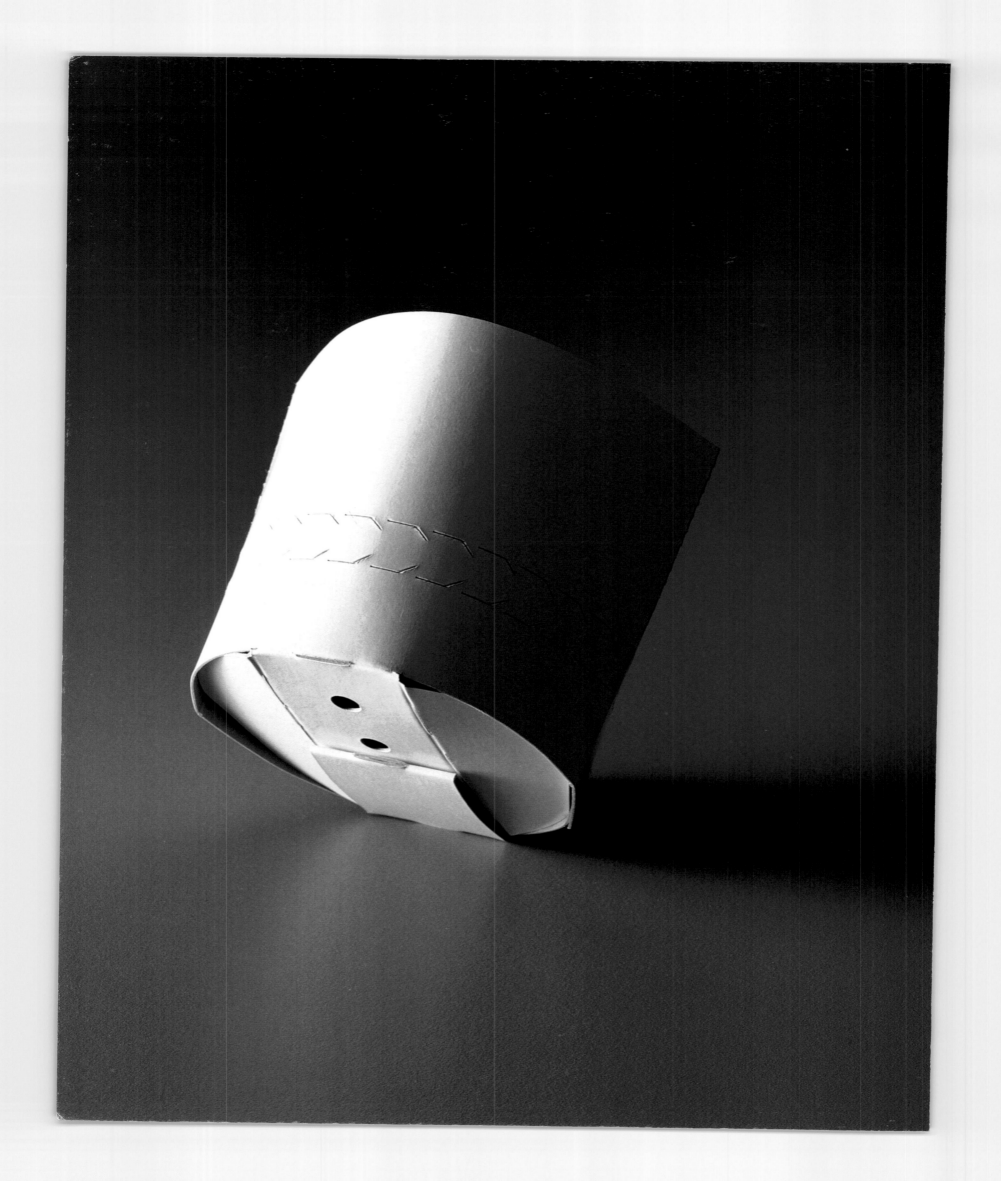

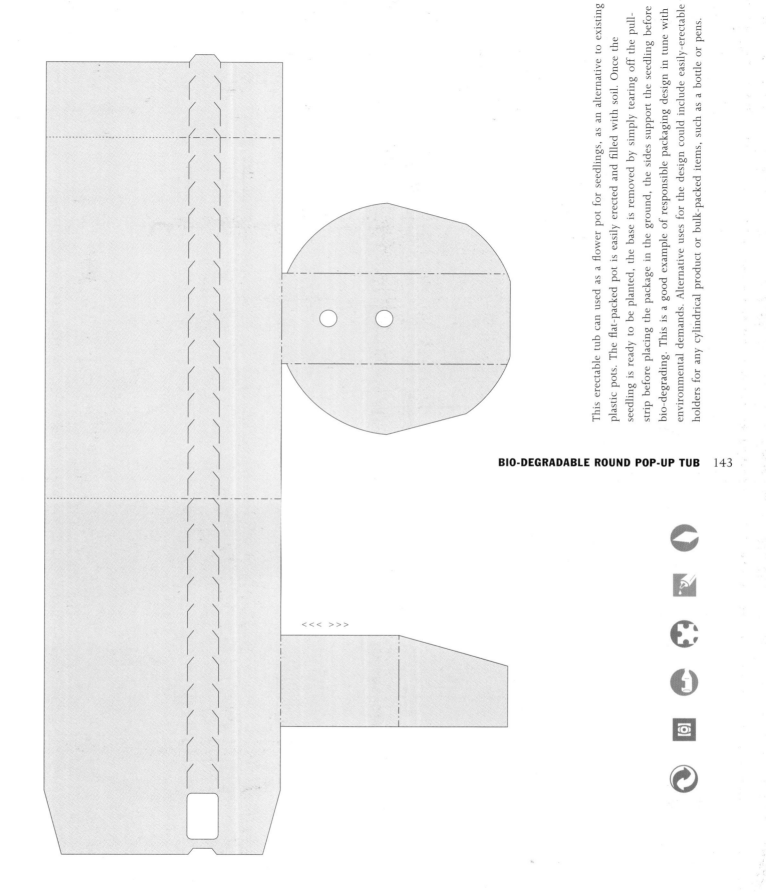

Patent Pending, Damapak

This erectable tub can used as a flower pot for seedlings, as an alternative to existing plastic pots. The flat-packed pot is easily erected and filled with soil. Once the seedling is ready to be planted, the base is removed by simply tearing off the pull-strip before placing the package in the ground, the sides support the seedling before bio-degrading. This is a good example of responsible packaging design in tune with environmental demands. Alternative uses for the design could include easily-erectable holders for any cylindrical product or bulk-packed items, such as a bottle or pens.

BIO-DEGRADABLE ROUND POP-UP TUB 143

A classic liquid carton design made from a single sheet of laminated board. Through a series of simple folds this flat sheet constructs to form a fully-sealed rectangular block. This is an excellent shape for transportation purposes and shelf storage, as individual packs can be stored next to each other with no wasted space. To access the product the carton can be opened by tearing the seal on the top, thereby creating a reusable spout through which the contents can be poured. Adaptations to this design include a die-cut polythene-sealed hole in the top for a straw, or polythene-sealed perforations in the top for ease of pouring.

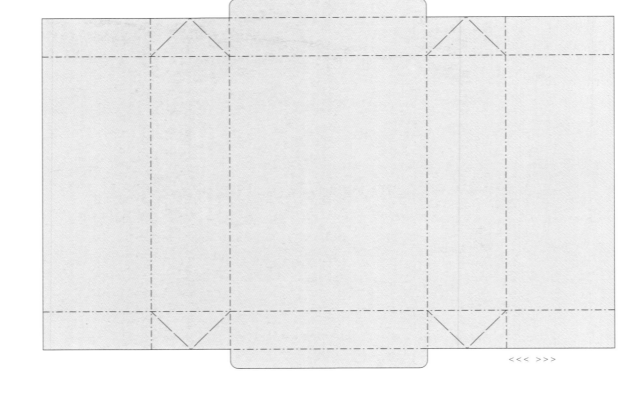

<<< >>>

HEAT-SEALED LIQUID CONTAINER

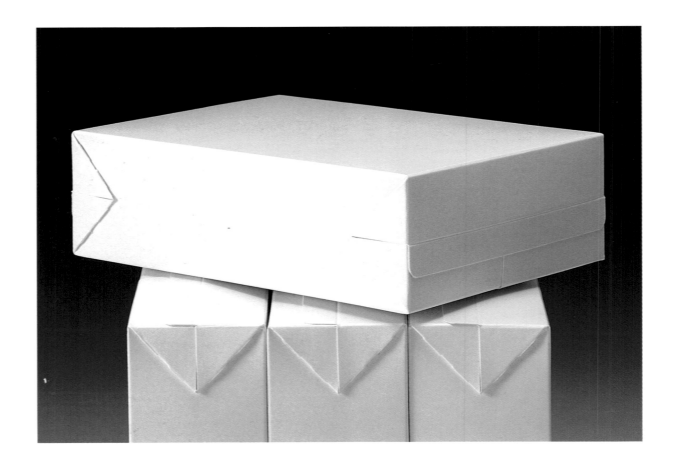

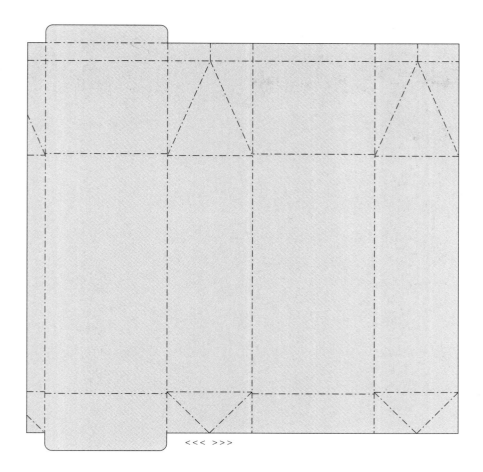

<<< >>>

This gable-top carton is a common design for confectionery or liquid products. It was made famous for containing liquids because of the easy-opening mechanism which gives access to the contents by pushing back the ridge on the top of the carton and pressing in the sides to break the adhesive seal. The internal tucks at the top of the carton also provide easy handling. The material used in this carton depends on the contents, liquid would require a multi-layered, waterproof board.

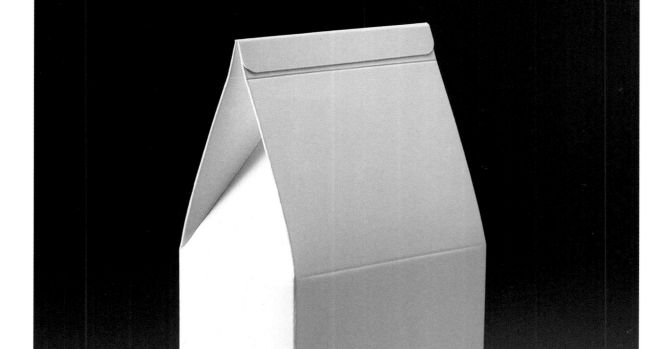

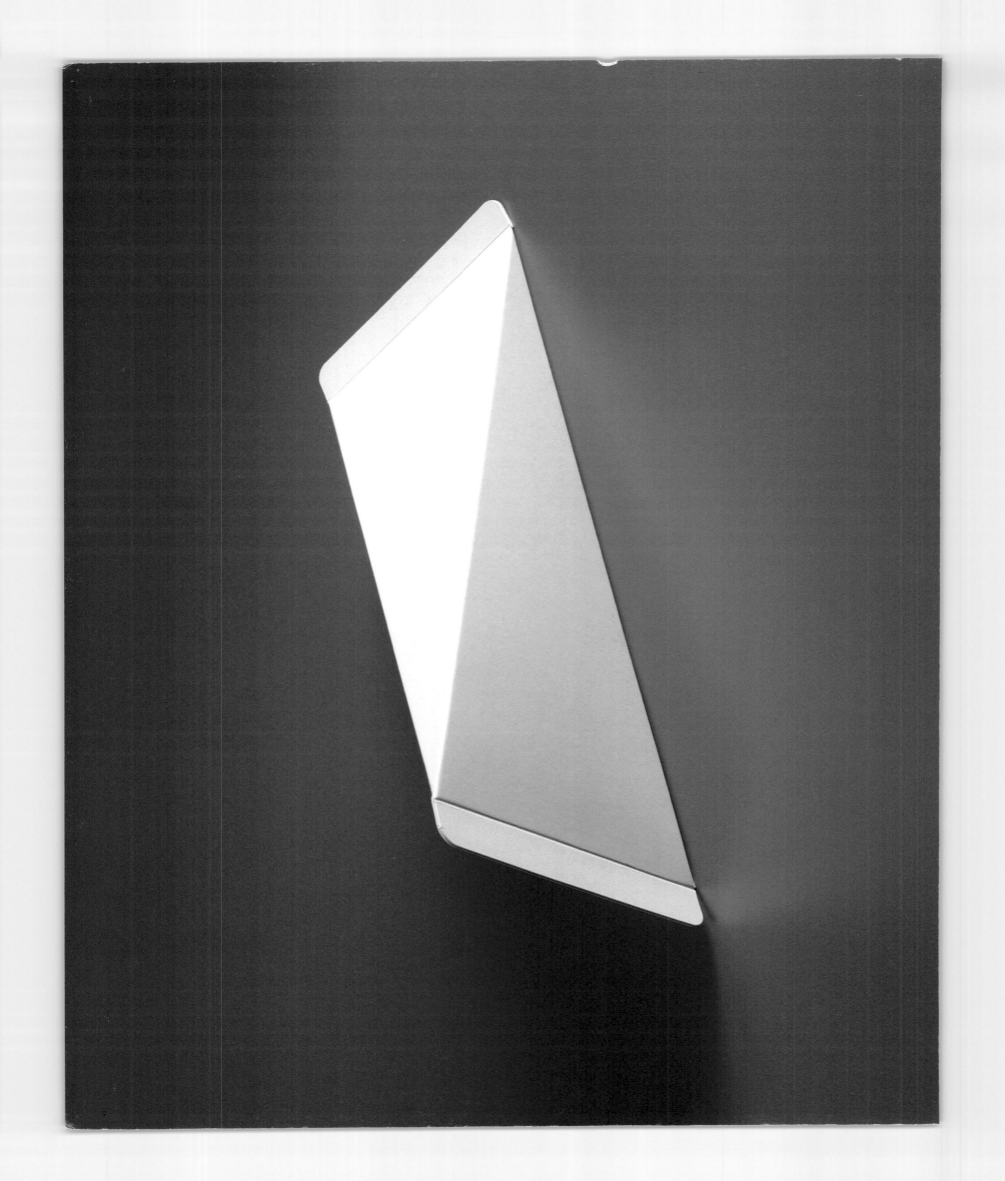

Tetra Pak, Tetra Classic

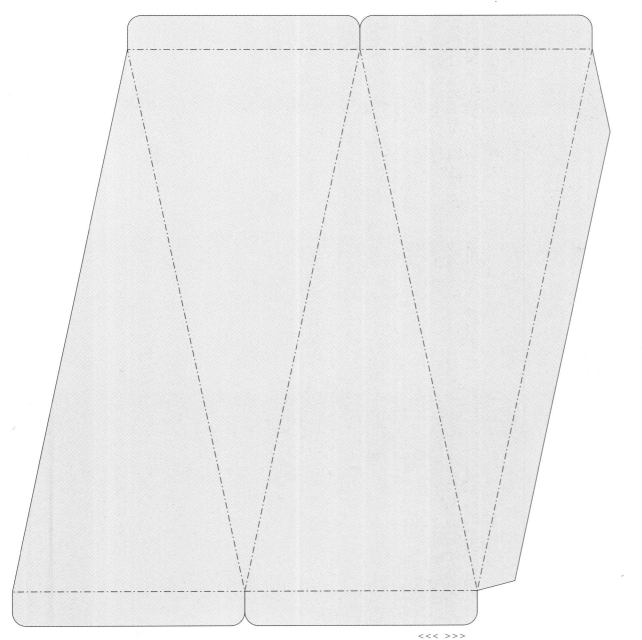

<<< >>>

A simple and classic example of early card containers designed to hold liquids. This design is still used around the world and it formed the basis for subsequent design developments. Laminated carton board is required for waterproof qualities and design problems include the filling and dispensing of the liquid. This is a seemingly simple, yet complex design classic.

Cartons can be used in conjunction with the visual appeal of the product on display. This carton is a good example of a method of grouping products without detracting from the product itself, it can be used to display families of products or special-edition product groups.

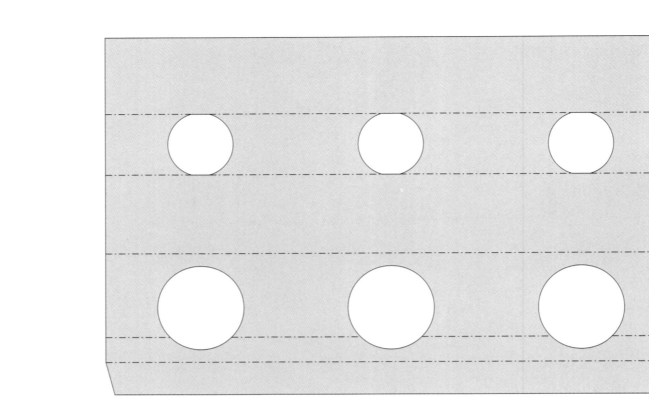

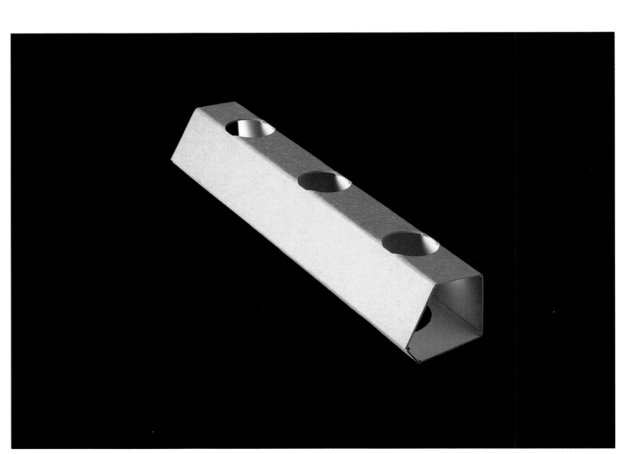

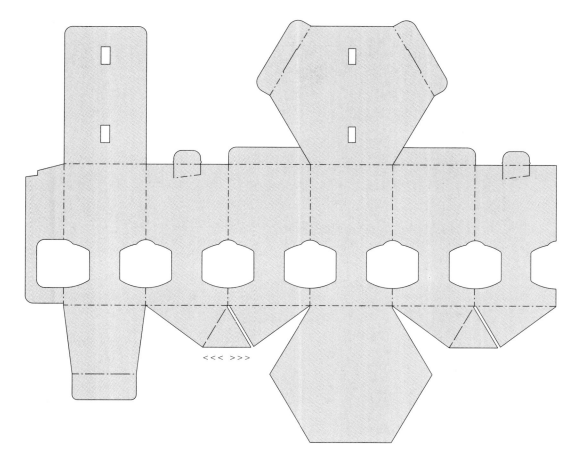

This shows how an unusual-shaped carton enhances the product it encases while providing stability and secure containment. The product labels are framed by the die-cut holes, this might allow a more inventive use of point of sale space on the side panels. By increasing the number of edges an octagonal version would be possible, depending on the strength of the material encasing the product. The case requires gluing along the base and the handle is optional.

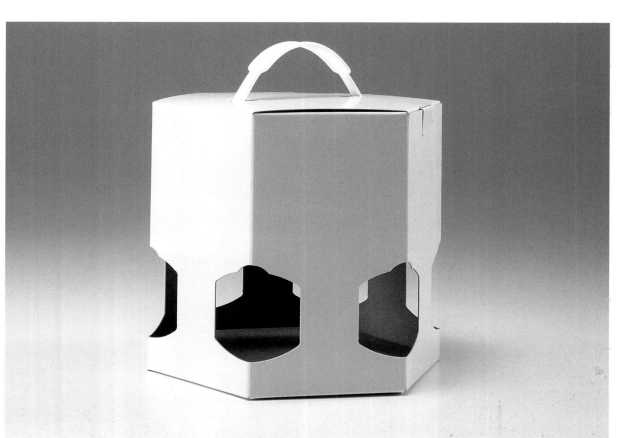

An erectable carton for holding bottles, this features a crash-lock base and a one-piece design which is erected by sliding open the carton so that the diagonal cuts form the dividers for the individual bottles. The simple configuration allows any number of bottles to be stored in a single package by simply increasing or decreasing the number of diagonal cuts. This convenient carton features a handle in the central dividing section for easy carrying.

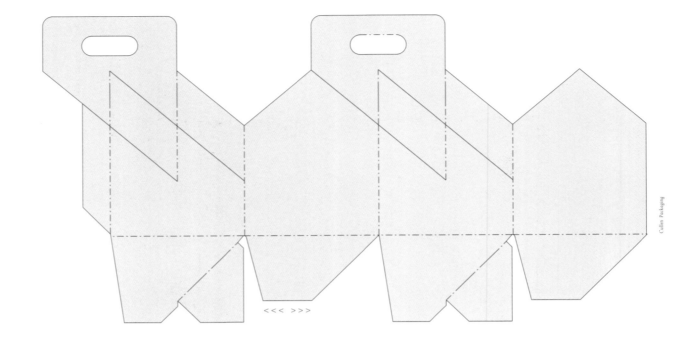

Cullen Packaging

<<< >>>

150 **BOTTLE CARRIER**

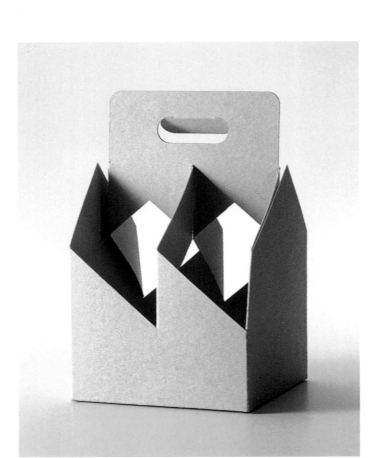

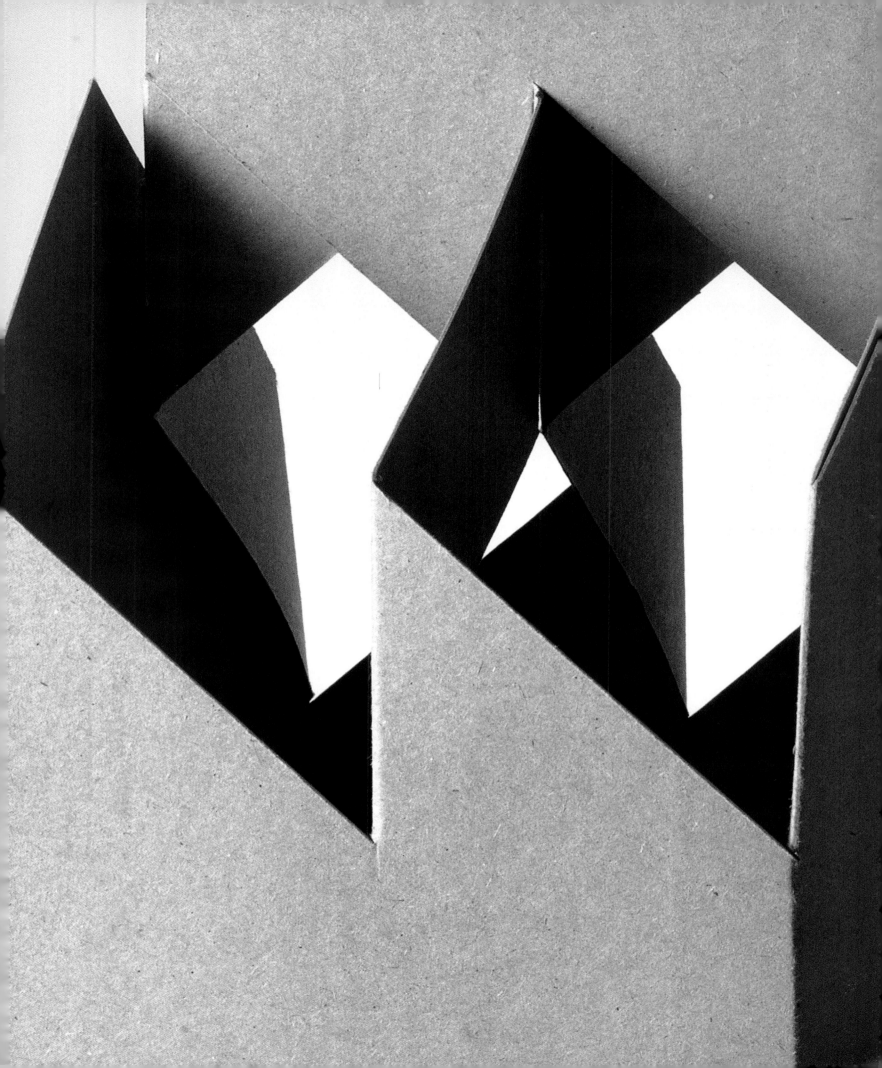

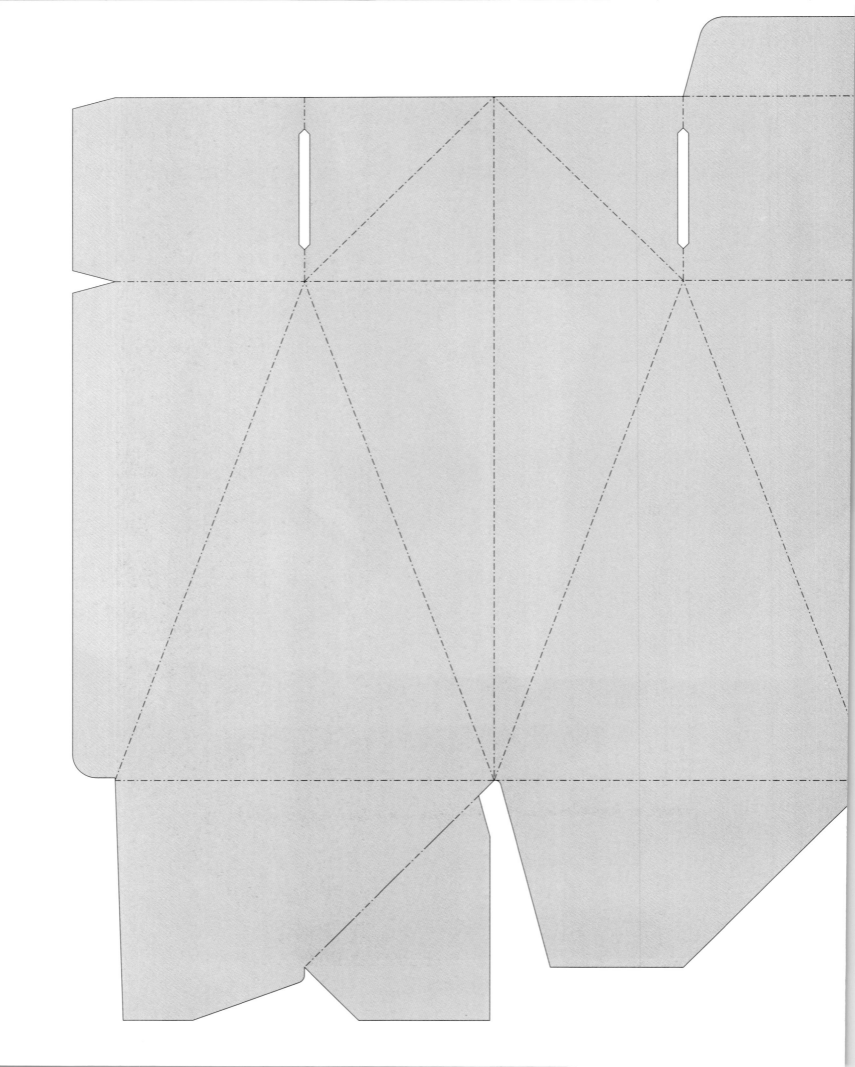

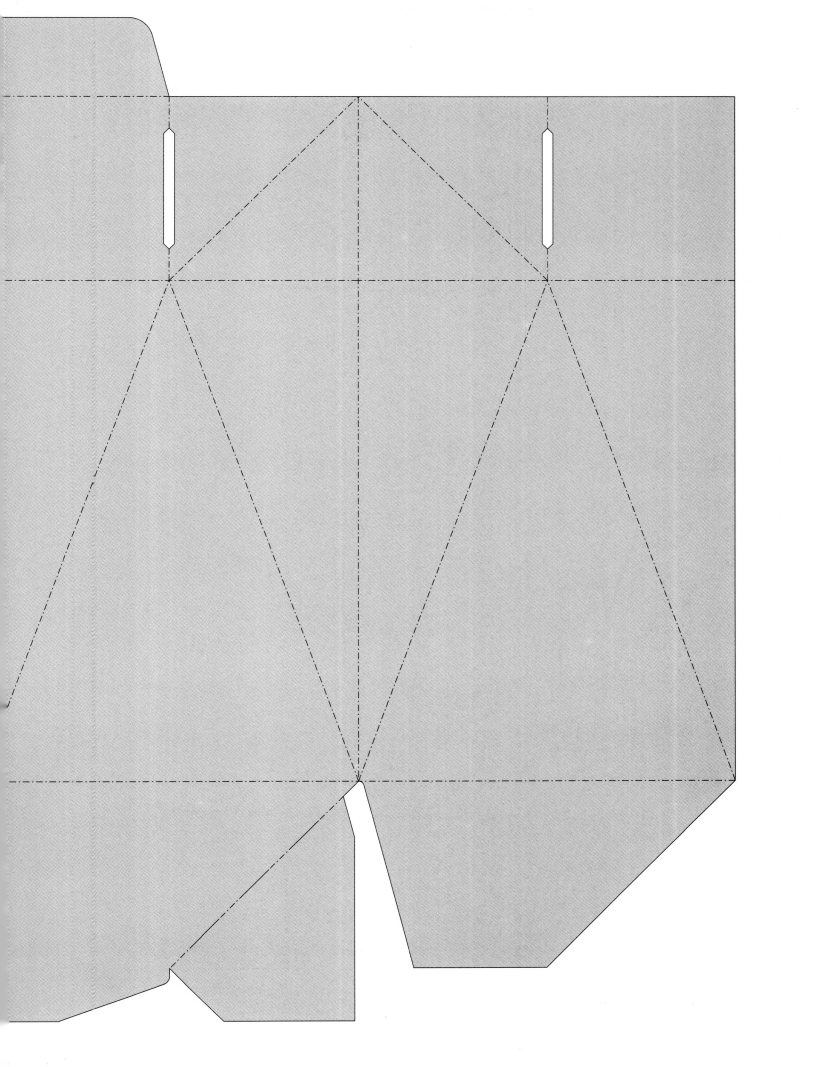

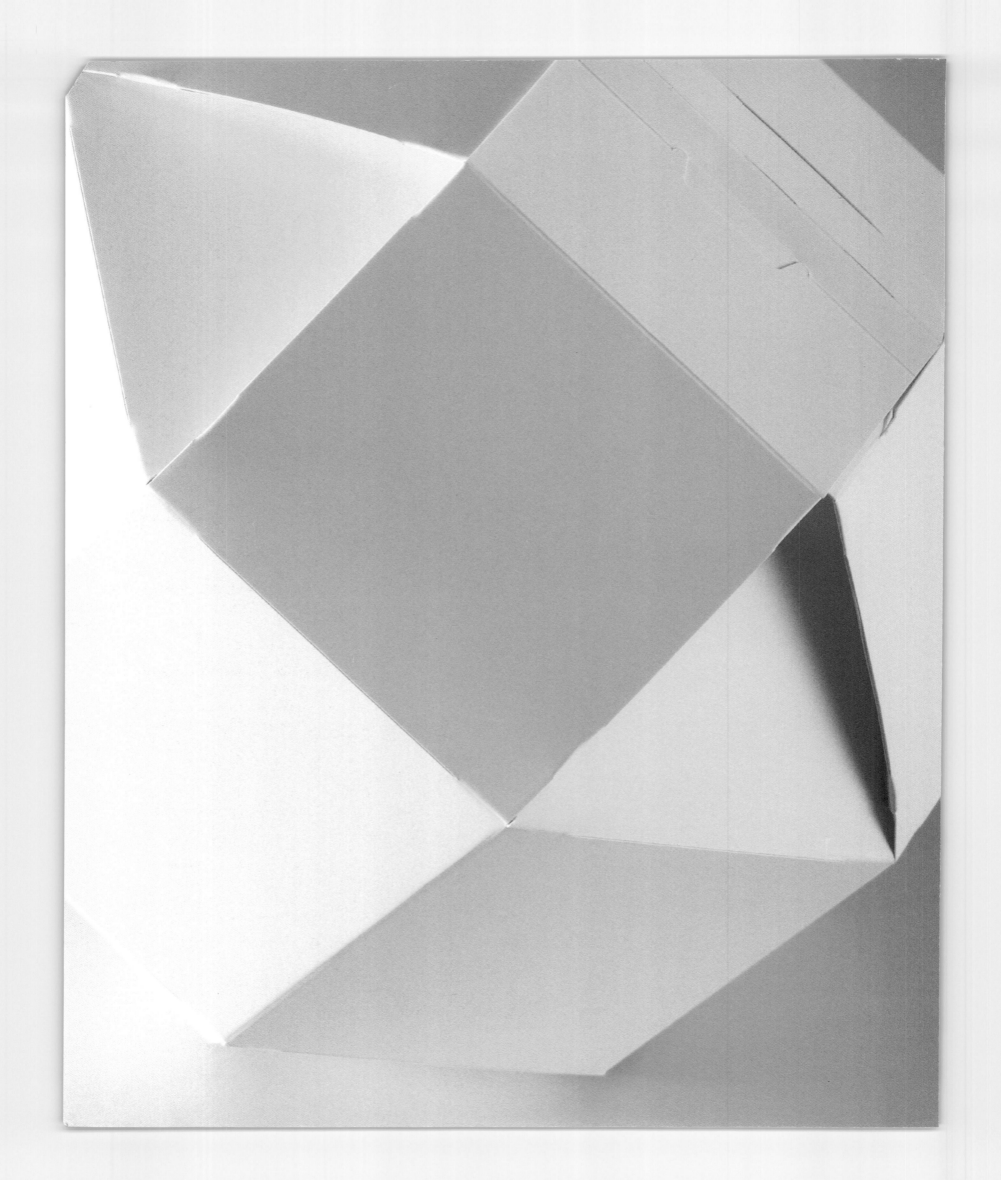

Useful Addresses

Alida Packaging Ltd., Heanor Gate, Heanor, Derbyshire, DE75 7RG, U.K.

Bonar Cartons, Gown Point, Hunslet Road, Leeds, LS10 1AR, U.K.

Brasso, Reckitt and Coleman Products, Danson Lane, Hull, HU8 7DS, U.K.

CGM Ltd., Silverstone House, 46 Newport Road, Woolfstones, Milton Keynes, MK15 0AA, U.K.

Coca-Cola Great Britain, 1 Queen Caroline Street, London, W6 9HQ, U.K.

Cullen Packaging, Robert Cullen and Sons Ltd., 10 Dawsholm Avenue, Dawsholm Industrial Estate, Glasgow, G20 0TS, U.K.

Danapak, Hill Close, Lodge Farm Industrial Estate, Harlestone Road, Northampton, NN5 7UD, U.K.

Field Group plc, Misbourne House, Badminton Court, Rectory Way, Old Amersham, Buckinghamshire, HP7 0DD, U.K.

Finnboard U.K. Ltd., Kings Chase, 107 King Street, Maidenhead, Berkshire, SL6 1DP, U.K.

GCM Boxmore, 16 East Park Road, Leicester, LE5 4QA, U.K.

H. J. Heinz Company Ltd., Hayes Park, Hayes, Middlesex, UB4 8AL, U.K.

Kiwi Shoe Polish, Sara Lee Household & Body Care Ltd., 225 Bath Road, Slough, SL1 4AU, U.K.

Kraft Jacob Suchard, (Schweiz) AG, Confectionery Plant, Riedbachstr. 150–151, CH–3027, Bern-Brunnen, Switzerland.

Mayr-Melnhof Packaging U.K., Fourth Avenue, Deeside Industrial Park, Deeside, Clwyd, North Wales, CH5 2NR, U.K.

PIRA, Packaging Division, Randalls Road, Leatherhead, Surrey, KT22 7RU, U.K.

Pro-Carton U.K., 250 Waterloo Road, London, U.K.

Processing and Packaging Machinery, Progress House, 404 Brighton Road, Croydon, Surrey, CR2 6AN, U.K.

Robor Cartons Ltd., Churchill Industrial Estate, Lancing, West Sussex, BN15 8TX, U.K.

Tetra Pak Ltd., 1 Longwalk Road, Stockley Park, Uxbridge, Middlesex. UB11 1DL, U.K.

ASSOCIATIONS AND FEDERATIONS

Aluminium Federation, Broadway House, Calthorpe Road, Five Ways, Birmingham, BI5 1TN, U.K.

Aluminium Foil Container Manufactures Association, 38–42 High Street, Bidford-on-Avon, Warwickshire, B50 4AA, U.K.

Association of Board Makers, Papermakers House, Rivenhall Road, Westlea, Swindon, Wiltshire, SN5 7BE, U.K.

Association of Plastics Manufacturers in Europe (APME), Avenue E. Van Nieuwenhuyse 4, Box 3, B–1160, Brussels, Belgium.

British Adhesives and Sealants Association, 33 Fellows Way, Stevenage, Hertfordshire, SG2 8BW, U.K.

British Aerosol Manufacturers' Association, Kings Buildings, Smith Square, London, SW1P 3JJ, U.K.

British Box and Packaging Association, 5 Dublin Street, Edinburgh, EH1 3PG, U.K.

British Carton Association, 11 Bedford Row, London, WC1R 4DX, U.K.

British Food Manufacturing Industries Research Association, The Leatherhead Food RA, Randalls Road, Leatherhead, Surrey, KT22 7RY, U.K.

British Glass Manufacturers' Association, Northumberland Road, Sheffield, S10 2UA, U.K.

British Fibreboard Packaging Association, 2 Saxon Court, Freeschool Street, Northampton, NN11 5ST, U.K.

British Plastics Federation (also Plastics and Rubber Advisory Service), 6 Bath Place, Rivington Street, London, EC2A 3JE, U.K.

British Printing Industries Federation, 11 Bedford Row, London, WC1R 4DX, U.K.

British Soft Drinks Association, 20–22 Stukeley Street, London, WC2B 5LR, U.K.

British Waste Paper Association, Alexander House, Station Road, Aldershot, Hampshire, GU11 1BQ, U.K.

Can Makers' Information Service, 1 Chelsea Manor Gardens, London, SW3 5PN, U.K.

Chartered Society of Designers, 29 Bedford Square, London, WC1B 3EG, U.K.

Corrugated Packaging Association. 2 Saxon Court, Freeschool Street, Northampton, NN1 1ST, U.K.

The Ecological Design Association, British School, Stroud, Gloucestershire, GL5 1QW, U.K.

European Carton Makers' Association (ECMA), Laan copes van Cattenburch 79, NL–2585 EW, Den Haag, The Netherlands.

FEFCO, Corrugated Packaging Association, 2 Saxon Court, Freeschool Street, Northampton, NN1 1ST, U.K.

Flexible Packaging Association, 4 The Street, Shipton Moyne, Tetbury, Gloucestershire, GL8 8PN, U.K.

Liquid Food Carton Manufacturers' Association, 30B Wimpole Street, London, W1M 8AA, U.K.

Metal Packaging Manufacturers' Association, Elm House, 19 Elmshot Lane, Chippenham, Slough, Berkshire, SL1 5QS, U.K.

Packaging and Industrial Films Association, The Fountain Precinct, 1 Balm Green, Sheffield, S1 3AF, U.K.

Paper Federation of Great Britain, Papermakers' House, Rivenhall Road, Westlea, Swindon, Wiltshire, SN5 7BE, U.K.

P. I. Design International, 1–5 Colville Mews, Lonsdale Road, London, W11 2AR, U.K.

P. I. Design International, Avenue Albertlaan 110, Bruxelles 1190, Brussels, Belgium.

Timber Packaging and Pallet Confederation, Heath Street, Tamworth, Staffordshire, B79 7JH, U.K.

World Packaging Organisation, 42 Avenue de Versailles, 75016, Paris, France.

INSTITUTES, DEPARTMENTS & COURSES

Dept. of Trade and Industry, Environment Unit, Ashdown House, 123 Victoria Street, London, SW1E 6RB, U.K.

The Design Council, 28 Haymarket, London, SW1Y 4SU, U.K.

Energy Conscious Design, 11–15 Emerald Street, London, WC1 3QL, U.K.

The Environment Council, 21 Elizabeth Street, London, SW1W 9RP, U.K.

The European Design Centre, Emmasingel 16, PO Box 6279, 5600 HG Eindhoven, The Netherlands.

Friends of the Earth, 26–28 Underwood Street, London, N1 7JQ, U.K.

INCPEN, The Industrial Council for Packaging and the Environment, Tenterden House, 3 Tenterden Street, London, W1 9AH, U.K.

Institute of Materials, 1 Carlton House Terrace, London, SW1Y 5DB, U.K.

The Institute of Packaging, Sysonby Lodge, Nottingham Road, Melton Mowbray, Leicestershire, LE13 0NU, U.K.

Institute of Paper, Hamilton Court, Gogmore Lane, Chertsey, Surrey, KT16 9AP, U.K.

Institute of Printing, 8 Lonsdale Gardens, Tunbridge Wells, Kent, TN1 1NU, U.K.

Institute of Waste Management, 9 Saxon Court, St Peters Gardens, Northampton, NN1 1SX, U.K.

International Tin Research Institute, Kingston Lane, Uxbridge, Middlesex, TW11 0LY, U.K.

The Packaging Federation (PF), Sysonby Lodge, Nottingham Road, Melton Mowbray, Leicestershire, LE13 ONU, U.K.

Packaging Standards Council, Firth House, Bramfield Road, Bulls Green, Datchworth, Hertfordshire, SG3 6SA, U.K.

Plastics and Rubber Institute, 11 Hobart Place, London, SW1W 0HL, U.K.

United Kingdom Reclamation Council, 16 High Street, Brampton, Huntingdon, PE18 8TU, U.K.

World Resource Foundation, Bridge House, High Street, Tonbridge, Kent, TN9 1DP, U.K.

Waste Watch, Hobart House, Grosvenor Place, London, SW1X 7EA, U.K.

Dept. of Art and Design, Sheffield Hallam University, Psalter Lane Campus, Sheffield, Yorkshire, S11 8UZ, U.K.

Dept of Packaging Science, Rochester Institute of Technology, 29 Lamb Memorial Drive, Rochester, New York 14623, U.S.A.

Faculty of Design, Surrey Institute of Art and Design, Faulkner Road, Farnham, Surrey, GU9 7DS, U.K.

Packaging and Design, Swindon College, Regent Circus, Swindon, SN1 1PT, U.K.

School of Packaging, Michigan State University, East Lansing, M148824, U.S.A.

Useful Reading

Burall, Paul. *Green Design*. The Design Council,
 Bournemouth: Bourne Press Ltd., 1991.

Elkington, John and Julia Hailes. *The Consumer Guide*,
 Gollancz, 1988.

Mackenzie, Dorothy. *Green Design*. London: Laurence King
 Ltd., 1991.

Opie, Robert. *Packaging Source Book*. London: Macdonald &
 Co. Ltd., 1989.

Papanek, Victor. *Design for the Real World*. 2nd edition.
 London: Thames and Hudson, 1982.

Papanek, Victor. *The Green Imperative*. London: Thames and
 Hudson, 1995.

Roth, Laszlo and George L. Wybenga. *Packaging Designers'
 Book of Patterns*. New York: Van Nostrand Reinhold, 1991.

Folding Carton Industry [magazine]. Andover, Hampshire:
 Brunton Business Publication.

Package Print and Design International. Versailles, France: Cowise
 Publishing Group.

Packaging Magazine. Tonbridge, Kent: Miller Freeman plc.

INDEX